Making and Effacing Art

# MAKING AND EFFACING ART

*Modern American Art in a Culture of Museums*

PHILIP FISHER

HARVARD UNIVERSITY PRESS
Cambridge, Massachusetts
London, England

Originally published in hardcover by Oxford University Press and reprinted by arrangement with
Oxford University Press, Inc., 198 Madison Avenue, New York, New York 10016

First Harvard University Press paperback edition, 1997

Library of Congress Cataloging-in-Publication Data
Fisher, Philip.
Making and effacing art :
modern American art in a culture of museums /
Philip Fisher.
p.  cm.   Includes bibliographical references and index.
ISBN 0-674-54305-X (pbk.)
1. Art, American. 2. Art, American. 3. Art, Modern—20th century—United States.
4. Art museum architecture—United States—Psychological aspects.
5. Space (Architecture)—United States—Psychological aspects.
I. Title. N6512.F57 1991
709'.73'0904—dc20  91-18602

# Acknowledgments

During the time that I worked on this book, I was fortunate to have the support and to be able to draw on the intellectual energy of several unique institutions. Above all I benefited from a year-long fellowship at what must be the most nearly perfect and generous setting imaginable for the life of the mind, the Wissenschaftskolleg—Institute for Advanced Study—Berlin. The genial and athletic ideal of work, thought, and international, shared cultural life that the Wissenschaftskolleg represents will always stand for me as a model of how the solitary work of writing can occur within a community and within a life of many friendships and pleasures. I owe many individual debts to different members of the staff of the Wissenschaftskolleg, but to its Rektor Wolf Lepenies, I especially owe gratitude for this fruitful time spent in a richly designed intellectual world.

Earlier I had benefited from the influence of the Program for Science, Technology and Society at MIT where I spent a year as an Exxon Fellow. At MIT the culture and history of science began to change the way I thought about works of art and their surrounding institutions. Thanks to Leo Marx and Carl Kaysen I was able to spend a year that changed the direction of this project.

Versions of several sections of this book were presented to the Cambridge Humanities Seminar whose directors, Eugene Goodheart and Alvin Kibel, had created a unique meeting point that reflected the many disciplines and universities of the Boston area.

Parts of this book have appeared in earlier form in *Representations, New Literary History, Critical Inquiry, Amerikastudien* and *Arts Magazine.*

Finally, I wish to acknowledge the support of the Hyder Rollins Fund of the Harvard English Department for helping with the costs of the color plates needed for this book.

*Cambridge, Mass.*                                                        P. F.
*May 1991*

# Contents

PART I

# The Work of Art, Museum Culture, and the Future's Past

chapter 1

# Art and the Future's Past

The life of Things is in reality many lives. A warrior's sword, known to him by its feel and balance, and by its sound as it cuts the air, would be known or seen by his community when the sight of the sword strapped on for battle is a recognized sign: we go to war tomorrow. The sight of it is one of the signs of war, terror, and possible defeat, and yet being *his* sword, a sign of the barrier still standing between themselves and defeat. The sword is his as property, but kept sharp and ready by a younger warrior whose right to touch the sword is a sign of his social place.

The sword after the warrior's death becomes a sacred object and no longer enters battle. Now controlled by the priests of the society, it is more often heard of in legends than seen, for it is kept hidden except for ceremonial uses to summon and transmit the spirit of the warrior. It is used for the initiation of young warriors and, like many sacred objects, used medically; one touch being enough to heal wounds, cure disease, or drive off depression. The priests, their ceremonies, those who touch or use the sword under whatever rules and limits: these make up a second life, a second system of access.

In time the society suffers defeat. The sword, along with all valued objects whether sacred, monetary, or human (the attractive women or those men or women useful as slaves), is seized as loot, converted to treasure by the victors for whom it is a souvenir that reminds them of a victory. Now the sword is an object of wealth. A third system of access, that of wealth, inheritance, treasure, and loot along with the permissible displays, including self-

glorification, comes into being. A new community of object inter-defines one another like the earlier military objects and sacred objects where the sword was found among potions, chants and relics. The objects that make up any society's treasure share social access and, equally, the withholding of access.

Each object becomes what it is only as a part of a community of objects in which it exists, as a hammer does within a toolbox, resting side by side with screwdrivers, nails, pliers, tape measures, screws, and functioning within a construction system in which wood is the primary material and certain skills and techniques are in everyday use. In its first life the sword occurs not only on occasions of battle and in the hands of a warrior, but mentally clustered with shields, protective gear, stirrups, helmets, and alongside such alternative weapons as arrows, bows, spears, knives, slings and rocks. It becomes a sword because of what Heidegger has called the equipment or gear context within which it is part of a working order.[1] In the same way a sharp metal implement becomes a scalpel by occurring within the gear context and practices of a modern hospital operating room.

As sacred object, the sword is found near, and given its nature by, a new array of equipment such as priestly costumes, ointments, prayers, and the historical narratives of deeds for which the sword is a relic or souvenir. Finally, as treasure, there are not only precise uses—and the access that the owner, on the one side, and the society whose regard he addresses, on the other, have that make it an object of wealth and display—but also the community of objects within which it is now located. The jewels, rugs, rooms, and servants make the sword part of the equipment that we call treasure. There can be no single piece of treasure that could be understood as such.

In none of these three cases is there any meaning to the question of what the sword is, taken in isolation, as a free-standing thing against a neutral mental background. Only with a cast of persons, a set of uses, with access and the denial of access, and an array that makes it a member of a community of objects that hold together because they work together for certain ends, only then does the sword become an object at all within its culture or within the culture that has seized it as loot. An array of objects is far more than a mere mental category. The objects that are, when taken together, the kit of tools for war, religious life, or civic wealth make those structures possible as actions just as the carpenter's tools make possible the act of building a house; or the surgical implements,

sanitary practices and training of surgeons, anesthetists, nurses, and staff make possible the modern act of open-heart surgery.

As a final stage of the sword's existence, all groups of this culture are destroyed by a higher civilization whose learned men take the sword to a museum, where they classify it along with cooking implements, canoes, clothing, statues, and toys as an example of a cultural "style" by contrast to the "artifacts" of other cultures or earlier or later "stages" of this style. In this new community of objects, which the sword could never have joined had it not been *preserved*,—that is, of interest to the earlier military, sacred, and treasure communities which preserved it while allowing other objects of every kind to rust, disappear or be destroyed in the act of conquest,—the sword is defined by a fourth form of access. Now it is looked at, studied, contrasted with other objects, seen as an example of a style, a moment, a level of technical knowledge, a temperament and culture. Art objects make up, just as weapons, sacred objects, and treasure do, an array that outlines and makes possible a sphere of activity and behavior.

Each of the four stages I have described is a socialization of the object based on a community of access chartered by a map of limited rights, demands, and uses for the object. The sword is touched and held in a knowing, determined grip only in the first; it is seen and studied only in the last. Only the first socialization was willed in the design of the object. It had to be a good sword, appropriately long, heavy, well balanced in relation to the style of fighting whether on foot or horseback, with two-handed swings or rapid forward jabs, in fights with typical military opponents, perhaps in this society always a single man, face to face. As the sword is resocialized as sacred object, treasure, and museum specimen, latent characteristics surface and surface elements of one moment become invisible at the next. The weight and balance are no longer known because no one from a later society knows how it was held in combat. We no longer know if it is a good sword, but we now know that it is a prize specimen. The small, intricate decorations along the blade, frivolous to the warrior, seem to us like a code for the spatial sense of a now vanished society and time.

What many have seen as the essential resocialization of objects in the modern period—the creation of the "history of things" was a product of the Enlightenment. From the mid-18th century on, a point of intersection came into being of new institutions and structures. The invention of museums and histories of art, new spatial arrangements of objects along with a new historical sequencing re-

socialized the European past by permitting it to rename itself art history, while ignoring those objects unable to be made part of that history.[2]

The objects that became part of these institutional arrangements and practices were naïve objects, like the sword, because they were designed for social purposes before the creation of museums. They were redesigned by the form of access that I am calling the "museum," the critical history and display of the total past.

Almost at once this specific socialization generated the next and all later series of objects, objects that have as their single, overt design, the desire to join history. Once the past had been organized as a past, a new type of cunning object began to appear, one that was no longer naïvely historical. Having to spend even a relatively brief time in the present became a burden that led to a set of strategies to cut short the inconvenience of a useful first life before an object could earn the honorable status of being part of the past. These sentimental objects, as Schiller would have called them, have as their intention to come to rest in history, to become at some future point the past, to enter the museum, to become not things but art.

What strategy does this form of *access* impose on objects seeking to be promoted in rank and value to the future's past? To see the present as history is to estrange our relation to it in the act of imagining it as the future's past. One part of that act of imagination is the attempt to control the sequence of descendants so that we will find, between our ancestors and our descendants, our "place." The name of this historical strategy is the avant-grade, a strategy that assumes the being of objects to be radically historical.

## Museum Space

What André Bazin has called the Museum Age[3] begins with the opening of existing princely and papal collections and the simultaneous ordering of such collections in a novel, historical, intellectual way. By different doors the public and the historical critic entered at the same moment. The museum became in effect the first teaching machine. One historian has categorized it as a "speaking history of art addressed solely to the intellect of the beholder."[4] With the dislocation of art during the French Revolution and the Napoleonic wars, the great European hoards were scattered, reassembled, and ultimately transferred from private to national collections, where they were located within the new system of exclusion and order.

An entire continent's treasure and loot began to be resocialized as art.

In 1723, 1749, and 1772, the Vatican collections were opened. The Sloane Collection, later called the British Museum, opened in London in 1759. In 1781 in Vienna all court-owned pictures were opened to the public three days a week, and, as a climactic act, the founding of the Louvre was decreed July 27, 1793. Collections looted during the Napoleonic wars were seldom returned to private owners, becoming instead the nuclei of national or state collections.

These museums locate for us one stage in the creation of new forms both of the assembly of objects and of the collective itself in social life, as new and deeply rooted in the realities of the new order as "the mob." This new collective in the face of which all future art will exist and agonize is "the public." It is for the public that society in the new democratic age retraces in social space—by way of the creation of zoos, libraries, parks, museums, and concert halls—the amenities of leisure and privilege once held by a few within the private space of moneyed or aristocratic property. The game preserve becomes the public zoo; the collection of books, the library; the pleasure grounds of large estates turn into public parks, forests, and reserves; private collections are transformed into museums; and the music once heard only in private settings becomes social and democratized in the public concert halls.

Once opened, the treasures became structured by the uses, by the access and demands negotiated between the public and the objects now known as art. It is an essential point that the definition of the demands, the control over these forms of order and access were in the hands of professionals, both critics and historians, who with the force of the Enlightenment and the new organic history behind them, explicitly converted the functions of art in the direction of educational goals. What had been riches became enrichment, became, that is, education and consciousness.

As important as what I am calling the democratization of treasure are two Enlightenment forces: the idea of systematic ordering, which came to be applied to many princely collections; and the use of spatial display as a form of education. Where sensory values once controlled the arrangement within a room, so that pictures, ornate frames, mirrors, furniture, tapestries, and wall coverings completed a visually pleasing total harmony, the new educational arrangement involved an instruction in history and cultures, periods and schools, that in both order and combination was fundamentally pedagogic. Where earlier collections, like that of Dr. Sloane, which would later form the nucleus of the British Museum, tended

to include such ill-sorted combinations of objects as antiquities, cut stones, medals, coins, and specimens from natural history (occasionally reaching as far into the rare and marvelous as the collection of bottled fetuses joined by one German prince to his relices, antiquities, armor, and works of art), the newer national collections begin with an essential definition of what is now familiar to us as the "work of art." Curious monsters, supposed unicorn horns, parts of the True Cross, historical battle souvenirs, impressive gems, part company with all of what can now be reconstructed within the system of access known as art. Along with the "work of art" the museum displays and stabilizes the idea of a national culture, an identifiable *Geist*, or spirit, that can be illustrated by objects and set in contrast to other national cultures.

Where Enlightenment forces, with the image of order and education represented by the *Encyclopédie*, held power, all public functions were seen as at least partially instructive. Collections of natural curiosities were no longer arranged according to the dictates of the eye, but according to systems and rules, what Foucault has so brilliantly described as tabulation.[5] Simultaneous with the opening of the galleries is the beginning, in the work of Winckelmann on Greek art, of a systematic, conceptual history.[6] The new history and the opening of the galleries join in the Villa Albani where Winckelmann himself systematically arranged the antiquities by subject, "placing godessses, emperors, and tragic reliefs together."[7] The rooms are no longer identified by shape or color, that is by the complex sensory harmony, as in the famed Green Room at Munich, but by the overall intellectual pattern that they embodied.

In the Belvedere Palace, the conceptions that Winckelmann had applied to ancient art were transferred to the paintings of Europe. The paintings were chronologically arranged within the three schools of Germany, the Netherlands, and Italy. Lighter frames were used. The paintings, as in the Green Room, came to be separated on the walls, moving from floor to ceiling stacks into, eventually, the modern linear, isolated series that we call an exhibition. "Those who kept to the older method of hanging, which they considered more pleasing to the eye, spoke of the 'murder of the gallery' but representatives of the enlightened bourgeoisie surpassed each other with enthusiastic approval."[8]

It is essential to see that the "subject" of the museum is not the individual work of art but relations between works of art, both what they have in common (styles, schools, periods) and what in the sharpest way clashes in their juxtaposition. The single scroll in a Japanese temple, seen alone in the act of meditation, seen *at rest*,

is an object, as far as any can be, in itself. That we walk through a museum, walk past the art, recapitulates in our act the motion of art history itself, its restlessness, its forward motion, its power to link. Far from being a fact that shows the public's ignorance of what art is about, the rapid stroll through a museum is an act in deep harmony with the nature of art, that is, art history and the museum itself (*not* with the individual object, which the museum itself has profoundly hidden in history).

Architectually, the museum is made up of rooms and paths. Once the pictures face us in a line on the wall we can convert rooms to paths by moving sideways from the entrance around the room, flattening it out, in effect, onto the wall. Viewing the pictures sequentially as we move from room to room, we follow the room numbers, the centuries, the schools. In so far as the museum becomes pure path, abandoning the dense spatial rooms of what were once *homes*, or, of course, the highly sophisticated space of a cathedral, it becomes a more perfect image of history, or rather of the single, linear motion of history preferred since Winckelmann.

Only the Guggenheim Museum has so far reached the ultimate spatial expression: it is pure path, without rooms. After an elevator ride to the top of the building, the visitor moves along its descending spiral ramp, pulled not only forward but down by gravity in what Frank Lloyd Wright has designed as a controlled fall. The Guggenheim is the only museum that actually hurries its visitors along by means of such an inclined ramp. As the museum visitor descends he stands with his back to one of the most spiritually grand bowls of space ever created, a space that in its scale and emptiness glorifies the art even while rivaling it. To enjoy Wright's masterpiece the visitor has to turn his back on the art, and to attend to the art he must neglect the great space behind him.

In the Guggenheim, by an effect partly achieved in the Long Gallery of the Louvre—a corridor really, along which one paces off the history of art, passing the line of masterpieces—the absence of rooms completes the spatial truth of the museum which throughout the 19th century still pretended to be a princely living space, highly decorated, ceremonial, and luxurious, where, along other things, art could be found. In fact, the museum visitor moves along a complex folded wall in such buildings, his back to the space that does not exist for him as "room." This tension between path and room ends when, in contemporary museums, one moves as though in a maze, facing the portable walls that break and turn the path but never complete the archaic rectangles.

In the museum the paintings move apart on white walls. They

form one horizontal line. The frames vanish. The secondary decorations of earlier rooms no longer complement or haunt the contents of the pictures (painted ceilings, complex plaster mouldings, textured wall coverings, domestic lighting). In this spacious historical track the public paces off the motion of this history. It is in the museum that one learns to "follow" art.

## Resocializing Objects

In his 1923 essay "The Problem of Museums," Paul Valéry wrote of the museum as a "strange organized disorder" which could never have been invented by either a sensuous or a reasonable civilization. He likened the museum to a room where ten orchestras played simultaneously, a room where from all sides the works call out for undivided attention, but where the sense of sight is violated by "that abuse of space known as a collection." For Valéry, the museum is a sign of the fact that the arts of painting and sculpture are now orphans, abandoned by architecture which once housed and gave them meaning as decorative details. Now assembled in this secondary space, each object, jealous and demanding attention, "kills all the others around it."[9]

Following Valéry, no one has written as brilliantly, even if exaggeratedly, of the violent resocialization in which the objects of the past were stripped of their worlds and resettled chronologically in the land of art. In *Being and Time*, Heidegger had spoken of museum objects as "worldless" because in so far as the museum is about the past, it cannot be the objects, still obviously present, that are gone, but their worlds.[10] Malraux writes that, "In the 12th century there could have been no question of contrasting or comparing a Wei statue with a Romanesque statue; on the one hand there was an idol, on the other a Saint."[11] Images were as subject to destruction as to preservation. The early Christian church buried classical art, it did not build museums for it. The preservation of images without belief, loyalty, or memory would be as unthinkable before the museum age as for a contemporary man to carry pictures of someone else's children in his wallet because the photographs he had of his own weren't artistic enough.

As Malraux has written:

> . . . a romanesque crucifix was not regarded by its contemporaries as a work of sculpture; nor Cimabue's Madonna as a picture. Even Phidias' *Pallas Athene* was not, primarily, a statue. The museums

have imposed on the spectator a wholly new attitude towards the work of art. For they have tended to estrange the works they bring together from the original functions and to transform even portraits into "pictures." . . . The effect of the museum was to suppress the model in almost every portrait and to divest works of art of their functions. It did away with the significance of Palladium, of Saint and Saviour; ruled out associations of sanctity, qualities of adornment and possession of likeness or imagination. . . . In the past a Gothic statue was a component part of the Cathedral; similarly a classical picture was tied up with the setting of its period, and not expected to consort with works of different mood and outlook . . . whereas the modern gallery not only isolates the work of art from its context but makes it foregather with rival or even hostile works.[12]

Like a crucifix in its cathedral, a portrait has its world where it is linked with roof and bed, silverware and diaries, heirlooms and legends of family life, and not with other portraits unless they are of other members of the family. A portrait fixes an image and is embraced and animated by what memories or sourvenirs remain. Further, it has within family life its complex uses of memory, solemnity, and compulsion. The look or bearing in ancestral portraits is instructive or formative to the children in a house where the ancestors continue to look down from the walls onto the ongoing family life, generation after generation.

The cases of portrait and crucifix are not exceptional. It is difficult to find any objects until those appear after the creation of museums that are entirely without religious, magical, political, or domestic value. No images without powers, without some address to scarcely controllable divine or social energies. In Malraux's words, "Ingres can call one of his pictures a *Virgin*, but it was not *the* virgin that he was vying with, but *with other pictures*; like the bison of Altamira, the Virgin of Amiens belonged to another world."[13]

To abolish context means more than taking the cathedral out of the crucifix. Context includes the signals that permit or deny access. The museum signs that warn us not to touch the sculpture are one example of a denial of access. What is controlled by access is the kind of recognition and the possibilities of demand in the face of an object. It would be an act of madness to enter a museum, and kneel down before a painting of the Virgin to pray for a soldier missing in battle, lighting a candle and leaving an offering on the floor near the picture before leaving. The museum suppresses, not the model, as Malraux claimed, but the practices within which any object becomes, when seen from the side of its social vitality, a

tool. As the example of the warrior's sword shows, an object can slip from one set of practices to another, from one social world and set of purposes to another. The same object can be weapon, sacred object, treasure, and archaeological specimen. In each world it has work to do. In each it is available to some people and not to others. Always we discover it within a social script where it is an actor. Early in the sword's life it is part of the script called a battle. Later it reaches the point where it turns up in the equally ritualized social script that we know as a display or an art history lecture where it occurs as an example. In between it can be found in medical or patriotic, educational, or narrative practices. As treasure, where it occurs as an unusually heavy piece of jewelry, it might play an instrumental part in seducing a beautiful woman at a dance, or be pledged to secure a loan.

Such examples as a crucifix, a family portrait, or a sword might seem to suggest that the museum is simply one of the many institutions that carry out Max Weber's idea of rationalization and demystification.[14] Objects formerly charismatic are subjected to classification and a rational approach that, in effect, bureaucratizes them, just as political power has been in the modern state or as knowledge has been within modern science. The museum relation can seem, from this angle, to be one further example of *entzauberung*. This process Walter Benjamin later made popular in discussions of art as the idea of a loss of aura that occurred within the modern system of mass production and mechanical reproduction.[15] The romantic and nostalgic concepts that Benjamin used continued in a sophistiocated way a campaign against modernity that had, in the 19th century, a bias towards craft movements and aristocratic resistance to modern society. Is this account of the museum simply another way of restating these descriptions of the loss of some putative fullness of being?

The imaginary history of the sword with which I began was intended to suggest that objects undergo resocialization in many directions, each lifetime of existence being equally full and potent. But several examples from other, more modern, everyday domains of use will make this fact clearer.

In the key days of July 1789 that preceded the fall of the Bastille in France, the crowds of Paris learned of the King's dismissal of his minister Necker on whom the people's faith in reform had depended. When they heard that he had been forced into exile in the middle of the night, the people swarmed through the streets. The crowd went to the museum located in the Boulevard du Temple to seize the bust of Necker and another of the Duke D'Orleans.

They covered the busts with crèpe and formed a procession to carry and display them through the streets of Paris, defending them with pikes, swords, and rifles. In the Place Vendome the statues with their honor guard met up with a detachment of Royal Troops who attacked, not the crowd but the bust of Necker, which they shattered.

Necker had not only been dismissed by the King, he had been ordered to leave the country at once without informing anyone. The King hoped in this way to minimize the chance of a rally that would force him to take Necker back. Missing, Necker was replaced by his bust which the people used in the religious style of processions behind the statue of the Virgin. Draped in crèpe, the image undoes his absence, substituting power in the streets, which he and his followers now symbolically control, for the power within the court of which the King had just deprived him. In order to enforce the exile—the absence of Necker—the King's officers must go one step further and destroy his image which in his absence can still function to keep his supporters together.

Several days later, after storming the Bastille, the crowd killed the prison's governor, the Marquis de Launay, and a butcher named Desnot cut off his head with a pocket knife and fixed it to the end of a pike behind which the crowd paraded through the city. The crèpe-draped bust of the missing Necker, which the Guards then broke to ratify the King's order of banishment, and the head of Launay mounted on a pike are two extremes of the activation of images in a political drama. By cutting off Launay's head the crowd had sculpted from his corpse the quickest possible realistic bust without having to call in any artist other than the butcher Desnot with his pocket knife.

This anecdote of the French Revolution offers a political instance of the relation of presence, absence, statue, and power that we are far more familiar with in the religious sphere because the very subject of the religious sphere is the presence of the invisible, the now no longer or not yet present reality. Robin Lane Fox in his book *Pagans and Christians,* a history of their relations in the second and third centuries, has described the settling down of precise images for the different pagan gods. A set of attributes and gestures stabilize over time out of the many anecdotes and reported deeds associated with the god or goddess. These gestures and anecdotes are given stability by sculpture and images. In the same way, out of the many names by which the god or goddess is at first called, one or some small number of what come to be considered "genuine" names finally settles into place as the official name or

names by which the god or goddess must be addressed. Rituals freeze into place the name and formula by which the god or goddess must be invoked, and in this idea of invocation is implied the full range of acts of prayer, appeal, blame, challenge, address, dedication, and sponsorship. The work of art, we could say, plays its part because it "envisages" the god, as Fox phrases it. Literally, the statue gives a visage to the divine figure, and its location in a temple creates the place to which one goes to speak directly to the god or make appeals to him. Each act of pilgrimage to the site of the statue becomes in itself an act of homage and reverence to this particular god or goddess as the one who can answer the plea, resolve the dispute, heal the injury. The statue, in its fixed location, stabilizes and presides over this entire sphere of life.

These statues were not themselves constantly or casually present to be seen. Access was a precise and carefully defined fact. More often than not the statue was hidden from sight and only on certain feast days did it appear in processions. The very mystery of the cult required the only occasional visibility of the statue representing the god or goddess. At the other extreme, Fox relates that Augustus, angry with Poseidon for too prolonged a spell of bad weather, ordered his statue left out of a procession. Finally, in a more everyday realm, protecting statues accompanied litigants into court or into the Emperor's presence when they came as suppliants. In every case the image was an actor in a complex social script. It was never simply standing around to be seen by anyone under any circumstance whatsoever.

In a wide set of social cases there is a close link between death, institutional continuity, and a work of art such as a statue or other image of the founder or some other key figure within a social organization. An image works as an act of replacement in which those who were important to society are claimed to be symbolically present in a physical way by means of a statue, even when absent or deceased. The founder of an institution often remains within it in spite of his death. Such a statue or portrait occurs within a precinct that is literally its own. If there were no fear that the institution itself would become vulnerable if the visible presence did not continue to preside over it, then the statue or portrait itself would cease to function, becoming no more than one more decorative object.

The work exists to make a memory of the origins of the institution an ongoing part of how actions or decisions take place in the present. Such works are site specific in that there is only one location in the world where they work at all. The same is true in an

especially intense way for statues commissioned to be part of a burial spot, or for monuments commemorating and listing the names of soldiers from a certain town who died in a war. But it is equally true for the founder's statue in the middle of a college campus or for the bust that we find near the elevator door commemorating the man who built up the business whose headquarters the building is. Outside the space of cemetery, campus, town green, or headquarters these objects lose the social intelligibility built into the image, its scale and expression. They might undergo resocialization or vanish, but to remove them from this one space is to silence them and to efface within them a cluster of attributes that only exist because of the socialization that this one location brings out.

At the edge of the Boston Common, directly across from the State House stands a Civil War monument, a bronze relief done by Saint-Gaudens that pictures Colonel Robert Gould Shaw leading out through the streets of Boston an all black regiment (Fig. 1). The bronze relief shines with a duller glow than the gold-leaf dome of the State House that it faces, but the colors are related. The monument stands within a park where, centuries ago, soldiers would have been mustered. A half-mile away, near the opposite corner, but apart from it in Park Square, stands a statue of Lincoln freeing a group of slaves, who are pictured rather humbly at his feet.

These two civic objects, but most of all Saint-Gaudens's bronze relief, with its solemn gaunt white commander on his horse and the rows of determined and noble black faces in rows, define both the abolitionist pride of Boston and, at the same time, the historical catastrophe of slavery and the Civil War that still preside over the American political present. The State House is face to face with this small bronze rectangle across the street. It exists now mostly as a stop for tourists and as a civic fact of Boston life. But it is also the subject of one of the greatest of recent American poems, Robert Lowell's "For the Union Dead," a poem that tied the civil rights movement of the 1950s and 1960s back to Saint-Gaudens's work, which Lowell imagined sticking like a fish-bone in the city's throat.

Once America is gone and its particular history of Puritan energy, its slavery and its race relations are over; once New England rectitude and the Civil War are all blurred or lost to memory, the Saint-Gaudens bronze relief might find itself in a museum in Brazil or Tokyo. For that is just what has happened to bring the Elgin Marbles to London or the stone reliefs of Assyrian art to Berlin, where we puzzle over Ashurbanipal hunting lions (Fig. 2) in the Pergamon Museum. The solemnity and violence of these lion hunts, along with their tropical atmosphere, are no less estranged as we

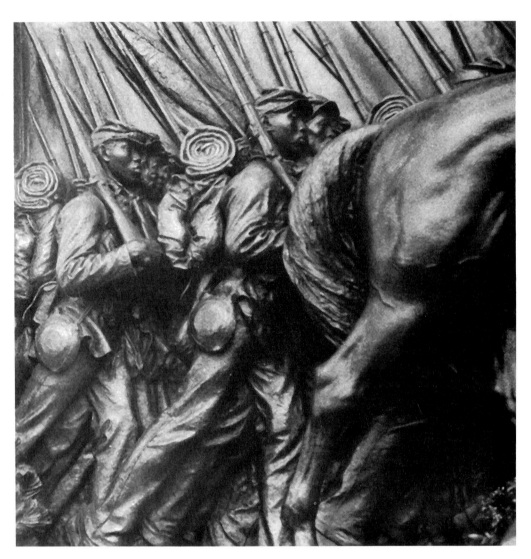

Fig. 1. Saint-Gaudens, Civil War Monument. Bronze relief. Boston.

see it today, and no less silenced than Saint-Gaudens's relief would be centuries from now in Tokyo.

While all works occur within an organized system of access and resonance in which a script of practices and knowledge holds them in place and lets them work, it is not at all the case that objects could be said simply to lose their worlds. Benjamin's loss of aura and the loss of world that Heidegger speaks of in connection with museums are elegiac concepts that turn away from the building and

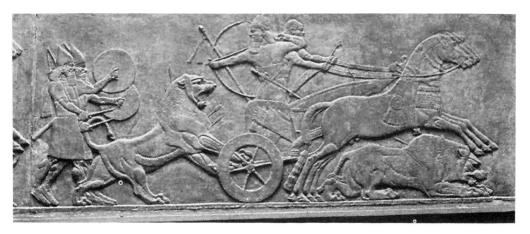

Fig. 2. Relief of Ashurbanipal hunting. Assyrian, 9th century B.C. British Museum, London.

rebuilding of communities of objects in which new characteristics come into existence by the same process that earlier features are effaced.

There are even objects in which meaning and location are found at last within museum arrays. The relatively small set of paintings that are self-portraits gain an unexpected resonance within this society of objects, a resonance that they were denied earlier. In the museum, in effect, every painting is taken as something of an implicit self-portrait in that what interests us is to read out the character, temperament, artistic career, and world-view of Rembrandt or Manet himself no matter whether the work in front of us is a landscape, a biblical scene, a still life, or a scene of everyday Parisian life. Whatever the objects, we learn more about "Manet" or "Rembrandt" and not simply in a biographical or historical sense. Within so many latent self-portraits the few candid, literal self-portraits seem to have been the only objects that set out to deliver the kind of information that elsewhere is only indirectly available. Without the museum the self-portrait, after the death of the artist, has, as an object, a troubled state.

The self-portrait is the one form of easel painting that resists being owned. It denies in its every detail that a mere owner has any right to it. It is not about him, while existing within a world where there are other painters whom he might have commissioned to make a portrait of himself, had he wanted one. Of course, the death of Rembrandt denied any later client the opportunity of hiring Rembrandt himself to do his portrait, and in that sense the self-

portraits that an artist like Rembrandt did paint become, in private collections, the surrogates for a portrait of the owner that the painter, unfortunately, did not live long enough to execute. The place is held by that poor but universal substitute, the painter's own face.

Since the self-portrait of Rembrandt or van Gogh remains stubbornly his own, it cannot be said to be the owner's even in the sense that a landscape by the same painter can be. Such a self-portrait, in the setting of a private home, would raise the question of whether the artist were being claimed as a certain special type of family member or ancestor. This appropriation would be implied because the ordinary social meaning of a portrait displayed in the home founds itself on kinship, even the spiritual kinship of the display of religious images. A portrait within a home cannot be a mere decoration like a landscape or still-life, two of the forms of painting in the modern period that are particularly comfortable within ownership and domestic display. The late 19th-century output of anonymous, all-purpose nudes by Courbet and Renoir, to name only two, played with this sense in which the owner of the object claims the content as something possessed in the form of property and personal relation.

Once the Rembrandt or van Gogh self-portrait exists in a museum room with several of the painter's other works nearby that we also take as works about Rembrandt or van Gogh since they tell us of his sensibility and interests, then the self-portrait functions almost as a shepherd surrounded by his flock of sheep. In the Louvre we often see the portrait of a painter presiding over the room where it occurs, intensifying the cult of art that depends on the reality of the artist. It does so because it gives evidence of the fact that the painter himself shared exactly this sense of the one real subject of all art: the artist.

The museum is more than a location. It is a script that makes certain acts possible and others unthinkable. For objects assumed into the museum, those practices efface just what existed as the features that were the very essence of the object in its earlier life or lives, each life being, in its turn, dependent on the suppression of yet earlier practices. When we think of an object as having a fixed set of traits we leave out the fact that only within social scripts are those traits, and not others, visible or even real. It is not only that in a museum we do not notice or even know about the balance of the sword. Once it is bolted down in a display and not swung in a certain way we cannot say that balance or imbalance is even a fact about it. Without a class of warriors, trained to fight in certain ways, even the permission to lift and swing the sword could tell us

nothing. Only one part of what is canceled within the object by the museum is what Malraux insists on as the model. Rather it is the repertoire of practices that brought out certain features and passed over other possible features. Our access assembles and disassembles what the object is, including the question of whether and in what sense it is an art object. Within a museum culture that has looted a past that had earlier been organized as a religious, civic, and familial past, one of the features of objects that came to be suppressed was the image within it along with those acts, such as memory, instruction, piety, and control that were elicited by those images.

## Silencing Objects

The suppression of images took place in three stages. First, in the process already described, images from within the culture, stripped from their context (when the crucifix is taken out of the cathedral, the cathedral is taken out of the crucifix), were silenced. To silence them meant, in part, no longer to attend to the imperatives that radiate out from that content. Most objects have the property that Austin made us aware of in those parts of language that he called Speech Acts. The objects compel behavior just as the shouted words "Wake Up!" do: they wake up the sleeper at whom they are shouted. A crucifix means, among other things, "Genuflect!" Such objects are silenced when, like tools no longer in use, we can just neutrally stand in their presence. Like a former church now converted into luxury apartments, or a cemetery now used as a playground, such objects have been de-consecrated.

A family object such as a wedding ring or a gift of atonement can, and often does, undergo a similar de-consecration, most obviously by the death of the owner. But if desperation drives someone to pawn a wedding ring, the object has suddenly been regarded as treasure, convertible into so much food, or a train ticket good for so many miles, or a room rent of so many weeks. After someone has died we might see his diary and make a decision whether to publish and sell it as literature or burn it now that its life as a part of the author's private self-relation has ended with his death. The de-consecration of objects, along with the previously latent or even not yet existent features that might let them now perform within a new social script is fundamental to the possibility that they can undergo silencing. The act of silencing is the other side of the act of bringing features into being that cannot be said to have

existed before. The metal blade of a two hundred-year-old hand saw might, in the 20th century, become a means by which one is electrocuted. But we would have to say that this new feature of conducting or not-conducting electricity only became a feature once the wider social frame of electrification had occurred. Only when a quality fits into a script that is itself a living script does that quality even exist within an object. The gain and loss of features, from without, even in objects that seem to undergo no change whatsoever, is one essential part of the life of things. The coming of the museum age was like electrification in that it raised about each object within the entire European array of sacred, domestic, and political objects the question of whether it did or did not conduct the new energy known as art, and at the same time, the question of whether it could survive the silencing of those quite different characteristics that had let it work within those earlier social scripts so as to let it stand forth purely as an art object.

After this cultural silencing, and as a second stage, the European museums began to include and exhibit objects converted into art by their presence in a museum, objects from alien societal, religious, and artistic communities. These traditions were not assimilated; that would be a common episode in cultural history like the Roman assimilation of Greece. The Chinese, African, or Indian art was preserved in its difference, in its estrangement, precisely by the museum. Both Bazin and Malraux point out that European collections were the first to include such alien objects as other than curiosities. These objects were not silenced; they were mute. The public did not have to forget their contexts; it was ignorant of them. We do not know what they once signaled—war, love, piety, fear of famine? What religious or ancestral figure's image are we in the presence of? They are mute as images and mute as to use. In what temple or domestic place did they occur? Carried in what processions? Used to cure or destroy or just to frighten away rain clouds? Fixing in memory what enemy or hero? We do not know and, except in a scholarly way, we do not care. It seemed plausible to accept these mute objects precisely because the civilization had already set itself to silence its own objects for the purposes of the new category of art. The new combination completed the process of silencing the first group.

These mute images passed back along the trails of economic conquest; Eastern objects in the second half of the 19th century, the essential exhibition of African objects, decisive for Picasso, in the early 20th century. Like the economy which based wealth for the first time not on its own fertile farmlands or hunting grounds,

on its rivers and other resources of the society itself, but instead on the society's ability to gather or loot the minerals and "resources" from the total surface of the globe, so too culture, spoken of as "resources," is a stock that is movable from place to place just as economic resources are, but at the price of surviving as mutes.

The third stage of objects joining the silenced images of our own culture and the mute images of those cultures we know "comparatively" or anthropologically are the "modern" abstract objects, progressively "absent" of images. We usually contrast these non-representational objects of Modern Art to what we call the realistic, representational, or referential traditions of our own art, but it would be more accurate to see them as the third and not the second sequence of objects. Abstract objects and paintings occur in a sequence that intensifies and completes retroactively the silencing of the first and confirms the proper place of the second, once alien, group. Abstract art is the natural art of a museum culture. Linear ordering and the cancellation of content are the two museum practices that come to be recorded within later art, where it occurs not only as one content among others, but as the essential subject matter.

One question raised by this three-stage sequence and theatrically acted out at the margin of modern art is the question of whether there isn't a simple procedure by which anything can be converted to art. On the one hand the artist might design and execute pseudo-objects, like the many rather disturbing "things" made by the modern sculptor. Once we have moved certain stones from Peru, certain carvings from Nigeria, couldn't we just as easily "find" things that have the look of art down the street or at the beach? The willful act of "finding" art is a clever copy of the anthropological relation whereby certain more and more long-lost members of the human family were found in the 19th and early 20th centuries. A filling out of the census of art occurred at the same time and was completed in the same colonial milieu.

Or, to take a shortcut, the artist could adopt already existing objects, a urinal, a stuffed goat with a tire around its neck, and by signing them, give them a secondary paternity; for it is he who has first "seen" them. In what amounts to a kind of pun on the massive creation of art out of earlier images, this adopted art testifies to the power of the signature and the museum to "silence" the image that the urinal, goat, or tire still stubbornly presents. Clement Greenberg, in a statement to which I shall return, summarized critically this margin of art when he wrote: "The notion of art put to the simplest test of experience, proves to mean not

skillful making (as the ancients defined it), but an act of mental distancing—an act that can be performed even without the help of sense perception. . . . Everything can be subjected to such distancing, and thereby converted into something that takes effect as art."[16]

This new meaning of "making" seems an outrage only if we forget that it is false to contrast it to the original artisanal making of crucifixes or portraits. Such objects were made into art later in their histories and by a process of mental distancing and conversion as outrageous as that represented by Duchamp, Picasso, or Rauschenberg who shout what is usually politely whispered: it is the museum that makes art, not craftsmen.

## The Frame of Criticism

The specific intellectual concerns the museum embodies are linked to the specialized problems of the historical study of art. Since the historian must authenticate, define economic value, date, and reach precise historical sequences, historians who were faced in general with anonymous objects, developed sophisticated keys to style and period, perhaps the most cerebral of concepts. The image was once a way of acting as though the Virgin were *there*, available for petition, conversation, repentance. In the museum the picture becomes a way of thinking that Piero della Francesca were *there*, as though the Renaissance were *there*, because from the picture we read out world-view, style, moment: the "problem" as art historians would say.

The museum itself permits this reading out by locating the object, now seen as a picture, in a space of other styles and themes. As Malraux has claimed, the museum is a structure for "pitting works of art against each other."[17] In this he follows Paul Valéry, who described a room of sculpture within the museum as "a tumult of creatures each of which demands, without ever obtaining it, the non-existence of all the others."[18] Valéry paints the picture of a chaos of wholes and parts, of grimaces and smiles, of giants and dwarfs, of monsters and heroes, works perfect of their kind next to mutilated or restored fragments; a world where an accidental line of sight forces us to see a distant noble bust between the bronze legs of the statue of an athlete.[19]

Towards the end of *Three American Painters*, Michael Fried suggests that the series of paintings might, in modern art, define the basic unit of work. In the precise, dated series the painter rules out the surrounding chaos by supplying the context, the commen-

tary of neighbors, for the no-longer-intelligible single work.[20] He creates whole sections of history at once, not pictures for the whims of history to supply antecedents and descendants for. In viewing such a sequence a striking effect occurs. Only one picture exists at any instant *as a picture*, the others are temporarily explication, frame, and criticism. The power of the series lies in the skill with which each picture can exchange roles; now a sensory experience, exhaustively commented on by the rest of the series; a moment from now, part of the explication for one of the other pictures. In the series we reach an authentic clarity of the part, the smallest detail of any structure comes in time to replicate the form of the whole: the series is not art, but a miniature art history.

As our approach to art has become more and more intellectualized, the terms of criticism have interiorized themselves to become the terms of art itself. Along the path that defines our access to the work, each work of art has ancestors, or as Gadamer has phrased it, is the answer to a question which we must discover in the prior history of art.[21] To understand the work is to know the question to which it is an answer. Within a horizon of problems and ongoing questions each work is an answer, a solution, a stage of development, and in its turn it raises—and it is this that makes it essential to history—new problems, questions, a new horizon for the next works.[22] It must be, as Fried has put it, "radical" and "fecund"; it must account in a deeply critical way for its past and become seminal for the future. The two define its "place" and it is place that is the essence of intelligibility. Its presence as a work depends on our knowledge of its horizon. The vocabulary of problems and series is, in and of itself, not just an historical, but a museum vocabulary.

The needs of the historical intelligence point finally to a stage beyond the museum, one further intensification of its procedures. Just as each picture has reality as a feature of a museum, so in its turn each museum is a fragment of one ideal museum. As collections become larger they become more intelligible. National galleries are more lucid than a dozen smaller provincial collections. But all museums have gaps, the history each displays is a history with holes, and the public must fill those gaps with memories of other collections. The ideal museum would be at last the complete history in which the path would go from horizon to horizon, each picture answering the questions asked by its neighbors, each intelligible in the visible society of styles and periods.

But this ideal museum would do to the rest of the world what Constable said a National Gallery would do to the distribution of

artists in England, "If we must have a national gallery (as they say) it will be the end of art in the small cities of England, and art will cease to exist there as it has ceased in every country that has one."[23] The ideal museum can be imagined in another way, or so Malraux proposed. If we see the long white wall of the Guggenheim as paper to be folded like an accordion, it becomes the art book, Malraux's museum without walls. With a book we must turn the pages instead of walking to the next picture, but the elements of isolation—one image per page; nextness—the sequence of pages creating the motion of time; and criticism—the use of images as criticism of other images or the juxtaposition of images and historical argument are all perfected in the art book. The total stock of art, no matter where located as "property" (a concept made less and less significant as the skills of reproduction increase) can be sequenced. The book imposes only one further transformation to those the museum has achieved; the objects are dematerialized.

> In our museum without walls, picture, fresco, miniature, and stained glass window seem of one and the same family. For all alike—miniatures, frescos, stained-glass, tapestries, Scythian plaques, pictures, Greek vase paintings, 'details,' and even statuary have become 'color-plates.' In the process they have lost their properties as *objects*, but, by the same token, they have gained something: the utmost significance as to style that they can possibly acquire.[24]

In this stage beyond the museum, which at last fulfills its intention, there is a more radical "capture" of the object. Each photo must be from a certain distance, at a certain angle, under a certain lighting. Selection of details rather than wholes, expansion or contraction of scale (a profile from a coin, expanded, equals on the next page, a reduced monumental face: both are 8" by 10"), denial of material, all permit access to the object seized by our notion of its meaning in sequence.

However important the art book has been in the last fifty years, Malraux's museum without walls has not brought about a resocialization of art in the decisive way that the museum itself had two hundred years earlier. This can be seen in the works themselves. As I will try to show in the chapters that follow, many characteristics of the modern work have to be seen as a kind of foresight on the artist's part that the work will find itself eventually within a museum as part of what the future will, it is hoped, take to be the past. What look like features of the work are really features of the wider work (the museum collection) within which it will later find

itself. No such thing can be said about the relation of those same works to the art books in which they will also find themselves. Just the opposite. In terms of the art book, modern works are naïve objects, unconscious of the fact that they will be produced in roughly 8″ by 10″ format.

When we think of one of the few painters who is conscious of this modern intimate form of the small, standard-sized work, the extent to which he is an exception is clear at once. Paul Klee produced thousands of works whose format is nearly that of the page. The works, although larger than a page, reduce effortlessly, as though this possibility were built in from the start. Klee is the first art book painter of our culture.

Otherwise the essential modern works are often gigantic, as though they wished to declare that it is not the domestic space of a living room wall, and certainly not that much smaller wall, the white page of an art book, but the museum space to which they are scaled. The public space, the dramatic but distant view, the domination of surrounding objects—these features speak out in the works themselves about the world in which they expect to occur. Scaled down to the page, their features frequently disappear.

For works addressed eventually to both the museum and the art book page, the modern abstract style would seem to be unusually convenient. One of its strengths is a certain mystery of scale. Looking at an abstract painting we often cannot tell what order of space it is about. Does the work magnify a tiny space, in effect blowing it up in a ratio of a hundred or a thousand to one the way photographs from a microscope do? Or is it the reduction of a gigantic space that we are seeing? Every modern visual work exists within our habits of seeing that the photograph, the microscope, and the telescope have leveled so that we are used to imagining in the same few square inches either tens of thousands of miles, hundreds of yards, or less than one ten-thousandth of a square inch.[25] Abstraction occurs within habits of seeing already made sophisticated by these modern possibilities of enlargement and reduction of scale.

But in reality, the abstract painting of the last seventy years has been keenly aware of the traditional facts of monumentality and intimacy, rather than of the merely quantitatively large and small. The monumental and the intimate are more accurately described as alternative instructions about response than they are questions of size. In their monumentality and rhetorical power, abstract works have decisively refused to adapt to the fact of the book to exactly the extent that they have eagerly adjusted themselves to the scale of the public, crowded life of the competitive

space of the urban museum. If anything, such works exist in defi-ance of the book by working for just those effects that cannot sur-vive miniaturization.

Similarly, the force of materials within the modern work, whether monumental or ordinary in size, presents a second obstacle to re-production. The movement towards sculpture in painting from the time of the Cubist collage, the inclusion of real objects within the painting, the concern with texture and a heavily worked surface are each evidence that the work of art since the invention of the art book has been contrary to the spirit of the museum without walls as a social space for the reproductions of art.

Instead of the painting it has been the photograph that has been most comfortable within the rectangular intimacy of the art book. Embarrassed from the start by the scale of the museum in which it is still pointlessly exhibited, the photograph thrives in the domes-ticated scale of the art book. The book or the collection of slides, like the phonograph record or tape that replaced the live concert in the 20th century, or the television performance that replaced the theater visit, permits the experience of the work of art to occur at home and at the time of choice for the viewer. This relocation of the experience of art into a sphere of domesticity is equal in im-portance to the earlier creation of public parks, zoos, museum col-lections, and concert halls that democratized the privileges and pleasures of an aristocracy for the new category of the public.

Even though one might prefer to look at and experience the paintings of Caspar David Friedrich at night, the museum hours are limited to the "working" hours of the middle of the day. Once a slide or an art book exists, the matching of moods between viewer and work can be perfected. The domestication of all art, its demo-cratic privatization in which a relatively valueless copy makes avail-able book, musical performance, video tape, or slide in the familial setting of the private home carried even further the universaliza-tion that the museum had begun. The museum socialized what it still preserved as property or treasure. It eliminated only the owner. The slide or tape eliminated the property itself, the "object" within the art object. At the same time the new means eliminated the commitment of the 18th and 19th centuries to the ideal that im-portant cultural experiences should take place in a public space where we find ourselves side by side with large groups of unrelated strangers who made up, together with oneself, the social category of the "public."[26] The art book makes art an experience of the lap, of the eye, and of the hand that turns the pages. Most important of all, it makes art an experience for a solitary and immobile person. Sit-

ting down to art, as we sit down to eat, domesticates it in a fundamental way.

The art book, in other words, is a rival technology of experience, and not simply an extension of the museum principle. It permits a totalization of the field that allows those elements that have surfaced to be intellectually placed within the most complete range, the range finally visible as one complex whole—Art. If it is objected that reproductions are ontologically different objects, while museums only relocate the same object in a different world, it should be seen that the estrangement involved in what makes up the "object" is similar in the two cases. The Elgin Marbles, as they are called under their museum name, are fragments of what was originally "something else." The photograph of what was in another place the Sistine Chapel ceiling (almost impossible to *see* on the spot) is likewise the product of an estrangement. It is one of the powers of art to declare new wholes. The *Venus de Milo* is whole without the arms. The famous archaic torso of Apollo described in Rilke's poem is, as a work of art in the museum, a whole, perhaps more moving as a torso than it was as a statue. No one repaints the once brightly colored Greek statues: as museum art they are white. Yet fragments of Greek vases are reconstructed by scholarly detective work into the object they "must have been." The presence of fragmentary wholes in the museum is a reminder of the violence that has seized every naïve object from what was once its world. Is the unpainted, armless, headless torso, its temple lost along with its limbs, a less "dematerialized" object than a photograph; is it any less estranged?

## The Museum Candidates

To this point it is the fate of naïve objects that has been described, those objects for which the museum is the heaven for things, the place where they spend their afterlife. After the stabilization of museums as the place of art, and of culture as the use of art, after the historical definition of the past that Winckelmann, Hegel, Wölfflin, and Riegl brought into being, a new and highly ambitious object began to be produced, one that did not have the accidental fate, but rather the destiny of the museum stamped on it from the start. This object which is at first what I would like to call a "candidate" for history, an "applicant" to the museum, is the object that we refer to as "modern" art. In size alone such objects no longer fit any but a public space. If the Cubist painter, in Mi-

chael Fried's words, "trues and fares" every shape within the painting
to the frame edge, he also trues and fares the paintings themselves
to the wall edges of the modern museum. It is a notable fact that
the homes of major private collectors like Philip Johnson, Norton
Simon, or G. David Thompson, where such objects "rest" before
finding final homes in public museums, have architecturally been
designed as miniature museums, often adjacent to rather than in-
tegrated with the living areas of the house. Where art was once
honored to be housed in the homes of the mighty, the mighty are
now honored to be permitted to sleep in the house of art. The
collector is an intermediary between the artist and the public whose
property the art will finally become. Like the Mellon or Frick col-
lections, the Simon "holdings," as we so appropriately call them,
are destined for both civic and educational functions.

Far more important as a factor in the existence of these works
as "candidates" is the technique for determining the price of a work
of art. Unlike the earlier commissions on which artists lived, the
price of a modern work does not directly reflect workmanship, time,
labor, size, cost of materials, or skill. Rather the price is a complex
speculation on the work's future as a "past." Price is set by imag-
ining how essential to any future series called art this type of object
will be. Its value, like that of a growth stock, involves an act of
prophecy. The "price" of a contemporary painting is a function of
a prediction of its future, and for this future value to be deter-
mined, criticism must move closer and closer to a historicization of
the present, determining on the spot what the historical place of
new objects might eventually be even as they are produced. With-
out this speculative, prophetic act of criticism, the object has, as a
commodity, no value. The painting is priced this way because it is
not yet at its destination, the museum. For a short time the paint-
ing will be "at large" until it is ever so slightly "past." Once this
probationary period is over, it will come to rest in sequence or will
disappear. The initial price is in effect a wager that in a reasonable
period of time the object will be priceless, permanent, and guaran-
teed by the civilization to be among the ten thousand objects to be
kept as little as possible subject to time until the end of man him-
self. We make an eternal promise to the objects in museums, be-
cause unlike the statue of Ozymandias that can be forgotten when
*he* is, these images are the past itself and not a set of images tied
to the calendar of our belief or memory.

The place of the museum can best be understood by picturing
it in contrast to not only the earlier private princely collections but
also the modern factory. The museum, in its dedication to unique-

ness, to preservation, and to those objects of the past whose useful life is in effect over, came to celebrate just such values, at least in part, because the modern production of objects in the factory system turned out unlimited numbers of identical, replicated objects made to be replaced as soon as they become obsolete. Museums became more and more central exactly in cultures touched most deeply by the modern system of mass-production. The British Museum in London and the Metropolitan Museum in New York represent a new kind of institution. No longer do they provide a visible history of the culture itself: that is, a display of objects rich with symbolic, local significance. Instead they are storage areas for authenticity and uniqueness per se, for objects from any culture or period whatever that were said to be irreplaceable.

On this side, museums are counter-institutions to the factory. As objects became more short-lived and geared to an ongoing series of inventions and improvements that produced, as one side effect, obsolescence, the museum became ever more skilled at preservation; that is, at keeping selected things in a state that would never deteriorate or change. The modern factory system expands during the same period as both the political nationalism and the democratization of access that dominate the historical period from the Enlightenment to the present.

The description of the alternative model of making that the factory system offered will be the subject of the last part of this book. Within a society of museums and factories the making of art had two paths before it. It might mimic the museum's act of effacing, resocializing already existing objects, designing objects that occupy a place within the sequences that came to be known as the development of art. Or, alternatively, art might take as its strategy the active social process by which the everyday objects of modern life were made, the process of a system of production that had left behind the craft processes within which both art and everyday objects had traditionally been made. These two stategies were not opposed. Making and effacing art were both antagonistic and intimately connected processes.

chapter 2

# Object Time and
# Museum Space

Once the objects gathered into the museum were sequenced in a decisively historical way, there remained an essential doubt about the meaning of this history, a doubt about the pattern of historical time. The history of art, unlike other histories derived from Enlightenment assumptions, does not base itself on the notion of progress. Where the history of civilization and moral life showed, it was claimed, greater and greater refinement in which reason replaced violence; where the history of technology pictured brute strength supplanted by skill and organization; where in political life despotism gave way to progressive freedom, and, in knowledge, superstition and religion fell before an ever more thorough scientific method, in art alone the Hegelian and all other histories began with the devastating suspicion that the later ages of civilization were not the great ages of art, that in fact we might find ourselves already, as Hegel put it, at the "end of art."

W.J. Bate, in *The Burden of the Past*, has shown that it was precisely those Enlightenment and 19th-century figures most confident and optimistic—Voltaire and Macaulay, for example—who raised the most telling doubts about progress in the arts, about any history of the arts that was not a history of decline into triviality.[1] Macaulay's essay on Milton raised the literary question of whether language wasn't inevitably less and less available to poetry as it passed from a metaphoric, concrete, immediate state that was sensory and playful, to the more abstract, precise, distant language

that our civilization requires.[2] Doesn't language wear out? And with it poetry?

Hegel stated the more general case. As reflection grows, as judgment, thought, critical and distancing activity move to the center of life, art becomes infected, deprived of immediacy and enjoyment, and competes with the more successful modes of speculative, critical activity on their own territory and loses. "The whole spiritual culture of the age is of such a kind; that [the artist] stands within the reflective world and its conditions, and it is impossible for him to abstract from it by will and resolve, or to contrive for himself and bring to pass, by means of peculiar education or removal from the relations of life, a peculiar solitude that would replace all that is lost. In all these respects art is, and remains for us, on the side of its highest destiny, a thing of the past."[3] This consciousness, the goal of all history and not simply one stage among many, is what Hegel's own work in every case completes. His *Aesthetics* and *Phenomenology of Spirit* exist historically at the end of the self-consciousness of spirit. The point that Hegel makes so decisively, that reflection and the institutions of reflection are the signal of the conclusion of art, became diluted into the more common statement of the 19th and 20th centuries that we live in a critical, not a creative or organic, age.

The paradoxical twist given to this characterization by modernist art criticism is to say that a new art, radical by nature, profoundly interesting, even "moral" as Michael Fried calls it, can result precisely from the extreme consciousness, the thorough but not paralyzing self-reflection of art, from the deep critical intelligence that our historization of art has founded. Exactly *there* were Hegel located the end of art can be found the new Kantian (as Clement Greenberg called it) burden for art to seek and manifest its own ultimate ground.

Unlike the other organic histories of the 19th century, the history of art, in its total expanse, lacked point. Hegel who modeled the history of art on the history of consciousness and society, divided the span into three stages: symbolic art, classical art, and romantic art. Architecture was the major form of the first stage, sculpture of the second, music of the third. Poetry, he found, could consort with each phase equally. While suiting Hegel's theme of the development from material to spiritual arts, the history is otherwise outrageous, useless in fact. Were not the Greeks most proud of their music? Do not the cathedrals, although massively material, express most powerfully the religious, other-wordly culture of the Middle Ages? Doesn't Hegel mean that architecture is what is pre-

served from most distant civilizations; music only from present culture, thus confusing the difficulties of the historian with the shape of history?

Likewise Hegel's classification on a range from objective to subjective, from the external art of architecture, to the objective art of sculpture, to the subjective arts of painting, music, and poetry, seems to suit his own history of the spirit more than the evidence of art.

Heinrich Wölfflin, who created the most dense categories of formal history, supplied a set of dichotomies that influenced all later histories, but Wölfflin himself treated only local segments of history, the Renaissance and Baroque, thus avoiding the question of whether or not there are more than cycles and repetitions of his famous opposites of style: linear vs. painterly, planar vs. recessive, closed vs. open form, unified vs. multiple effect.[4]

Alois Riegl alone of major art historians created a plausible total history on thematic grounds by focusing on the period in late Roman art when the transition took place that, in Riegl's view, was decisive for all art—the change from haptic or tactile values to optical, visual ones.[5] Both Greenberg and Fried take over Riegl's general history to apply it, in miniature, to modern art. The last struggle for a purely optical style, for an experience purged of tactile, textural responses and suggestions, is traced out in painting since Manet. Whatever the truth of Riegl's general history of our sensory map of reality, it must be noted that this change from touch to sight is one of the major effects of the museum which suppresses and overtly forbids touch, denies any experience of texture or weight, and deprives us of the "feel" of things, even of objects like vases once primarily known by being carried. So, it is likely that what Riegl speaks of as the history of art is in reality the history of access within our sensory map.

In the absence of thematic convictions like those of Hegel or Riegl, the most telling history of art has been that based on the premises of science. In this pattern we hear of innovations, inventions, discoveries, even of breakthroughs. Pound and Eliot standardized this vocabulary in literature. All true artists are innovators, experimenters in fact. Why should any artist do once again what has already been done. Pound argued. But, unlike technological inventions, artistic innovations do not seem to form a permanent, expanding series. Where Fried speaks of Jackson Pollock's cutouts as a "discovery" or as a "solution," he uses the same language as we might for the internal combustion engine. Yet neither Pollock himself, nor any other painter since, has seemed to feel the need to take advantage of this solution. The discovery of the arch

as a method of spanning was a "discovery" only because it was adopted and the continued in use; because, that is, the need or problem remained. In a shrewd comment Arnold Hauser has said that in art there are no problems until there are solutions. It is the arrival of a solution that calls our attention to the existence of a prior "problem" which the solution does not solve so much as liquidate.[6]

There is, however, a genuine meaning for the term "invention" in art. In *The Shape of Time*, George Kubler notes the change near the end of the sixth century B.C. in Greek vase painting: the figure/ground relationship reversed from black figures painted on a red ground to red figures on a black ground. Now the figures could portray more detailed expressions, carry more refined psychological descriptions. "This amounted to a reversal of figure and ground in order to favor the figure and convert the ground from a decorative setting into an atmospheric distance."[7] This change was a "discovery" precisely because it prevailed. A changed relationship came into being that was a deeply inviting one. One mark of essential discoveries as Kubler points out, is that they seem to occur simultaneously in many places and crafts, then jell as discoveries without conscious decision. In the craftsman's language, they survive because they "work." Such a discovery is surely the many-sided epistemological change in literature in the 19th century that we associate with the rise to importance of point of view in the novel, the importance of the dramatic monologue in poetry, the popularity of the detective form, and so forth. These are changes which converge to a discovery but which have no one inventor. Equally absent is the "problem" to which the discovery is a "solution."

If we accept this meaning of the word "discovery," then the form of cultural history cannot be a list of innovators, as Pound thought. To discover, in the essential sense, is impossible as a self-conscious deliberate act. The history of art as a chronicle of innovations involves a search for turning points or, what Kubler has called, prime objects, those novel departures that found a series of repetitions and minor variations. Hegel in his *Philosophy of History* imagined the turning points of history as the work of "world-historical individuals." The history of art in charting innovation is in search of similar heroic individuals. Manet, Cézanne, and the Picasso of *Les Demoiselles d'Avignon* represent such turning points, or so it is claimed. The decisive paintings, the prime objects associated with these turning points make up a category entirely separate from the somewhat archaic category of "masterpieces," and these works in fact more often suggest the early struggle than the

later finished elaboration traditionally associated with the master-piece. The analogy between the deliberate artist who innovates and Hegel's world-historical individual misses the essential Hegelian point: such figures act *unconsciously*. They expend their energy for the narrow intentions of their private wills, acting out a vision that has no relation to the unwitting design that their feet are tracing. The world spirit, history, uses them and writes, so to speak, behind their backs. Hegel sees a gulf between historical actors and historians. The very definition of modernist art involves a claim that action and reflection can become a single act, that an artist can be self-consciously historical through the act of decisive innovation.

## Self-conscious Painting

The historical pattern that overlaps both the thematic and the technical histories of art is the uniquely interesting "Kantian theory" that acknowledges itself to be a local history and accepts, while giving form to it, the notion that all objects after the onset of the museum age have a dramatically new intention. The deepest formulation of this new history lies in the work of the Russian formalists, particularly Viktor Shklovski in his theory of estranging and perceptibility, but the outline and procedures of this history are most available to us in the writings on art of Clement Greenberg. In this history, modernism is seen as an episode of a unique kind with laws and procedures that are radically new. Painting since Manet, literature since Flaubert and Baudelaire are reflective, self-conscious, deeply historical in inspiration, defiantly concerned with the grounds of art itself, in search of the minimal conditions of art, relentless in freeing themselves from irrelevant or impure features found in earlier art. As Greenberg has written "In seeking to go beyond Alexandrianism, a part of Western bourgeois society has produced something unheard of heretofore; avant-garde culture. *A superior consciousness of history*—more precisely, the appearance of a new kind of criticism of society, an historical criticism—made this possible."[8]

The first claim of such works of art is that they are historical because they are about history. What Nietzsche said with contempt, "Our modern culture is not a real culture but a kind of knowledge about culture,"[9] is changed to the sign of absolute authenticity of culture. For Fried, certain painters are essential because their work "appears more advanced, more radical in its *criticism* of the modernist art of the recent past than any other

contemporary work . . . There is an increase in the formal and historical self-awareness on the part of modernist painters. The work of such painters as Noland, Olitski, and Stella not only arises largely out of their personal interpretations of the particular situations in which advanced painting finds itself at crucial moments in their respective developments; their work also aspires to be adjudged in retrospect to have been necessary to the finest modernist painting of the future."[10] In short, radically critical of the immediate context (the past), fecund and prophetic towards the future. The act of painting is a self-historicization, an interpretation, and a prediction. An object is produced whose *content* is not an image but the instructions for setting it in historical relations.

Cézanne as Greenberg describes him, sounds almost scholarly; in fact, a critic with a brush. "He was making the first pondered and conscious attempt to save the key principle of western painting—its concern for an ample and literal rendering of stereometric space—from the effects of Impressionist color. He had noted the Impressionists' inadvertent silting up of pictorial depth; and it was because he tried so hard to reexcavate that space without abandoning Impressionist color, and because this effort, while vain, was so profoundly conceived, that his art became the discovery and turning point that it did."[11] One obvious implication is that this problem might be more easily defined in words than through a painting, that in fact the critic might be a more interesting, because more profoundly historical and philosophical, commentator than the artist. Fried at one point acknowledges this.

> Criticism that shares the basic premises of modernist painting finds itself compelled to play a role in its development closely akin to and potentially only somewhat less important than that of the new paintings themselves. Not only will such a critic expound the significance of new painting that seems to him as being genuinely exploratory, and distinguish between this and work that does not attempt to challenge or go beyond the achievements of prior modernists; but in discussing the work of painters he admires he will have occasion to point out what seems to him flaws in the putative solutions to particular formal problems; and, more rarely, he may even presume to call the attention of modernist painters to formal issues that, in his opinion, demand to be grappled with.[12]

Is this a passing, accidental arrogance? I think not. Where criticism becomes the decisive act within painting, the question is bound to arise whether there aren't moments in which artists themselves fail to give a radical enough account of their art.

The remarkable development by which criticism (which previously floated outside the work of art) appears more and more internal to the work itself suggests a more general speculation. The museum, or the historicization of art that is reflected in the museum, comes openly to manifest its implications as a system of access only gradually. The spatial progression from room to path to art book is one such manifestation, in which the latent becomes overt. But as a final stage of this manifestation what existed originally as an exterior operation on objects appears inside the objects themselves as content. The path appears within the work of art as the series, the educational, critical arrangement imposed on art as a sequence in the museum, appears finally within the individual painting as the radical, knowing stance towards its immediate past that Greenberg and Fried describe. Institutional qualities are introjected. This introjection is the highest form of self-consciousness within works.

Manet is often chosen to begin the history of modern art because he is the first "frank" painter. Similarly Cubism acknowledges the "edge" of the canvas. The literal, irreducible facts of the painting are not disguised, but openly discussed within the painting itself. The paintings make these ultimate facts "perceptible," to use Shklovski's useful concept.[13] Much of the brilliance of Greenberg's or Fried's criticism depends on their remarkable powers of description about this process of making perceptible the fundamental nature of flatness, line, surface, shape, weight, and color.

For Greenberg or Fried the statement and solution of a set of internal problems within the nature of painting appear directly as the matter or subject of the individual works of art. Candid, self-conscious, rid of irrelevance, these works are in the nature of demonstrations. The elements open to exploration are few in number and result from a Kantian process of subtraction. Paradoxically, in a century where one of the general cultural themes is the dematerialization of objects and their replication (the normal experience of most works of art being through slide images projected on a screen or reproductions in books), the elements isolated within this Kantian process are rigorously material. They define the this-ness and the here-ness of a unique physical object. The object is first of all flat. Since it is not interminable, it has edges; because it ends, it has shape. Tension and therefore energy accrue wherever an act has taken place that acknowledges, denies, or complicates these few material facts. If two vertical bands of different width and color are painted side by side from the top edge to the bottom edge of the canvas, optical tensions are created. Because they differ in color,

one band will be read as behind the other in space. Yet the canvas is flat. The bands have no given end other than the canvas edge so they can be felt to have been cropped by the canvas or to be continuing invisibly beyond the canvas. Since they do not exhaust the area of the canvas and are placed off center, they generate the issue of balance, indicate the symmetry of the rectangular canvas, and fracture the whole into two parts, painted and unpainted. In this brief account the painting is described as self-inhabiting.

The important exception to this optical self-reference is the continuous interplay between habits and expectations that are residues from ordinary spatial experience. That color relations define forward or back, far or near; that sharpness, color saturation, blur, and blending are distance clues; that edges like those of a building or a horizon are not ends but only temporary impediments to our desire to see the rest of the car or boat: such experiential facts are the implicit pole of reference. In fact, this means that the *subject* of the painting must be stated as both that the canvas has an edge and that the world does not; that the canvas is flat and the world is not. Banished as a content, the world hovers as a spiteful secondary presence.

The three central matters, flatness, edge, and opticality, resist philosophically different temptations. For flatness, the denied complement is an illusory, excavated space behind the canvas, the box or room or world into which we seem to look in traditional painting. With flatness, looking into is replaced by looking at. It is important to note that flatness is also opposed to whatever actual matter occurs on the canvas or between the surface of the canvas and the spectator, but this not-flatness (whether of thick paint, papers, or objects attached to the canvas, or sculpture-like extensions of the canvas itself towards the spectator) amounts to a real as opposed to a virtual three-dimensional counterpoint to flatness.

The colonizing of this space between the surface of the canvas and the viewer has been one of the most aggressive features of the 20th century. Instead of luring the viewer back through the surface, the painting extends forward towards the spectator, sometimes soliciting, sometimes threatening. In Jasper Johns's painting *Zone,* a plain white, cafeteria style coffee cup, neatly labeled, is attached to the surface of the canvas. Since the painting comes with a cup held out to the viewer it defines itself as something of a beggar, a witty characterization of this modern choice to break out from flatness forward, rather than backward into the deep stage of traditional art for which the canvas served as window and curtain.

The tension made visible through edge is of course a tension

with the ongoing nature of the world. The third feature, opticality, or the account painting gives of visual sensations, leads to a more intricate problem of alternatives. Of course, at the simplest level, the claim here is only that, just as music is auditory, so painting is visual. Yet sculpture and architecture are also seen, and if sculpture has a gravity, a weight, and a set of textural clues, so too, in fact, does painting. The opticality is not in tension with olfactory or auditory sensations; painting never developed a technique for implying either realm, neither for feasts, rotting corpses, musical performances, or a whispering couple. The only sensory realm held at bay by opticality is the tactile.

Here an important distinction must be made. There were in fact two entirely unrelated tactile realms. The first concluded only the clues to texture and touch within the illusory representation, the rendering of the look-of-the-feel-of silk or skin, glass or sand. This should be called the tactile realm of consumption. It locates itself inside the space and amounts to a realm of illusion as sophisticated as perspective. The second tactile realm is on the surf─ ─nd gives an account of the production of the painting itself, the still visible record of brush or knife strokes, drips, smudges, and scrapes. This tactile realm of production is real, occurs on top of the canvas, between the representation and the spectator, and narrates the history of the manufacturing of the art object. With Monet, at precisely the moment that the optical quality of the world is given in a more precise way behind the canvas, the tactile history on the surface becomes an engrossing companion subject. By means of addition, juxtaposition, assembly, and repetition, the surface comes into being as a made object, not a represented one. Its laws are those of the hand and of the conditions of production, not those of the eye and of reception, or, as it is called here, consumption. In the final Cézannes, the late Monets, or the work of de Kooning and Pollock, this frozen narrative history of production asserts a radically factual subject in much the same way as the *tableau-object* of Cubism had.

Once perceptible these Kantian features of the flat surface vs. spatial depth, linearity vs. painterly (the categories that Greenberg and Fried work with are Wölfflin's) are seen, in an almost heroic way, to be overcome in moments of paradox. How can there be a line without a boundary? How can an overall style create drama and inflection? The solutions, like Pollock's cut-outs or Louis's stain paintings have something of wit about them, but in their very sharpness they make more richly perceptible the grounds of painting itself.[14] The dramatic force of these paradoxical "solutions" rests

on their power that lies outside themselves, a tension about which they are a form of discourse, a tension to which they allude. In the series of works that deny, disguise, or wrestle heroically with the fundamental limits of certain choices, these works, when seen sequentially, have the power of exhilarating quips that for a moment seem to defy what we had imagined as the limits of the possible. The painting most demonstrably flat is an empty painting, a blank canvas.

Where a ground element becomes perceptible the painting retroactively enlivens all previous parts of the sequence. This reinvigoration becomes a part of *its* content as they are part of its explication. The new work makes *them* perceptible in a decisive way, but it does so through the act of estranging. By announcing within the content of the painting the limits of painting itself, so that these limits become the subject, the painting makes of *Art*, of painting itself, a matter to be distanced and therefore made into—Art. On an individual level, the painting with its self-distancing as its subject authenticates itself as—a painting. The definition by Greenberg, cited earlier, is essential: "The notion of art put to the simplest test of experience, proves to be not skilful making (as the ancients defined it), but an act of mental distancing—an act that can be performed even without the help of sense perception . . . Everything can be subjected to such distancing and thereby converted into something that takes effect as art."[15] By this word everything we usually understand, even crucifixes, even what was once a sword, even a soup can, even a urinal, but the final "even" has to be reserved: even "art" can be distanced to produce—art.

Unlike the Hegelian or technological history of inventions and breakthroughs, this Kantian history of art is only the history of an episode, not of art as a whole. Such paintings reflect on an already assembled series called art. They call attention to features within that series, even proposing themselves as a rather severe guide to all that had come before.

Unlike the objects lifted out of reality and made into art—the stunts and jokes of modern art—the self-estranged works have a weight and importance that cannot be dismissed. They do, however, share the tactics of distancing and making perceptible. Only now it is the history of art itself and its institutional base, the museum, that is the final world of objects from which one can be torn free, as the Elgin Marbles were torn from not only a specific building, but from Greece itself.

The historical act by which works achieve this particular place in time—the reflective, self-conscious Kantian objects of a tradi-

tion—is the act of designing themselves as a kind of appendix or afterthought to the history and to the museum which they imagine themselves to complete. The most tempting historical strategy, one that has hovered over all work within modernism, has been the desire to be the Last Work of Art.

## Spaces Where Art Can Occur

Just as the historical order within the museum freed only certain temporal locations for the new work that might set out to imagine itself collected and ordered there, so too did the museum itself as a space provide only a specialized set of possible spatial locations in which art might occur. One that has already been described was the linear path, a path reflecting the temporal sequence of the history of art. A second which will be described later is the spatial location of justaposition, or nextness, by means of which one object occurs as a contrast to another.

As Alois Riegl's contrast between the optical and the tactile made clear, the essential progression within works was in the direction of an ever greater retreat of the tactile in favor of the optical. That this is found within works only reflects the prohibition on touch that is one of the major details of our relation to art. The glass that is, along with light, one of the basic constituents of the museum experience, works as a filter that delivers only the optical features of the work. Glass delivers the work as a purely optical space.

The notion of opticality or visual space is, even without contrast to tactile space, a concept in need of refinement. Most of the so-called ordinary features of visual space are in fact the characteristics of the middle interval of space, that volume described by a room or a landscape. The differing images of the two eyes, essential for binocular depth perception, is significant for near objects, but falls off rapidly. The blur of peripheral vision, unnoticeable while standing and looking attentively at a distant object, becomes disquieting when driving 40 miles per hour through a tunnel, particularly when the nearby wall is covered with repeating square tiles. The clues to depth and perspective—of which the essential psychological work of Gibson, *The Perception of the Visual World* and *The Senses Considered as Perceptual Systems*, lists thirteen—vary or are cancelled according to the scale of space.[16] For example, the fact that texture separates near and crowds further back is only visually important for relatively close objects; past a certain distance there is in fact no texture, just as past a certain distance human beings have

neither expressions nor faces. Contrast of hue is most prominent at a near distance so that, for example, the stripe paintings of Morris Louis allude to visual experience of a fixed proximity even where, as a result of magnification, a certain extension of the distance can be created. Similarly, the atmospheric effects in Monet invoke a sufficient distance for the atmospheric build-up to efface and blend the separate colors. The cardboard flatness of distant objects, their unique vestigial color and shape, has traditionally been one of the subjects of the paintings of distant mountains. That Cézanne modeled with color, not with value, and that Impressionist color is keyed unusually high are both signs of an assumed far space, even when applied to the near at hand.

Even the most well-known of spatial clues, the convergence of parallel lines, requires a spatial scale of a precise kind. The example of railway tracks is the familiar one precisely because, by standing on the tracks with the two rails a few feet on either side of the body, one has one of the only examples of continuous lines, near enough to begin with yet extended flat for two hundred yards so as to appear to meet. That is, the effect depends on the contrast of scale from width to length, eight feet to two hundred yards. Where the convergence operates dramatically in a smaller space, as it does in many van Gogh paintings, the feeling is one of a collapsed space, one where more length has been assigned to each distance than is in fact physically possible.

By themselves the many details of variations in the visual perception of space would force us to account for a variety of representational strategies, each at home in one or another of the primary scale and distance experiences of the world, but then applicable by entension to all other scales or distances and even recoverable as a kind of memory experience in abstract paintings. Intuitively we realize this in saying that certain paintings feel like blown-up details of something seen very close up. Yet the total effect of these physiological differences becomes relatively minor compared with the psychological and social zones of experiential space.

The museum specializes in a small group of spatial experiences drawn from the wider array of possibilities within both everyday visual experience and alternative institutional settings like the private home, the public park or the Roman Forum. The pages that follow draw on work by Gibson and such interpreters and popularizers as Hall, whose book *The Hidden Dimension* attempts to define a science of proxemics, and Richard Neutra whose book *Survival through Design* sets out to translate psychological and sensory experimentation into architectural and design implications.[17]

Unlike sound or smell the visual world includes always an un-
seeable and mysterious space, located behind our back. No matter
how we turn to uncover that space, we only succeed in plunging
into darkness part of what we had until that moment seen. It is the
space where we are all blind and in danger. We can be approached
without being aware of it. Clues of sound and smell let us in part
monitor it. About this space we are always ill at ease, vaguely
threatened. Furniture is placed against walls to eliminate this space
while we sit, and the device of the rear-view mirror (one of the
truly haunting modern objects) gives us, when driving a car, a more
complete control of this space than we have at any other time. Of
this space there can be no representation, just as there has been,
for the most part, no representation of the blurred margin where
our peripheral vision operates between the back space and the half
of the world more customarily included in our notion of visual
space.

In front of the face and extending straight out, as through in a
tunnel, is the space in which we expect to find other faces. This is
a shallow space, beginning two feet in front of our eyes and ex-
tending no more than twenty-five feet. In this tunnel detailed at-
tention is common. We give and receive signals of mood and re-
action, we converse and monitor effects of our behavior. The details
of expression are missing once we are beyond a certain distance. In
this small cylinder takes place most of the human world in so far
as it is relational. One of the effects, in museums, of no longer
hanging paintings all over the walls is to place them in a single
line, opposite us as faces are. The term "eye level" is much too
weak to cover this effect. An object set at this height "reads" as a
face. Many of the small metal sculptures of Richard Stankiewicz,
for example, are made of welded, rusted junk-like metal. These are
exhibited set at this height and humanized simply by occurring in
this zone of space.

The photograph not only appears in exhibitions neatly in rows
at face height, but in its standard size (8" by 10", a four-times
enlargement of the standard 4" by 5" negative) is both the size and
shape of the face. Part of the difficulty of viewing photographs in
a gallery is that the level of detail forces one to come in much
closer than to a painting, in fact, to stand about a foot from the
surface. So close a distance, at that height, involves a gesture of
intimacy that strains against the ordinary content of the photo-
graph. The viewer is forced again and again to enter a consensually
intimate space in order to get any visual information at all.

Perhaps the most important quality of this space zone, after its

humanity, is that it is democratic. Within this space appearances register as equal, neither looked "up to" nor "down on." Finally, the location of objects within this space invites the analytic attentiveness and critical scrutiny that we give to orienting ourselves in the face of others. To locate the mood, imagine the demands or needs, and infer the reception that one's own moods, demands, or needs will meet creates an intuitive visual sensitivity of an implicational kind that, transferred from the human to the object world, underlies the modern critical attitude toward the work of art. The analytic stance appropriate to this space replaces, in the modern period, the reverence, appreciation, and awe that defined the relation and response to art in periods where art customarily appeared in the zone of elevated space to which we must look up.

The decisive changes in the use and meaning of elevated space in the modern period are among the key facts of the location of art. Traditionally, we would look "up" for authoritative, symbolic, or spiritual objects. Thrones are raised, the pulpit within a church sets the minister up in space. Political rallies isolate the leader above the citizens. Religious art ordinarily appears high in space, and the "upper space" of cities was dominated by temples, cathedral towers, and elevated monuments. In fact, the fundamental *place* of sculpture, whether frieze or statuary, was located within the "up" space. One way to state the crisis of modern sculpture is to note that since this space is no longer available for art, there is literally no longer a place for sculpture. The attempts since Rodin to locate sculpture down in space (as Brancusi did) or at the position of persons and faces (as David Smith did) or on the ground (as Giacometti or Caro did) have not yet recovered a location for objects calling themselves sculpture.

The upward space has not remained—in the absence of art—uninhabited. It has been technologized, and succeeds in attracting the traditional awe, humility, and distant respect to objects of engineering and scientific and corporate triumph. The limits of this space are now defined by airplanes, skyscrapers seen from the city streets, bridges and gratuitous technological demonstration pieces like the Eiffel Tower or the St. Louis Arch. The elevated space is also dominated by the symbolic representations of commodities—billboards and corporate symbols. One of the great 20th-century achievements has been to colonize this space with night images constructed of neon signs, office building lights, and highway pinpoint overhead lamps. As Venturi, Scott Brown, and Izenour point out in *Learning from Las Vegas*, the highway strip is designed as a night world.[18] Undifferentiated blackness stretches out beyond a

tunnel of light. Giant signs, unconnected to any structure, lean out over the motorist's space from above, competing through size, height, movement, and color for his attention. These monstrous iconic objects create a world of pure light divorced, in a way that a lighted skyscraper is not, from use and structural definition. They are, for that reason, the essential inhabitants of modern elevated space.

The characteristics of our response to objects located within this zone of space reverse those of the democratic, analytic space where faces (and now works of art) appear. The upward space is not shallow, nor is it crowded. Details are less important because they cannot be read. It is a crucial fact about most traditional religious art and sculpture that in our modern meaning of the word it could not exactly be seen. The Parthenon Frieze and the Sistine Chapel Ceiling are prime examples. The gestures possible in this space are grand, inviting reverence and awe. Baroque ceiling paintings, civic monuments, and cathedrals, no less than the Eiffel Tower or the John Hancock Building, make designs upon these realms of feeling and avoid appeals to what we now think of as the sole appropriate response to art objects: the analytic contemplation of an object close enough so that its details can be seen.

The fourth significant zone of space is the downward space in front of our feet. This space exists only because we move, and it is made up only of paths and obstacles. In extent it is the most abbreviated space of all, no more than ten or twenty feet in front of our shoes, and it is fundamentally directional. It is always oriented toward a *there*, the nearby goal of our motion. The space is short because the distant ground, the horizon for example, in fact appears out there, across from us, at middle height. The ground is in this way a bowl rising from under our feet up to middle height at the horizon. The actual downward space is always nearby, just in front of us. Every object within this space appears as an obstacle, something that we most move around or that we might stumble over. It is an impediment and is resisted in a primary way. Western art has, until recently, refused to occupy this space. Japanese gardens, particularly the Zen gardens of paths and rocks, represent the most important artistic tradition utilizing this space. Now, however, with the loss of upward space by modern sculpture, the first exploration of space in front of the feet is taking place. The work of Anthony Caro, among its many other strengths, has decisively occupied floor space for the first time. The sculptures become obstacles, places where one cannot walk, traps and barriers. The witty insouciance of Caro's work gaily toys with the danger, sharpness, resistance, and frustration of this blockaded space.

A pioneering work in this space was Alberto Giacometti's disturbing bronze work *Femme égorgée* of 1932 (Fig. 3), in which the metallic, insect-like victim sprawls on her back on the floor, her legs apart, her hands flat and incapable of self-protection. The sexual violence of this work takes place first of all by means of the shock that the sculpture, like the woman that it represents, lies on the floor, open at our feet. We cannot look at it without looming over it. To walk around it we have to avoid tripping over it. We cannot see it without taking the position, standing erect above it, that is the very position of violence to it, and, more importantly, to her. The sexual frailty of the thin stick-like legs, along with the shrinking of the head and facial features to tiny details that we can no longer respond fully to, leaves us facing the rounded torso, the flat hands, the legs and back that open like leaves. The victim of a crime is commonly found on the floor, just where this work of art occurs. Giacometti represented in this work an act of violence that created a narrative explanation for his own structural act of tearing the human figure free from the high space of the pedestal and casting it down to the floor where we stumble over it or move cautiously around it. In the work, beyond the violence of the subject, it is space itself that is shocking. To find a work *down there* is to undergo a quintessential enlightment about what had been until that moment the ordinary experiential location for sculpture.

In a photograph or art book, this work cannot be experienced at all since the mind reads the white background as a wall and not a floor. In a book the murdered woman at our feet becomes something of an erie insect clinging to an imaginary wall that only our spatial habits with art has provided.

For sculpture, which commonly occurred in civic space up above us, eliciting our respect even in the act of looking up to see it, this occupation of the floor which Giacometti achieved with his many standing figures as well as with this woman, captured a space to replace the space surrendered. Just as painting within the modern museum moved off the wall forward in space to colonize the few feet or yards between the surface and the observer, replacing the deep space in behind the surface that, with the passing of realism no longer existed as a content of the work, so too did sculpture, once it was denied the dominant upward space that pedestals and architectural locations had offered, resettled itself upon the floor, among the spectators, democratized or humbled by being seen against the floor instead of up against the sky.

As an institution the museum imposes a specialization of space, a restriction of works of art to the psychological resonances of eye-

Fig. 3. Alberto Giacometti, *Femme égorgée*, 1932. Alberto Giacometti Foundation, Zurich, Collection of Mr. and Mrs. Pierre Matisse.

level wall and floor. On the wall we find ourselves face to face with art, on the floor we find it impeding the steps we might otherwise be able to take. It is far more common to look down on rather than up to art in the 20th century. The abandoned spaces, the requirement of intimacy with the work that the eye level proposes, are spatial features like the temporal history of the series, juxtaposition, breakthrough, and solution. From two directions these spatial and temporal constraints control the place that each object must fit in order to be taken to be a work of art. At the same time, they define the window of opportunity that works intending to become part of the Future's Past must work within. It is to those strategies that the next three chapters will turn.

# Jasper Johns and the Effacing of Art

Within the strategy that we call the avant-garde there are two sets of tactics, the one immediate, the other long-term. One set of tactics could be called a tactics of short-term attention, and it is these that have been most often noticed. Shock, surprise, self-promotion, the baiting of middle-class solemnity, outrage, a subversive playfulness, a deliberate frustration of habitual expectations, an apparent difficulty or refusal of communication, a banality where profundity and seriousness were earlier the norm: these are a few of the tactics that again and again appeared as part of the competitive marketplace strategy for advertising the new.

To be a notorious artist was always halfway to becoming a famous one, and many were willing to take the chance that once conditions were right the slight move from notoriety to fame could be accomplished. These tactics made it clear that the problem for an artist within the modern period was first of all to stand out within a crowd, within a surplus of candidates for the few places available nationally or internationally. The rivalry for initial attention under modern conditions set every artist the question of how his own work might have clear identity and felt importance. This was, in an age of products and advertising, the problem of how to turn a style into a brand.

A hundred years ago the Kodak camera, Coca-Cola, and other brand names had invented the machinery of self-insertion in a crowded marketplace. The coincidence of this brand-name strategy

with the artistic problem of the avant-garde is not accidental. Most ingenious of all was the problem of convincing a public that Pillsbury flour, Clorox bleach, or Domino sugar—each in fact no different from any other flour, bleach, or sugar—had unique characteristics, a special magic or reliability. The Kodak camera, like the later Polaroid, was, in technological terms, a unique object, and such an object had only, we might think, to be described in order to find its niche in the marketplace. But even here, the market always appears to be crowded with already existing procedures and objects that will have to be disassembled and replaced if the new object is to enter. The professional photographer, with his large kit of equipment, who defined the center of the earlier system had to give way to self-made amateur photography and a chain of dealers who develop the prints professionally. Only by bringing this structural change about could the Kodak catch hold. The creation of a place is most often done by tearing up the entire fabric of relations that seemed to be the very essence of an action like photography.

What is new always inserts itself into a crowded space in which all needs are somehow already being met. Whether the object is genuinely new, like the Ford car in a world of horse-drawn carriages, or simply newly packaged, like Pillsbury flour in its campaign to drive out "mere" flour by the added cachet of the brand name, the problem of insertion is similar.

One side of avant-garde strategy addresses the needs of arrival and insertion in an art market that for a hundred years has operated much the same as a flour market or a car market. This market is made up of art dealers, galleries, art journals, newspaper coverage of the arts, annual competitions, and major regular samplings of current work. It includes reviewers, art critics, and those skilled at description and equally skilled at the invention of classifications that make possible the creation of an art language for the moment. An art language is a necessity if art is to exist within social discourse and that economic sidecar of social discourse, the marketplace.

Unlike literature, art cannot be quoted; that is, passed around in small samples. Literature has this constant advantage or disadvantage among the arts of occurring in the same medium as social relations themselves, that of language. All other arts in order to exist when not present have to be described instead of quoted. As a result a language of music, a language about dance, or sculpture, architecture, or painting becomes a necessity if any work in these media is to exist for us when we are not within the experience itself of listening to the music, walking around and through the building,

or looking at the painting. To turn away and speak of it or to offer an account of it later to someone who has never seen it we are forced to step into language. And those whose skill lies in translating the effects of dance or painting or architecture into verbal descriptions will always exist alongside the makers of those works like step-parents or guardians with some of the same rights and importance of those human roles in family life. In art this translation into an art language—the essence of the activity of art criticism—has its function not only in the replacement of quotation, but as an integral part of an art market that has a simple focus: the small number of collectors and the moment of the sale. For art there is both a public and a buyer and the two categories are not only distinct, but can only be reached by quite different rhetorical undertones within description. Art language is in this sense a political language with two different constituencies, that of the mere viewer and that of the potential owner. A language that might make you want to look won't necessarily make you want to buy.

But only a part of the look and feel of this art can be explained by the operations of a market. The second set of tactics is not addressed to the market at all because this market itself is sheltered within the shadow of a museum world for which it is the minor leagues, the training ground, the locus of sorting out and waiting for the real transaction. And it is to the museum that the deeper features of art, in so far as each work is a probationary candidate for the museum, are now addressed. The art work is a candidate for sale; but in the long run even that transaction exists only as a bet on its being in the end a candidate for the permanent civic collection of which the various museums in the world are local branch offices. This large collection spells out the meaning of the word Art by induction, and it is to someday find itself a member of this set that every knowing work designs itself. Its ultimate seduction is not of the temptable buyer, but of the impersonal, social world for which works of art are as much its patrimony and its Sunday pleasure as Central Park or the harbor and the view by which you approach Manhattan by boat.

If painters were designing works that would someday be attached to the outside of buildings we would expect them not only to make their works weatherproof, but also to build in a set of linking stylistic elements that would later make them seem natural features of those buildings themselves once they were set in place. Every painting is just such a whole that will someday be a part of what is, in effect, a larger work: a collection or ordered display. What it will join is not a physical object like a building, in the way

that the stained-glass windows of Chartres had to fit into the massive stone cathedral, but an institutional order.

The hinges and joints that will later facilitate the work's capacity to slip into place within the institution of the museum are the most conspicuous content of the modern work of art. Nothing could be less true than to say of non-representational works that they have no content. It might be truer to say that these works have that particularly intense content that we find traditionally in portraits. For most viewers and in most settings a portrait is a mere picture, but in one location, the home of the subject, and within one social world it is truly located and uniquely at work as a portrait. On display within the home of its subject or the descendants of the subject a portrait is an actor within a rich social script, no different from a sword on a battlefield. Modern works have this same quality of passing from mere pictures to resonant and living functional parts of a social order when they pass from the world at large to the museum. The best thing to say would be that the more abstract or non-representational a work, the more relentlessly loaded with the content that will later bond it to the museum where it hopes to come to rest. It is all hinge, all fasteners whose matching half is ambient within the structure of the museum.

The future of every work is to become either art or nothing. One reason for these stark alternatives is that a decisive feature of the modern work of art is that none of its claims upon us and therefore none of its right to go on existing are grounded in an appeal to memory. Its content does not carry on the communal or individual task of remembering the look of certain faces, the details of certain events, the concrete elements of landscape in one or another season, the look and feel of rooms or of the objects of everyday life. Memory itself has its own time scheme which becomes an argument for our continuing interest in the images of things as well as the things themselves. We still want to remember what Abraham Lincoln looked like, and as a result every sculptural image, every painting or photograph of him, whatever its other values, participates in the task of memory and is sheltered within the protection and longevity that memory sponsors. In so far as we care less to think about or remember Franklin Pierce, all works in which he appears have less value of the kind owed to the process of remembering than do those works that anchor the look of Lincoln.

Naturally civic remembering, as a task, is also competitive, selective, and subject to a thinning out over time, but at a slower rate of decay than within family or personal memory where the death

of each single person brings about a disappearance of a system of memory, a disappearance that amounts to a devaluation of all of those things that only that one person any longer knew the value of, or as we say, knew the story behind. Without storing religious, civic, or personal memories, the art of the last hundred years, even in its representational or realistic styles, puts us face to face with people, places, and events that, other than within the painting itself, have no links to any other experiences or values within our system of memory. Like Cézanne's *Card Players* or Manet's *Bar at the Folies-Bergère*, such works are paintings of "someone," but who these people are we cannot say. The most accurate statement would be that all modern painting has as its subject that new urban personality, the stranger. Everyone we see is, as far as our earlier or later stock of experiences, a one-time seen stranger whose whole existence occurs within the facts presented here within the frame of this painting.

It is memory rather than realism that photography drained from painting and sculpture. The value of reminding us of persons, events, and objects and atmospheres, and doing so for as long as we want to be reminded of them, is a value that has been transferred to the photograph which is now our archive of stable, external memory. It is because the claims of memory that were once an inseparable part of the right to go on existing and interesting us within art are now relocated outside art, that the harsh future of every work is to become either art or nothing, either infinitely valuable or worthless. It cannot remain even an investment or speculation unless it remains probable that it will soon be, as we put it, "beyond all value." It can only keep alive the fiction of its value in the present so long as it seems possible that it will soon be necessary for the future's understanding of the past. So many 20th-century paintings include objects like newspapers or debris that we intuitively recognize as valueless because they acknowledge the gamble within all art: either art or junk.

## Jasper Johns and Museum Art

To find yourself at some point in the future a member of an institution, the best strategy is to start out by including within your own contents a subtle version of the very object of which you hope at some point to be a part. This subtle, miniature version of the museum present within the modern work of art itself has two sides. First, within the work we find a collection rather than a narrative,

a composition, or a space. A group of events or objects, a cluster of discrete styles or scales of experience, is assembled. By remaining stubbornly separate such styles or scales reproduce and anticipate the condition of a room of diverse objects, the canvas becoming, in effect, the flat map of the problem posed by the rooms and walls of the museum where ten or twenty strongly individualized objects are held together. By aggregating fiercely individual pieces, the painting makes an overt refusal of composition, not in the name of decomposition, but in the name of a side-by-side set of loosely united matters for attention. If the museum itself is a collection of the diverse, then the individual painting might adapt itself to this heterogeneity by offering itself as suitable for a collection in so far as it already is one.

Second, since the act by which a work of the past has become a part of the world of art is an act of effacing rather than an act of making, then this act of effacing might be done by the painter himself so as to present his own work as pre-effaced. The very act that the museum would accomplish for the African carving, the medieval crucifix, and the Cranach portrait by lifting them out of the social context for which their use was designed, can also occur as the act within the painting itself. This social context is not merely a place, but a life world of relations in which the use of the object was limited to certain occasions, persons, and practices. It is this that makes up, in the fullest sense, the content of a work. The silencing of content and the erasure of access can take place as an aspect of the act of painting itself.

Both the refusal of composition in favor of collection and the carrying out of the act of making so that it already includes the act of effacing are strategies of a calculating or knowing art. To make it clear just how these strategies can be more than incidental to the work, how they can become, in fact, the content of a work of art, I want to look at a set of works by Jasper Johns painted between 1955 and 1970. I will do this in three stages. First, I will consider the way in which effacing can itself become the making of the painting. Second, I will show how the canvas can present itself as a room where a collection occurs rather than a space that has undergone composition. Finally, I will then turn to the means by which the painting makes us aware of its relation to a past that is commemorated and a future that is possible or anticipated, and in doing so makes of these two the present that we actually see.

## Flags, Alphabet, Numerals

What the museum has lifted out of the social life of the past are most commonly objects that made up a core of symbolic or practiced value. The Greek statues are of the gods, goddesses, and heroes of a certain society at a certain moment of time. They are not symbols at large available for borrowing or incorporation. The medieval paintings are of the life of Christ; the portraits are of the ancestors or founders of families in secular 16th- and 17th-century Europe. Jasper Johns begins as an artist by lifting the American flag into a series of paintings that are not so much reproductions of the flag as museums for it: museums with one work inside. Johns himself did not create the flag with its pattern, colors, rectangular shape. Nor did he create its social importance within American life, any more than Fra Angelico did for the Crucifixion or Cranach did for Martin Luther.

As far as the image is concerned his paintings are, we could say, stealing a ride on an already settled visual energy. The red, white, and blue *Flag* of 1955 (Fig. 4) done in encaustic almost makes the flag a celebrity, done in wax, of the kind that we find in a very different kind of museum, Mme. Tussaud's Wax Museum. A clever counterfeit, this flag looks as though Johns were something of a taxidermist to whom a hunter might take a fox or a bear to get it back a few months later stuffed and made permanent for his library. This encaustic flag has only minimal texture. It looks semitransparent, as though the image were a veil behind which we felt the presence of an overall worked, nearly white surface. Just where, in looking closely at a real flag, we might find the woven threads that tell us what it was made of, in this flag we find the painting. The painting is what you have when you look closely at this flag. To see the analogy with the threads: the painting is what the flag is made of. But of course the reverse is equally true. The flag is what the painting is made of.

The entire canvas "is" the flag. Johns takes over the flag, but in a new way. The flag is not his subject, something that he sets out to portray, realistically or otherwise. From one edge to another, all that we see is simultaneously flag and painting. Nor is it his goal to react to the flag, making an expressionistic or political statement about it.

Since anyone who wants one can buy a real flag, there must be some quite different use for a flag painting. The painting cannot let us see a flag for the first time, as a painting of Moses might, thus filling in a visual blank in the mind with some version of how

Fig. 4. Jasper Johns, *Flag*, 1955. Encaustic, oil, and collage on canvas. The Museum of Modern Art, New York. Gift of Philip Johnson in honor of Alfred Barr. VAGA, New York, 1991.

Moses might have looked. Nor can the painting supply us with something absent, like a painting of the now dead George Washington or a landscape painting of a mountain that is far away from the place where the painting is located. None of these commonplace motives for making a likeness or, in the case of Moses, a possible likeness, can apply to the flag.

Almost the reverse is true. The series of flag paintings records a struggle between painting and flag in which the more painting there is, the less flag. The painting exists at the expense of its subject. In the *White Flag* of 1955 (Plate 1) the whiteness is that of a ghost. The spirit of a flag hovers over the painting much like our fantasy of a vaporous ghost in a room. Where is the red white and blue that "has to be there" if this is to be an American flag?

Where are the sharply contrasted red and white stripes, the distinct, countable white stars? The white, ghost-like flag hardly interferes at all or seems to make few demands that would determine the painting's shapes, colors, contrasts (or lack of contrasts), lights and shadows. It would be more accurate to say that this is a painting done at the site of a flag in the way that a suburban housing tract can be built where a farm used to be. With Johns's painting we find ourselves bumping into faint traces of the flag as we go about our way looking at the painting, just as the new residents in the suburban tract can find themselves running into what used to be the well of the farm or can find the view unusually flat without knowing that where they stand was once carefully leveled to make an easily plowed cornfield.

In other paintings within this series, the strokes of paint, the bright, but irrelevant colors (to the true colors of an ordinary flag), the turbulence of the surface, all are signs that to paint a flag is to efface it. The more it is represented, the less it is. Its character as a flag appears through the painting or behind the painting, it is not the painting itself. Or at least, given the techniques and materials that make up the process of painting as Johns sees it, each step of painting, while carrying out its representational duty, calls attention to itself, and consequently away from the flag. Perhaps painting a flag is just an excuse to paint. It might be that something like "just painting" as opposed to "painting a flag" sets up a division of loyalties within the painter that becomes the subject of the painting.

This struggle between the subject and the painting was already there in Cézanne's repeated painting of Mont Sainte-Victoire. But in Johns's flags a cultural as well as a representational act is taking place. It is not just how a flag looks that is at stake, but what we do with a flag. A sight like Mont Sainte-Victoire is similar to a painting in that both are viewed; we stand and look at each. Whatever difference and overlap there might be between beauty and order in a natural landscape and the beauty and order of a painting, between pausing to look at a painting in a museum and pausing to enjoy the sight of a landscape that comes in view when we make a turn in the road, still the experiences are parallel and interdependent. They instruct one another. We learn, in part, to look at Cézanne by means of all of the experiences of pausing in nature to look at a view, and we learn to recognize something in nature as a "view" by means of our experiences of looking at Poussin's or Cézanne's or Monet's or Turner's paintings.

But our use of a flag is one of the highly specialized and for-

mulaic social experiences of modern patriotism and nationalism. Music plays in the background—the national anthem. The act of looking at the flag is timed by the length of the singing of the national anthem. The music is not one part of the experience. It is what defines it as "saluting the flag." All stand and place one hand over the heart. The flag is raised or lowered. Taps are played at the funeral of a president. The crowd at a football game rises to salute the flag. These acts all accompany and pattern the act of looking at the flag of one's own country. The act of looking includes an act of showing respect for the flag.

By painting the flag Johns brings it down from the sky—the ordinary spatial background for our experience of looking at it—and locates it there in front of us in the museum, at eye level. No longer are the familiar experiences possible if the flag is located in this eye-level space. As a rigid painting it is not soft, flowing in the breeze as a flag usually is. He lets us look at it, perhaps we should say, stare at it since it is a cold look instead of the reverence or respect of normal civic occasions. This normal civic occurrence of the flag designs our access to it as a society. Part of that access is a highly specific act of looking: looking up, standing silent, with patriotic respect. Here in the painting it is this social access that is effaced far more than the simple image. The image we might find is hard to see, especially in the white flag, but the effacing of the image is only the literal installment of the social effacement of a whole behavior—comportment—in the face of a flag that is now made obsolete (for the time of looking at the painting). This makes the experience the opposite of looking at Cézanne's painting of Mont Sainte-Victoire after looking at the actual scene. With Cézanne the two acts flow together, distinct but shaping one another. With Johns's flag, the act of looking at the painting takes place on the site of the effacing of the civic act of saluting the flag, a civic act in which the part played by mere gazing is a minor one. For the time of looking at the painting we place ourselves in relation to all of the comportment that would ordinarily make up our patriotic act of looking as though it were now irrelevant. The flag painting exists for us in the aftermath of a cultural set of feelings that we notice and become aware of exactly because in this case they have been ruled out. That is the meaning of saying that the process of effacing can become itself a deliberate and felt component of the work of art.

For this act of effacing we can list a number of features. The object has been taken out of the visual zone where we ordinarily encounter it—looking up—and located in a visual zone where we ordinarily encounter quite different things. Next, the social ritual

within which an experience of this object commonly takes place is stripped of its features, while we nonetheless are acutely aware of them, and a quite different, equally ritualized experience is substituted, that of looking at works of art in a museum with others during the hours and under the rules of museum access. Finally, a complex visual and symbolic act, only one part of which could be called seeing, is replaced by another which still has as its core an act of seeing.

When we think of the museum's relation to cultures that are past—the Greek gods that no one any longer sacrifices to, the portraits of kings whose descendants no longer rule, the scepters and crowns of countries that no longer exist on the map—then Johns in painting the flag locates it in the position of a look that only applies to symbols that no longer symbolize. He treats his own culture as though it were extinct.

His strokes of paint produce it while extinguishing it, both as a content (an image with bands of contrasting stripes and a field of 48 stars) and as an object to which we (as American citizens) have access only in certain ways and by means of certain actions and sentiments of our own on those few occasions when the relation to the flag is active. Although a flag is often somewhere in the environment, it is only on certain occasions really there for us. When the Russian soldiers hauled the German flag down from the Reichstag in 1945, any German watching had such an access to the object.

In the same years of his flag paintings Johns also painted or we might say painted-out the 26 letters of the alphabet and the numerals from 0 and 9. What the flag is as a symbol for the United States, the letters of the alphabet and the numerals of decimal notation are for modern civilization as a whole. They are the crucifix, Virgin and Child of modern secular civilization. There are no more fundamental symbols of what we mean by rationality itself than the letters and numbers that are the tools of our literacy, our existence as an economy, and as a scientific civilization.

But these symbols are so only in so far as the letters are used to spell words and the numbers to count or number. The symbols of language and quantification—the two accomplishments of rationality that are as fundamental as government in human experience—are in Johns's canvases painted, but, as in the case of the flag, painting both presents the object and poses itself as a rival to it. The letters, as in the *Gray Alphabets* of 1956 (Fig. 5), are just barely there. They exist almost as ruins do. We can recognize them only because we know so well what an A or an R ought to look

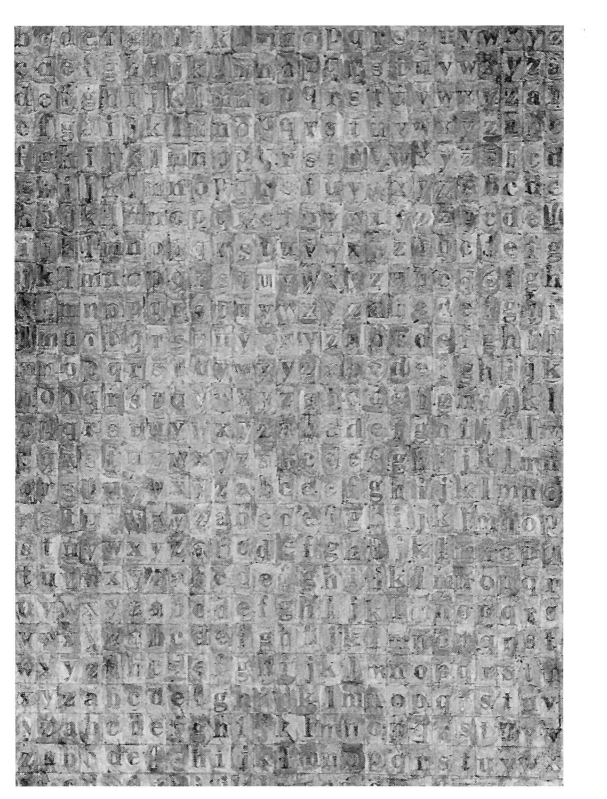

Fig. 5. Jasper Johns, *Gray Alphabets*, 1956. Encaustic and collage on canvas. Private Collection, U.S.A. VAGA, New York, 1991.

like, just as the mere outline of a foundation or cellar, door-sill, and broken chimney will let us see, behind the ruin, the house.

With their atmosphere of nostalgia and memorial these paintings imagine what it might mean to find the alphabet and the numerals part of the fading, ghostly past. From what standpoint could the alphabet be ready for its monument, its noble epitaph, a part of civilization that had done good work in its time, but that time was now long past? Could we imagine a nostalgia for the alphabet? One more obsolescent technology like the bow and arrow or the sailboat? The disappearance of the 26 letters in the "Gray Alphabets" is one of the most powerful and moving images of American art. It imagines a memorial relation, but not to the superficial details of our culture—the Coke bottles and Brillo boxes of Pop Art—but to the rationality of the culture itself, imagined as a subject for tenderness and memory.

Again, as with the flag, it is not primarily the image that is effaced. Certainly, it is hard to see these letters and numbers, they occur in the paint almost as in a mud that dissolves their outlines. Rather it is our normal use of them, our access to them that is effaced. Although, like the flag, the letters and numbers are among the things that we see most often, day after day, they are also, like the flag, things that we never stare at, or even look at. Wherever there are letters, we read. With numbers we count, add things up, or pass beyond them to the objects counted (Fig. 5). "Three apples" lets us pass through the "3" to the apples that we can eat; "three hours" that we will have to wait because we missed a flight lets us pass through the "3" to the boredom and waiting that lie behind it. But whether we count or add or pass beyond, we *use* the numeral, and part of the meaning of that use is the quickness with which the "3" dissolves into apples, hours, fingers, friends. Even when, like a child in school, we are counting out loud from one to ten to show that we know our numbers, we do not gaze at them.

To paint numbers or letters is to remind us of our access to them by creating a context—a painting—in which that access is obsolete. The numbers are being commemorated here as though they were our Jove and Saturn, Aphrodite, and Herakles. Only what is most common in a civilization can truly be its deepest facts. St. Jerome, Mary with the child Jesus in her lap, and the Three Magi were as common a part of the mental furniture of the 12th century as the numbers 4, 8, and 2 are today—the basic machinery by means of which the world was what it was and made sense.

But what Johns's paintings of the letters are parallel to is not Giotto's painting of the Virgin as it functioned within the 14th

century when it was venerated, prayed to, used within a cathedral as part of an altar. Instead it is parallel to the same painting in the Uffizi or the Louvre where it exists for looking at, for examination as a painting in a secular context of art. Once broken off from the social practices of religion and inserted into the quite different practices of a work of art, the earlier access is effaced. Johns's *Gray Alphabets* begins with that defeat of access. The work arrives already effaced. The act of painting itself has been an act of effacement. The act of breaking off a piece of the machinery of culture, isolating it for attention and observation, relocating it physically outside its normal corner of social space: these acts on which the museum is premised are obviously easiest when time itself has already destroyed the social space of which it was a part. An Egyptian sphinx can be lifted out in this way to Berlin, London, or New York because the social space in which it existed as a working object has disappeared, leaving those who now live in Egypt in as abstract relation to this object as citizens of Berlin or New York for whom such a Sphinx is equally their past in the sense of the source of what, after many mixtures, they now find themselves to be.

One question that these paintings seem to pose is this: do we have to wait for our civilization to be over before we begin rescuing its most central objects for the Future? Secondly, can a painting be made that cleverly previews the very thing that it hopes will happen a few decades later to itself? Johns's ambition for this work is that ten or fifty years later it will be lifted out of the American culture of the second half of the 20th century where it occurs as an object to be bought and sold, a part of household decor, a transient member of various exhibitions, and relocated in a collection in Stockholm or Los Angeles. Knowing this, he himself uses the opportunity of the canvas to do a parallel act of lifting out and converting into art, but in this case taking such working, everyday objects as the letters, numbers, and flag, and using them to instruct the future about what to do with his own painting. Naturally, this involves a claim, or an arrogant or playful hope, that the canvas that he has made has the same central symbolic value to American culture as the flag, the numbers from one to zero, and the twenty-six letters of the alphabet. Art, and in particular this individual painting, is proposed to be an object of this kind, part of the machinery of rationality and public life, and the future is advised to do with it as it has done with the objects within.

His act is both a physical act of making and an institutional act of opening up one form of access (looking at or studying something hung at eye level on a wall within a frame) by means of sterilizing

the everyday social access. The painting is a monument erected on the site of an experience, which by existing it declares to be a tomb. That the letters and numbers are—as a result of the strokes of paint and the excess of colors that make up the practice of painting—both rendered and made difficult to see defines a physical level of effacement that is the allegory within the work for the more important social and cultural act that this effacement of social access by which we reach the territory of art requires.

## The Painting As Its Own Collection

After the museum effaces each individual object, it then subjects it to assortment. In grouping objects, the museum puts together, heterogeneous objects, each with its own mood, intention, scale, and address. They are put together in one room under an intellectual order that invites us to forget the strains imposed on each object by having to live within this particular neighborhood of things.

Each individual object is juxtaposed and surrounded. It is next to, and therefore compared with, one or two other works with which it is side by side in our visual field. Then it is clustered in a given room with objects that, while we look at any one object, make up a field that surrounds it. The two relations of juxtaposition and surrounding define the meaning of aggregation or of a collection as they impinge on each object's self-sufficient identity, its need to be a complete experience, the one and only thing present for contemplation or experience, the only mood or set of topics for thought. The object in a museum is never alone.

In a set of paintings done between 1962 and 1986, Johns operated inside the work itself with these very premises that, if the work were successful, would become its own uncontrollable fate. Because it would become part of a collection, the painting itself became a collection. Unable to control what—beyond its own frame— would be the works that would in the end be side by side with it or across the room from it, the painting builds in this loose cobbling together of unlikely things. The painting takes on the character of a room in miniature.

In paintings like *Diver* of 1962 (Fig. 6) we see a set of bands that are almost like distinct paintings side by side. The work itself is already a wall of paintings, but with the intervening white spaces reduced to zero. Such different things go on in each band that the rules themselves seem to change as we go from one to the next. The second band is a set of dark to light gray stripes in careful

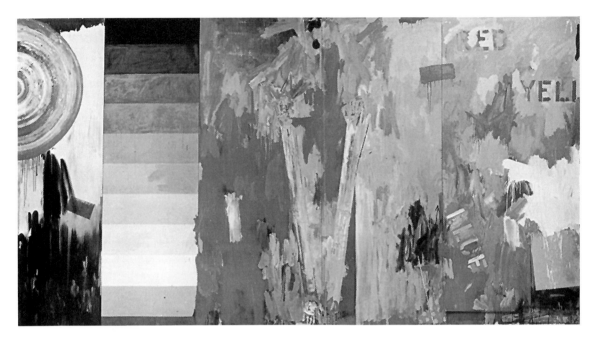

Fig. 6. Jasper Johns, *Diver*, 1962. Oil on canvas with objects. Irma and Norman Braman Collection. VAGA, New York, 1991.

order from top to bottom. Next to it on the left is a band with a half-target in red, yellow, white, and blue. The target, or semi-circle, occurs within a field that is otherwise made up of moody black and white strokes of paint. Some bands at the far right have words stencilled in. The diversity looks beyond itself to invite further side-by-side works with equally diverse rules. The painting welcomes in advance the neighbors that it can only think about.

No composition organizes its effects inward around its own devices. Just the opposite. Its effects cluster at the edges and remain incomplete as though in need of partners elsewhere in the environment. At the far right the word "Yellow" is unfinished. Only the letters "Yell" are done before the edge of the canvas was reached. The painting seems hopeful that the "ow" needed to finish the word will occur in the space beyond the work. Similarly, at the left edge only half the target is completed. The edge cuts it off. We look off the edge to feel the completeness of the word or the target. The same is true of top and bottom edges. The gray scale in the second panel passes from black to white as we go from top to bottom, but then it has room to start back towards black. With only room left to take one and a half steps the scale is speeded up. We

go from white to middle gray, to dark gray. We could reach black in four steps as opposed to the nine that it took to get from black to white. But there is room only for white, the second step and half of the third. We go beyond the edge to complete the third step, making it equal in width to the others. Then we imagine the last step, the final black for which we do not have even a part as we did for the dark gray.

As the work clusters at its edges and looks beyond itself for completion it creates a set of hinges to the works beyond itself. Also, by being already a conspicuous arrangement of parts, both physically in the panels and artistically in the different styles and rule systems, the work presents itself as an aggregation, opening itself out tolerantly to any nearby wider aggregation into which it might later be inserted.

Where a painting like *Diver* presents itself as a wall of paintings, others of Johns's work declare themselves to be not one wall, but a room. Since Matisse the relation of the painting to a room has been a common topic within the problem of composition and design. The almost scholarly Studio paintings of Braque work out the Cubist process of binding the facets of a three-dimensional room into the linear flat plane where they can be assembled like a puzzle. Johns, too, has painted a set of Studio paintings, but with an opposite interest to the compositional, self-contained goals of Matisse and Braque. So far only Brancusi, whose actual studio was for a time made into a room within a museum, has managed literally to colonize the museum room with the setting that for every artist would be one of the preferred, explanatory surroundings for his own work: the studio in which he made it. But Braque or Johns can instruct the future, by means of Studio paintings, about the level of surrounding that the works can tolerate or enjoy. In Johns's case that tolerance would be very high. Should one of his paintings find itself next to the museum fire extinguisher, a radiator, or a light switch—let alone another painting—the fraternal gestures towards those objects would already be found within the work itself. A sign like "Do not touch the works of art" or a label or large brass room number would already be accommodated. The studio is used not to refer to the painter's right to an entirely personal space, every detail of which reflects his personal taste. This was Brancusi's point. Rather, an artist's studio is one where there are already alien presences—a Savarin coffee can in which the brushes sit, a reproduction of another work tacked up on the wall, a set of scribbled messages. From the point of view of thought it is an already invaded space, already impure. It is, in other words, an alternative

collection of which the work began as a part. It previews the collection within which it will finish up. And it describes that fact.

If the room, or studio, lies beyond the wall as an aggregation, what lies beyond the room is the house. In the painting *Fool's House* of 1962 (Fig. 7) the painting is already declaring itself to be a heterogeneous space, like a house. Attached to the canvas is a large household broom that occurs in the center where the main figure would ordinarily be found in a portrait. The bristles of the broom are worn down and paint covers it in places. Below it, in a neat row we see a towel, an artist's stretcher, and a cup. Each object is labeled, with the word "Towel," "Stretcher, "Cup," and "Broom" with an arrow connecting the word to the object. Behind the broom we see that it has swept the paint in an arc, as though the painter cleaned up his canvas with it before hanging the broom neatly on a hook from the top center of the canvas. The cup hangs down so that it extends beyond the frame of the painting. At the most elementary level, the painting in front of us is, itself, a collection of these objects, a museum for them where they are displayed, labeled, and arranged according to an order. The painting is tidy, even mechanical, in its placing of the objects.

But the painting also gathers together ontologically diverse things: first of all, a painted canvas, then the actual things which are themselves "painted." Paint has been applied to them, they are not represented, rendered in their absence through the illusionistic devices of painting. This might seem to be a joke about the word "painting." A house painter paints a house and Cézanne paints a house. Johns, here, is on the side of the house painter rather than Cézanne. In addition to the painting and the objects, and, of course, the two are mixed up at this point, the painting also contains words of two different kinds: the title in stencil, "Fool's House," across the top, but implying a circular space such that the word "house" can begin at the left side and finish at the right as though the canvas were a cylinder. Then, in addition, the hand-written, unpainted labels that were added last to point to and identify the objects.

Who needs to be told that this is a broom, a towel, a cup? It would be one thing if Johns had only painted a broom. His style might be so obscure that we wouldn't recognize his strokes as constituting a broom without a label. But this is a "painted" broom so that it would be hard to be wrong, unless his words mean: it still is a broom. Even though we see it in a painting it still is exactly and nothing more than a broom. Becoming art did not alter it. Or, on the other hand, the labels might not be addressed to us, his

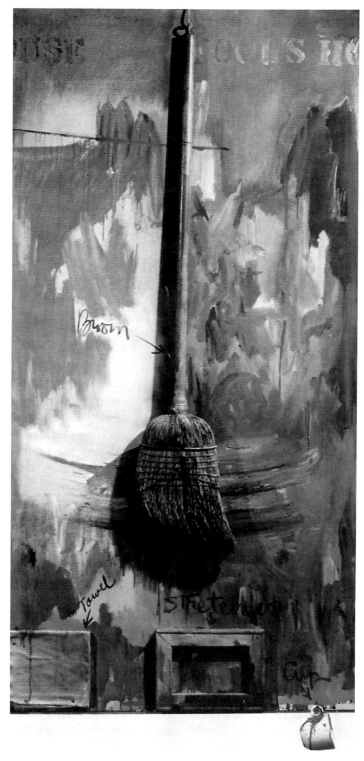

Fig. 7. Jasper Johns, *Fool's House*, 1962. Oil on canvas with objects. Collection Mr. Jean Christophe Castelli. VAGA, New York, 1991.

American contemporaries, but to a future time in which objects like these would not clearly be understood any more than certain Aztec objects. But would the words still be understood if the objects were no longer in use—if civilization no longer had such a thing as a cup? Would the recognition of the words decay at some slower rate than the recognition of the object? The broom might quickly disappear in a world of vacuum cleaners, the towel in a world of warm-air electrical dryers, the stretcher in a world without easel painting (one, for example, that only painted on walls).

The words are names as well as labels. But why are only certain things named? Why is there no label "screen-door hook" with an arrow pointing to the hook from which the broom is suspended. Or "eye-hook" for the hook from which the cup is hung? Are these not things in the same way? Are we not supposed to notice them? Words seem to distinguish between things for attention and mere things, necessary but irrelevant. The words convert certain things into subjects while leaving others behind as mere necessities like the blank wall between paintings in a museum or the parts of a face that are not eyes, nose, mouth; the parts in between the features.

The stencilled words "Fool's House," carefully painted with the blue-gray and white of the painting itself, stand in a different relation to the object on which they occur from the written word "Broom" with its arrow connecting it almost pedantically to the actual broom. This is not a "Fool's House" in the way that the broom is a broom. The words are metaphoric or playful if they describe the work as a whole. They cannot be its label, because a label has a literal relation to an object: the word "Aspirin" is only a label when it is on an aspirin bottle. The words "Fool's House" are a title rather than a label. Or we could say: a painting is not a thing, like a cup or a broom, and it is that that the title makes clear by being different from a label, in stencil, painted, and without an arrow. The label is next to the thing; the title is itself part of the painting. It is part of the "Fool's House," one of the objects within the house. It also is about itself along with the cup, broom, rectangular canvas towel, cup, hooks, and so on.

Even from this short description it is clear that the painting gathers diverse and ontologically distinct materials into a collection. A collection of things (cup, towel, broom, stretcher) is included in a larger collection where things, words, and painted space act on and fuse the more heterogeneous collection into a new whole. For example, were there only words in front of us, they would remain just words. But next to things words become labels. It is

the fusion of two separate collections that makes this happen. The broom, once labeled, becomes an example of a broom, no longer a mere broom. The painting and the broom make up a similar, mutually transforming pair that their stubborn social differences would seem to rule out. A painted broom that has also been used as a paint-brush for a while in the execution of the painting ends up by raising the question of what the real artist does. Is he a house painter or a painter of houses? Does he sweep away debris in order to leave us with what remains as a painting? Does a painter make order in as primitive a way as a householder who puts "everything in its place" in neat rows, each object on its own hook, after, of course, sweeping away what is unwanted? The broom cannot remain uninflected by this problem in which it now finds itself a central actor. Nor can the coy or lazy painting which seems to have dispensed with the meticulous picturing of a broom in the manner of Vermeer by this joke-like act of "painting a broom." Although the broom has been used to paint the painting, certainly it could not have been used to paint itself blue-gray. There must be another brush which we cannot see, at least one that was used to paint the broom itself. Just as the words and objects became labels and examples in one another's presence, so too do the objects and paint and the words and paint.

Words, painting, and objects work together, but only once this highly intellectual set of perceptions lets us overcome their stubborn diversity. Order is either mechanical, as in the row of neatly hung objects, or it is obscure and philosophical. The pressure that binds together this collection is a pressure of reflection and not an act of painting. What the painting opens up is a set of questions so general and at the same time so playful that the painting is ready, in advance, to become itself a mere part of some larger collection. The hetererogeneity of the things brought to order within it makes it easy to imagine this painting's comfort with any further side-by-side partner or room. It is willing to be juxtaposed or surrounded because these are already things that it does very well in itself.

Even more, the very philosophical questions that it sets in play will reach out from the canvas to include within its Socratic questioning whatever is nearby or surrounding it. It is because these questions are already about the infiltration of one realm by another—words by painting, objects by words, objects by painting— that any further infiltration will be welcomed. Any thing that comes near this painting will already fall within the boundaries of the questions it has raised and sent out in all directions. The work has

built into itself the machinery for mastering its environment. It can do so because it already is what it must become—an aggregate—but more importantly because its very subject is the politics of aggregation. The painting goes out armed for that struggle in advance. It will not, like a Rembrandt self-portrait, naïvely find itself next to a Vermeer interior, forced into some relation in order to confront the eye of the viewer that will take them in successively and even, at times, in the same glance. The Johns painting knows about this problem in advance and comes prepared.

The painting *Fool's House* of 1962 displays a strategy of aggregation and philosophical challenge that can be found in many variations throughout Johns's work of the 1960s. The importance of these strategies lies first of all in Johns's success in making of them a rhetoric that holds the viewer in front of the painting.

We are held there by a fresh, intricate power of content as opposed to execution. The content raises explicit questions and leads any viewer, or at least one who thinks the painting through, along a path with many turns and surprises. The strategy is one that holds the viewer in front of the work for a time, baffles and then rewards him, and does so in a world where glancing and passing on, taking the work in as an instantaneous impression, had come to be the rule.

Beyond this self-interested design, the work displays the general conditions that every work encounters in being itself a totality—one complete thing—while being both made up of parts and at the same time destined to become a part of a wider but unforeseeable whole. Whether that wider whole is the literal museum room or, in the abstract sense, the aggregate of things that one hundred years from now will be thought of as the American Past, or Painting of the 20th Century, the problem remains that it cannot be foreseen just what that aggregation will make prominent and what it will make it hard or even impossible to see within the work.

## The Site of Archaic Acts

Both effacement and aggregation within museum culture are the premises for an act of attention, an act that could simply be called seeing. But in fact the contours of the act of looking cannot simply be described by such words as "carefully," "thoughtfully," or other intensifying terms. Seeing is itself a script, and the clues to the particular script for seeing a work of art can only be brought into

the open by working out the similarities and differences between what goes on in the presence of a work of art and what goes on in a variety of quite different scripts. The museum requires a kind of seeing that calls attention to a certain double nature within the object seen. The seeing is composed of a superimposition of patterns. Can the topic of seeing be raised within the painting as its content in the way that effacement and aggregation are?

The act of seeing rises to the surface within Johns's work as though it were an unstable act in our time. The paintings bring the problem up by means of paradoxical demands that we do two things at once. Can we carry out two acts of seeing at the same time? Can we look at a map and a painting simultaneously? Can something be not a painting of a map or a painting whose subject is a map, but both a map and a painting, or a painting and a flag? The even stronger problem is posed by words. Can we completely carry out the requirements of seeing words; that is, can we recognize clusters of lines as a word, grasp it, and recognize it, while at the same time looking or seeing it in the manner of looking at and seeing a painting?

In each case the acts factor out different meanings of the general act of looking. We speak of reading a map, not of looking at it. We read words or follow a sign—an arrow, for example. Seeing is a quite different experience in each case and each overlaps in part with the act of looking at a work of art.

But is this doubling or factoring of activities any different from the ordinary division between looking at the painting's surface for its effects of touch, stroke, color, and shape while also looking at what is represented? Vermeer's realism makes of the act of looking this familiar kind of double act. A blue-white area with a certain set of shapes is also part of a wall, a hand, a pitcher, some milk, or cloth. In a wider sense it is also part of a human act of pouring milk in a certain social scene. Every colored shape is, from another side, once again seen two ways: first as a flat design on a surface; second, as a feature of illusionistic space in front of or behind, parallel to or receding from the surface. It would seem that we have to begin always from this doubled or multiplied act of seeing. Is Johns's situation any different?

In some of the simplest cases it is easy to see that it is. Among his early works are the paintings of flags, targets, and maps. The entire canvas is both map and painting, target and painting, flag and painting. In the 1961 painting *Map* (Plate 2), a map of the forty-eight states with the name of each state stencilled in, the object actually is a map. One could use it as a map while looking

at it; for example, by becoming interested in such questions as, what states border Kansas? or whether it is further from Michigan to Maryland than from Texas to California? How many states have more than one straight line border? What is the fourth largest state in area?

Part of the time we find ourselves lost in the activity of reading a map. Then we remember that this is a painting and become interested in the use of orange or of blue, in the freedom of the strokes, the balance among the colors, the relation of colors to borders, and so on. But then we fall for a while back into map questions, following the Pacific coast line or thinking about the group of New England states. The two interests (map and painting) are more than distinct ways of looking, although as interests they include or require a set of habits that in combination give a quite specific meaning to the word "looking."

Each act is also tied to chains of memories that puzzle the mind about the alternative ancestors for the work. Every American carries the memories of being a schoolchild assigned to color in with crayons a map exactly like this. Every child has had to memorize the names of the states or take tests in which the name of each state had to be written into the correct place on the map. This particular ordinary map is an almost Proustian object for the American viewer, but for no other. On the other side, the painting is a lively example of Abstract Expressionist brush work, linked to a set of New York paintings of the postwar period. The third-grade schoolroom, the mimeographed paper map, the crayons, tests, abbreviations for the states, the ordeal of memorization make up an inescapable pole of memory that supports but also undermines and distracts us from the act of looking at the painting as a map, let alone from the even more difficult problem of seeing it as a painting. From the side of painting, the individuality of this painting is defined by, but also undermined by, the memories of de Kooning's paintings from a few years earlier: the Abstract Expressionist style that was always said to have "put American painting on the map." Is it "seeing" this joke (a radically different idea of seeing) that the painting aims us towards? Does the moment that we get this joke give us the answer to what the painting is about or does it distract us entirely? A joke or riddle is a situation in which we say, "Now I see it!" The meaning of this entirely different script of seeing throws light back onto the equally distinct, but also, perhaps, equally distracting scripts of seeing that were at stake in recognizing the classroom map and falling into memory, or reading the map, or recognizing Abstract Expressionist painting style.

The part played by memory in constituting a familiar experi-
ence while at the same time distracting us from actually seeing
deepens the divided loyalties already present in the act itself. To a
certain extent Johns might be seen to be carrying out experiments
within what Wittgenstein called the problem of "seeing as." We
cannot see without recognizing. We cannot simply see an object.
We must see it *as* a map or *as* a painting or *as* a third-grade school
map or *as* an Abstract Impressionist painting, or even *as* a clever
joke about putting American Painting on the map—the type of dumb,
literal pun-type joke that James Joyce loved.

Recognition always makes the object just one more map, just
one more painting, one more pun. It locks it into familiarity. Lodged
within memory, classification, and our habits of response, the ob-
ject operates in a very narrow free space. But here the problem is
set of two divergent classifications, two trains of memory, two op-
posed recognitions. These produce a rivalry at the heart of the act
of looking, but a rivalry that also isolates in a certain way the
specific kind of looking that makes up looking at a work of art as
opposed to looking at a map.

This almost pedantic instruction about what is and what is not
looking at art is even clearer in the case of words. At the same
time the painting of words is a less subversive puzzle to the mind
and eye. The Flag or Map is co-terminous with the painting itself.
Every square inch is both flag and painting, map and painting. The
two are ontologically inseparable. With words the case is different
since words occur within or on the painting, making up a part of
its surface. They can be fused in places, but the painting itself is
the dominant reality within which the word is an actor. Still it is
by means of words that an even more strident clash within the act
of looking can be staged.

If we consider the painting *No* of 1961 (Fig. 8) we are faced
with the question of what specific acts we mean by the inclusive
term looking when we look at a printed word like the word "NO."
To look at NO we do not attend to the combination of three straight
lines that make up the letter N, two identical vertical lines and a
slightly longer diagonal line joining the top of the left line to the
bottom of the right one. Nor do we think about or notice that
the word is made up of two letters, one made of straight lines,
the other a rounded circle or ellipse. We do not think about the
opposition between line and circle or the unity of the second letter
O as opposed to the multiplicity of the first letter N with its three
lines.

These facts about the word "NO" must not be seen if the word

Fig. 8. Jasper Johns, *No*, 1961. Encaustic, collage, and sculpt-
metal on canvas with objects. Collection of the Artist. VAGA,
New York, 1991.

is to be successfully seen as the answer "No" or even just as an example of a word, any word. In fact they are not facts at all of its existence as a word. Looking at a word involves not seeing or considering that it is black or linear or oppositional or anything else. But to see it as a word does require an inner voice that says the word "No." To see it is to say it. If we imagine seeing or looking at a Chinese word or an Arabic word that we cannot say, let alone understand, or, even further, obey (if, for example it were a command), we can see how much our seeing the word "NO" is completed by the inner act of saying it.

The word "NO" is also only a word in English. By including so many words within his paintings Johns has made either a provincial or an imperial decision to—as we could say—paint in English. If his titles like "Fool's House" had remained outside the work on little tags beside it, they would be translated into German or Japanese, but inside the work they make the work have a cultural address—an English-speaking viewer—every bit as much as his American Flag paintings. The abstract painting of the 20th century was a natural outcome of the internationalization of art. The canvas had to be purged of provincial references of all kinds. Johns took step after step to re-provincialize the experience of the art object; that is, to give it a specific address to only some viewers. Alternatively, we could see his work as part of the assertion of American culture as a new world culture. In that case the English words would be no different from the appearance of Latin words within the Christian painting of the Middle Ages. Whichever interpretation is given, it is an important fact about Johns that he decided to paint in English.

To look at NO requires us to take the kind of interest in it that we take in words. Second, it requires that we overlook most features of the object while attending to others. This is not merely a selection of features, because the mind treats as non-existent the other features so as to be able to look (read, in this case) at all. The other features do not exist as facts within this act. Third, an activity that is not itself visual—in this case, the inner voicing of the word—can be essential to the act of looking in so far as it is a complete act. Its purely ocular features are swamped by others that have nothing to do with the eyes alone. Recognizing and understanding, let alone obeying or disregarding in the case where the word is a command, are among these acts.

To read a word correctly is also a quick act, not a lingering one. We pass right on to the next words NO SMOKING or NO EXIT or NO SENTENCE CAN BE SHORTER THAN ONE WORD. If

we are reading the word correctly we are finished with it as soon
as we understand it. The normal situation of encountering it is in
a context of other words. This structure of getting it and passing
quickly on to the next is itself intrinsic to what we mean by look-
ing at a word. It is frustrated by there being no more words or by
the requirement to go on staring at the object because it is a paint-
ing of the word "NO" rather than purely and simply the word.

Because I will return to the kind of seeing involved with words
I want at this point only to regard it as another case, like that of
the map, where seeing has two different activities in any situation
where a painting is made up of words. Attending to the painting
while reading the words painted within it sets loose a rivalry within
the mind. One of the things at risk within all of Johns's word
paintings has to be seen as the relative weakness of paint compared
with words in the contest to attract the attention of the viewer and
set off the act of either looking at a painting or reading words. The
power of the word "LIAR" over the paint in which it is imbedded
is part of the fact of words within a reading civilization. The paint
has trouble competing for attention, just as paint did in the days of
gold leaf. Where a word exists, the other things going on give way
to it, make up a background for it. Johns's paintings like *Tennyson*
and *Liar* are probes of the viewer, tests of whether he or she can
stop being a reader so as to see the painting. To accomplish that,
the word has to recede into the texture of the work and become for
the mind one more set of details equal in importance to any other
few square inches of the surface. Normally, this is impossible, and
that in itself sets part of the problem of painting as one among
many rival solicitations within the wider category of looking.

The rivalry between two complete acts that cannot occupy the
same time or site is even stronger in the case of the flag paintings
than in the map or word paintings. With the flag, the non-visual
act is dominant. In our ordinary experience of looking at the flag
we do not ordinarily spend any time at all on its details. We regard
it as a whole, and when we find ourselves in relation to it as *our*
flag, we fall into our patriotic relation to it. That relation can either
be chauvinistic or one of strong reaction against it out of a dislike
of chauvinism. Being in the presence of a flag of one's own country
is completely at odds with looking carefully at it, although patrio-
tism also requires keeping one's eyes fixed on the flag.

The flag itself is not just not there in space on various occa-
sions. It is, as we say, "displayed." It is raised and lowered, set
onto the coffin of a soldier at his funeral, shown and saluted at the
start of a football game. The flag and the act of looking at it are

ceremonially defined. It cannot really be looked at just by glancing at it or gazing at it, or even by looking curiously at it as an American might look at the flag of Brazil or Italy. To look at it entails this complex orientation in which we pause with respect and thoughtfulness. Most uses of a flag are disrespectful, even criminal under American law. The many scenes of burning the flag during the Vietnam War did not weaken, but rather added to the power of the flag and to the act of looking at it. To see it partly consumed by flames or desecrated and trampled underfoot during a period of historical danger thickened the symbol's power just as much as seeing, in a western film, the flag still flying over a fort in Indian country when it was thought that the fort must surely have surrendered.

Every act of looking correctly at the flag is an act of honoring it, no less than every act of looking correctly at NO is an act of reading. In making an entire painting be a flag Johns poses the problem of whether there is a distinct act of looking at a painting just as there is for words, maps, or flags. Can we detect in ourselves a pattern of seeing this as a painting once it is forcibly juxtaposed or superimposed onto the second act of seeing a flag, map, or word?

Since we have to carry out the intellectual instructions and ceremonies of two entirely different activities—seeing a map and seeing a painting; seeing a word and seeing a painting; seeing a flag and seeing a painting—we become charged in the face of the object, self-aware of the pull in several directions. Each activity requires our cancelling out just those acts that the other insists on. The flag is seen globally, but the painted flag draws us into minute details of texture (Fig. 4). We find ourselves inspecting it closely or thinking about the proportions between the square field of stars and the larger area of stripes. We find it made up, for example, of just how many short stripes and how many long? Do the short stripes (where they leave room for the field of stars) signify some difference among the thirteen states, some of which are represented by long stripes, others by short? And if there is no difference of meaning, how can only certain things about a design like this have meaning (the 13 original states which are represented both by a stripe and by a star, as opposed to the other 35 which have only a star) while other equally visible facts (long versus short stripes among the original 13) have no meaning? Does the act of "seeing" this as a flag require that we not notice, not even see, certain facts like this one of the long and short stripes?

Each habit set is partly undermined by the temptations of the

others. With the word we wish to read it and pass on to the next word in order to discover the context in which the word means something, but the painting keeps us in front of it. The same is true even more powerfully with the flag. But do these acts always interfere with one another? Can painting here be staging itself at the site of more stable activities in order to borrow their cultural stability or even to instruct its audience? Does the flag play with instructing us to honor the painting, feel reverence in front of it, or to regard it as a nationalistic fact—American Painting—and accord it the respect and personal loyalty that we instinctively give the flag, especially a decade after the end of World War II? At least, in part, the painting could be said to loot the domain of responses and habits already intact for the American flag, but then, to find itself in a paradoxical situation as each viewer refuses those responses.

One final example within Johns's early work will make this factorial relation to other acts of seeing unmistakable as the central question of the first phase of his career, and make it equally clear as a museum question of just how far effacement proceeds since what is effaced remains at a certain level of activity, still there within any work, even an Aztec work that an ordinary viewer has no means of spontaneously recognizing. Among Johns's first works are a number of painted targets (Plate 3). Unlike a flag, a word, a number, or a map, a target really is an object of intense visual staring. In ordinary life the eyes, as we say, lock onto the target. We concentrate on it, fix it in our field of vision. In any room a target draws the eye to itself. Among other things, we could say that any object that becomes a target is going to be able to compete for attention in even the most visually crowded environment, even in a museum room. For a work that knows that it will someday find itself in a large room where each visitor will enter to find himself solicited by twenty visual claims for attention and time, there could be no more clever act than to disguise itself as a target, one of the few things at which we cannot not look. The eyes will notice it first. Several books of reproductions of Johns's work have used one of the target paintings on the cover for the same reason. On a table of books in a store, the target defeats its rivals and captures the eye.

A target defines a specific type of visual space, one organized around a center. It itself is a center for the wider visual space, and within itself it has a center. Instead of saying that we "look" at a target we speak of "aiming" at it. Aiming is a combination of careful looking, hoping, and willing. We try to strike the exact center.

Any movement of our focus away from the center will cause us to miss. So the normal exploratory glances of the eye are resisted. If we are looking at a painting the eye darts from detail to detail, creating a dance-like motion of attention that searches the object for interesting points. But to look at the painting of the target is extremely difficult because the eyes want to *hold* the center so as not to miss.

One of the most lovely details of the 1974 *Target* painting occurs in the lower right-hand corner, a space that it is difficult to study let alone enjoy because the center keeps drawing us back. The corner, where the round space of the target meets the square space of the picture frame, is itself one of the privileged spaces of any abstract painting, particularly any overall abstract painting. The corners are unique because they are the places where a basically unendable, non-narrative painting has to, nonetheless, come to an end. The painting *Target* gives us four of these triangular spaces where the hypotenuse of the triangle is the blue curving outer edge of the target. Since there are four of these spaces, two pairs, they invite the mind to compare them, to regard them as four chambers in which events take place. Each of the four is flecked with green liquid shapes, more in the bottom pair of corners, and most of all in the bottom right-hand corner where there occurs a lively struggle among the round blue edge of the target, the square red edge of the painting, and the mediating, free, liquid shapes that are mostly green in color but with some leakage of blue drips from the target.

For the eye to spend time in this corner, the climax of the series of four corners, is a natural response to acknowledging the painting as a painting, following through on our habits of seeing a work of art. Loyalty to those habits drives us to linger in the excitement and beauty of this corner. But to accomplish this and to enjoy this pleasure we exist in a state of anxiety relative to the target which insists on calling us back to the center. Even within that center, or the rings right around it, the target-glance does not allow us to enter in a relaxed way into the many details and dramas that occur once we break down the unity of, for example, the first blue ring, into its actual painted details. Each ring, as painting is a narrative space that we travel around with the eye through the 360 degrees, enjoying the events as we make the circle. Instead, the target-glance insists that the bull's-eye and surrounding rings are uniform, equal in value inside any one zone. Seen as painting, these same areas fall apart into a richness of local facts and contrasts that are never the same from one patch to the next and never the same in interest or value to the eye.

The two habits of seeing exclude one another: as target we feel

we have to keep aiming at the center, but as a painting we have to explore, move from point to point, and this is an activity that our consciousness of it as a target makes into a feeling of failure. We are going to "miss" (in target language and feeling) if we try to "get it" (in painting language and feeling). Any gesture to fulfill the one script is felt as a failure of the other. The target is what we could call an imperative script. Like an octagonal sign with the word "Stop" it imposes itself as a command: "Aim!"

An even stranger problem occurs when we wish to pass on from the work to spend time with another. To look away from the target is to "take your eye off the target." The habits of target-looking build in a problem about just how to stop looking at this painting in order to pass on to the next.

Each of these features is a specification of the visual space of the painting. The painting *Target* has a center with various decreasingly valuable spaces arranged in rings around that center. In this it is unlike an ordinary painting which has no center and imposes a composition of spaces in a rectangle that we are invited to explore. With the target we lose points as we go from the bull's-eye to the next ring, and so on to the edge. Everything beyond the outer edge is a miss and counts as zero in target space. The target, as an attractor for the eye, organizes an hierarchical, circular space; it is a flat pattern; it instigates a tension whenever we follow our painting-habits and try to explore details away from the center. Finally, it enforces a prohibition on looking away entirely or going on to the next painting. This makes up what we might call a familiar recipe for correct and incorrect activity in the face of this object, in so far as the object is a target. In so far as it is a painting each of these instructions runs into serious clashes with an alternative familiar recipe.

Clearly, we are not simply faced with different kinds of attention, shades of some central act of looking. Instead, each of these is a distinct script or formula of activity in the face of an object, a script in which the acts of the eyes and the mind are only a part. The pace and duration of looking; the relation of the global glance to the breaking down of the whole into a series of details that we turn into a narrative as we pass from one to the next; the accompanying acts of an inner voicing of the word, the standing silent in front of the flag rather than discussing it as we do with a painting; the state of mind of which looking at something is a part (honoring, aiming, studying, reading): these in combination make up scripts. They are what we do when we find ourselves in front of a flag, a target, a map, a word, or a painting.

The feeling of not knowing what to do with it is one of the

most conspicuous and important audience problems in the art of the 20th century. These objects, which the average man or woman knows what to do with, point out just this absence in the case of painting. Target, map, word, and flag are objects that every citizen knows how to act in the face of. They might, as a result, each be seen as an attempt to stabilize, in a period of experiment and uncertainty, the now unstable act of looking at a work of art. The untroubled rituals of attentive seeing are proposed, while at the same time, the conditions are created under which the differences among looking at painting-maps, painting-targets, painting-words, and painting-flags might isolate and make unmistakable the root activities of aesthetic contemplation. Johns's very choice of a variety of contrasting instructions rather than one onto which he might align the act of painting, in effect basing painting on it, suggests that this variety will help factor out a set of quite distinct differences that in the end will add up to an aesthetic looking. No one alternative could make that clear.

More essential is the fact that art itself is and has always been this double script. For every object in a museum whether it be a sword, a gold chalice, a funeral urn, a painting of the Madonna and Child, a wood carving from Benin, the looking that we call art is situated at the site of another practice of attention, care, and use. This prior structure of regard is effaced but still present, held in a tension that, as the target or word examples show best, goes right to the heart of seeing itself. To have captured this charged state of seeing as Johns did and made of it the topic of a set of works of art is to have created one of the most profound reflections of a museum culture.

At this point we can now see that the earlier question that Clement Greenberg, among others, has posed can be made more sophisticated. Greenberg had asked if what we call art might just be said to be an act of seeing. Found objects often look art-like, a piece of driftwood, for example, that has a intricacy and haunting mood. But what we mean by art-like is clearly dependent in this case on there being a set of works in the background, made by the normal processes of art and made by human hands, that this found piece of driftwood could easily fit into. It looks as if a craftsman had worked on it with the intention of producing these shapes and for the purpose of evoking these states of feeling. The found object is completely dominated by the strong clear categories in the background that make it plausible (on an "as if" basis) as one more object of that kind. Similarly, a certain shape of stone that we find in digging up a garden might be taken by us as an arrowhead only

because we have already seen hundreds of arrowheads elsewhere so that we have refined, somewhat, the distinction between the category of small, chipped stone and the category of arrowhead.

Seeing the driftwood as art means seeing it as a very familiar cliché of a certain tradition of art. On the other hand, the act of seeing that converts something into art might refer to the few, now very tedious, scandals of modernism, for example, the urinal that Marcel Duchamp exhibited as a work of art. Here the word seeing refers to the act of lifting something out of its normal cultural setting and relocating it in the social space of a museum where it is looked at as we look at works of art. The artist becomes a museum director. He chooses something, buys it, transports it to the museum, and fastens it on a wall of a certain room where the object is juxtaposed to and surrounded by other objects that have arrived there by means of the same museum process. Here the case is exactly the opposite of the driftwood. The artist does not claim that this object looks like art, he is saying that anything picked out for attention *by a person recognized as an artist* is a work of art. His so-called daring lies in picking out an object of social concealment, concerned with rituals at the opposite extreme from the religious, patriotic, or familial spheres from which art usually comes, and then isolating it for attention and a comic parody of honor. So arbitrary is the power of the artist that whatever he signs is a work of art.

With both the driftwood and the urinal a line is drawn between the institutional acts that make something into art and the act of making per se. The artist does not touch or alter the object at all. These stunts or paradoxes are minor and briefly interesting acts at the border of a strongly defined concept of art. What they make clear is just how sophisticated the process and the response that Johns has opened up are. He has installed inside one work the tacit facts of an entire institutional system. In trapping us between scripts for looking, and locating each work at a site of superimposed requirements, he has both narrowed and refined what had seemed a coarse and simple problem within the open-ended possibilities of art after the museum revolution.

## Words, Numbers, Colors:
## How Representation Might Be Done

The strategies of effacement and aggregation that occur as content within Johns's works—along with the creation of a script for look-

ing at the works that draws on, while rivaling, the set of formulas for looking that are culturally untroubled within the modern period—make up, in combination, an appeal within the work addressed to the future. The painting will be lifted out and set within an aggregation and will be used within a system of looking that it can talk about while only hoping, in its own case, to see it come about. These features all concern the work's own aftermath. They make up a set of instructions for how it might be used. There is a final museum strategy within Johns's paintings, one that might be called a cultural strategy because it involves an inventory of resources, a display of possibilities for representation.

Among the paintings that stir up a rivalry between reading and seeing one set creates a special resonance between the words and the painting in which those words are embedded. These are the paintings in which the words are the names of the colors, usually the primary colors; red, blue, and yellow. Naturally, in a painting, the word "red" is at home in a way that the word "fool" is not. The painting *By the Sea* of 1961 (Plate 4) is made up of four bands of blurred or smeared colors with a blue haze predominating. In the top band we recognize the word "RED," its final letter "D" painted crimson. In the second band the ghostly word "YELLOW" can be made out, stencilled, done as though the stencil had been pressed into the wet paint at a certain point in the process of the painting. But even this does not describe the feeling that the word gives. It is not painted on the paint; nor is it a shape or boundary within which paint occurs. The word is within the paint the way a body is within clothes, recognizable, yet obscured, inflecting the paint in places but seen almost as a building through a fog.

Below this second band is a third where the word "BLUE" can be seen. The first three letters are themselves blue but imbedded in the painting going on around them. The "E" is painted black and is the one letter in the whole work that is painted onto the painting or over the painting instead of being merged with it. In the final band the three words are superimposed and can be made out only by an act of concentration in which we decide to try to read the word "RED" or the word "BLUE" while disregarding the rest of the palimpsest. The words are mixed and since it is out of mixtures of the primary colors that all other colors are made, these words and their mixture becomes a way of saying "ALL COLORS." This blur describes the materials of painting itself in so far as any painting is pure color and not shape, stroke, texture, or figure. As Mallarmé said about poetry: Poems are made out of words and not ideas. Paintings are a systematic mixing of red and

yellow and blue. However, when Johns puts the three words on top of one another he makes "All Colors" except that the words destroy one another rather than yielding a new word in the way that colors would. Whatever parallelism was at work in the first three bands has broken down in the final one, where a lively riot of colors triumphs over a ruin of words.

The color words, in the first place, differ from such words as "Fool's House" or "Liar" or "No" because they are the only words that might be literally about the larger or adjacent activity. But the stir of activity set off by these color words is far more radical. When I am reading the word "RED" I am not at that moment seeing anything red. Even if the word itself is red, or part of it is, to read it and to see its redness are two acts. Although most letters that we read are printed black we never smile when seeing the words "white and black" thinking that the second word describes itself, because the ink is black, whereas the first contradicts itself because the word "white" is written in black ink. To read is to have made irrelevant the color of the print. If the word itself is red, to read it and to see its redness are two acts.

When I read the word "RED" no matter what its color, do I picture inside my mind redness or a red patch? Does the word, in this case, stimulate its own production of the fact? Is the word "RED" like the shout "Wake Up!" that actually wakes the sleeper? In the 1959 painting *Jubilee* (Fig. 9) Johns stencils the words "red," "blue," "orange," and so on onto twenty or so areas of a black and white painting. Among the color words are the literally true words "Gray," and "Black." Do the color words as we look at them, make the painting occur inside the viewer's mind? As he looks from one area stencilled "Blue" to another stencilled "Orange" do the colors appear, or if not, does a similar gray look different with one or the other word stencilled into it? Could we say that the painting is mostly blue and orange or do these words stand for the failure of words, their powerlessness in the face of paint. We might say that the color words tell the story of a painting that the words tried to impose but which did not occur.

In the case of *By the Sea* (Plate 4) with its four bands these questions are turned in a variety of directions. If the word "yellow" is painted yellow how would that differ from the same word painted blue (imposing a dissonance between word and fact) or just some mixture that seemed indifferent to the existence of the word? Does reading the word "YELLOW" make us notice in the zone around the word all the yellow that we can find? If so, the word would have the power to organize whatever colors were nearby

Fig. 9. Jasper Johns, *Jubilee*, 1959. Oil and collage on canvas. Private Collection. VAGA, New York, 1991.

into a space in which whatever yellow there might be would occupy the foreground while all else became background. How is the identical painting seen differently if, while staring at it, we notice within it the single word "BLUE" as opposed to the single word "RED."

The color words seem related, not to the titles like "Liar" or "Tennyson" or "Fool's House" but to the philosophical words like "NO" or "THE" that Johns has also used within paintings. The word "NO" works like a logical paradox. An act, painting included, cannot be a "No" any more than a painting can be a "Nothing." It has to be a something, because even a blank canvas is just a different kind of something. In this sense a painting cannot be a "No," it has to be a "Yes" since something has been brought into existence. It is inherently a "yes" structure, just as it is a "this." An object cannot choose to declare itself not to be a "this." The 1957 painting *The* is self-constituting in this way. Every painting is a "the" because the article asserts the minimally true thing about anything. To be there in front of us it must be a "the" and it must be a "this" and it must be "here" somewhere.

One of the paintings of 1961 is called *Disappearance I.* Still the painting itself is always an appearance. It cannot be a disappearance because it is always still there. To be a painting is to be always still there. In Johns's "NO" painting the "No" is outside the painting, hanging by a wire just in front of the surface. The shadow of negation falls on it, but the painting itself is untouched by it.

Taken together these philosophical words for objecthood might seem to be prior even to the words for the three primary colors, but a word like "The" is static, a one-time gesture. The color words, like the letters and the numbers, open up a field of permutation that can be exhaustively worked out. The colors red, blue, and yellow make up the base of a complete code, like the dot and dash of Morse Code.

It is by means of a content that makes permutation possible that the individual work becomes a series or sequence. The series or sequence in its role as a strategy in the face of the intellectual order of the museum will be the subject of the next two chapters because it is the series that converts an aggregation into a linear history. The sequence is then the fundamental unit, far more than the individual work, of the museum. For now I only want to notice that it is the closed set, subject to permutation, that permits a natural passage from individual works to series. That is its fundamental importance as a special type of content. The word "Blue" can, among other things:

1. itself be painted blue;
2. occur in a black and white painting where it sets off a color in the mind;
3. be painted something other than blue;
4. be painted within a zone where it sends the eye in search of blue, organizing the space into foreground and background;
5. be used as a label or title for the painting as a whole.

The situation suggests doing variations that generate a series of works. The color words are important to Johns just because they generate this set of possibilities. The same is true of the numbers from 0 to 9. He can make ten canvases, each one with one number, or he can superimpose them one on top of the other, forcing the viewer to try to "see" the six within the tangle of clues, and then, by a separate act, to "see" the four within the same clues. Or, the same numbers, side by side, in small square cells, can cover a large work with a hive-like structure of repeated series.

For the alphabet the same is true. With the color words, numbers, and letters in their permutations Johns has given himself a subject matter. He has almost, we could say, assigned himself a set of problems the way a child is assigned homework: writing five times the multiplication table for nine. At the same time, he can, like Raphael with the Madonna and Child return again and again to execute another variation. As with all painters who work with a fated subject matter, there is a melancholy to Johns's style. Sometimes he seems like a man in prison with only one book, to be read over and over.

But it is equally true to say that with the colors, numerals, and letters he has taken for himself the most fundamental content of rationality itself. He is a grammarian of pictures who has taken for himself only the elemental words—The, One, in, with, and, etc.— leaving to others the multiplicity of nouns, verbs, and adjectives. He captures for a secular society its residue of symbols, those letters, numbers, flags, colors, and maps that function in our lives as the shared symbolic wealth, our gods and goddesses, stabilizing, just as those deities did for the Greeks and Romans, or just as the Life of Christ did for the Middle Ages, a core of cosmic order.

Each of the objects at the heart of Johns's representation is an instrument of civilization and an invention as powerful as the control over fire or the use of non-human force for human purposes. Each of these trivial objects is also, and more importantly, a means to assemble everything. From the twenty-six letters we can reach any point. Some combination of those letters will spell out any

detail of human reality that we can notice, and any new reality can be accommodated within those same letters. Since words, sentences, and descriptions can map the entire universe, the letters themselves in their economy are a remarkable miniaturization.

Similarly, from the ten numerals all numbers can be assembled, all measure and quantitative description can be accomplished. The color system of red, blue, and yellow can be added together in various proportions to make every possible color. With those colors a painter can reach any detail of the physical world to paint, for example, a nose or a belt buckle or a storm at sea. Such systems of permutation and combination make up the heart of civilization in a unique way. They remain open-ended and are inexhaustible. Any person who wants to can say aloud a number never yet said aloud within human history. New words can be coined, new colors mixed, within the twenty-six or three elements.

This is to say that what Johns is interested in is the base out of which everything can be produced in representation. Yet, how is the list of the twenty-six letters—ABCDEFGHIJKLMNOPQRS-TUVWXYZ—different from the word "Everything" or the word "Being," which seem also to state everything at once? The letters, numbers, or colors are a means to reach a representation of each individual thing. They address human possibility while in themselves being nothing. The twenty-six letters do not themselves make a word. There is no White word for the alphabet, although there is a combination of the colors that itself is a color, and even a number, 1,234, 567, 890, that is the simple number formed by a list of the numerals. But these numbers and the color white are not themselves important. The codes are not a way of summing everything up and blending it into one thing. Just the opposite. They are a means to get more and more precisely into the most exact, local fact of the world. The difference between a spool and a spindle, a bicycle and a scooter, is blocked out by there being a different combination of some of the twenty-six letters that locks these exact differences into place. The numbers let us reach the difference between 164,529 and 164,528 grains of sand in a pile. The eye could never tell the difference between the one pile and the other, nor could the hand in weighing them. Only the existence of the numbers lets us reach precisely this clarity and difference, and it is to the numbers as a technology of difference that Johns's tribute is directed. Numbers, letters, and colors, let us map in a second realm the richness and diversity of the realm of being. That the painter's normal work lies within only one of these simple, combinatorial domains of mapping, does not, in this case, stop

Johns from saluting the possibilities of the other two while locking the cultural importance of painting onto this philosophically rich meeting point with numbers and letters.

Paradoxically, the mood in which Johns paints these cultural monuments is a mood of melancholy and elegy, as though he is constantly aware that having the twenty-six letters you actually have nothing at all—yet. You have the materials out of which anything can be made, but at this point you have only possibility. A painter with a brush, a canvas, and the mysterious properties of the three primary colors can then have any content. But nothing is represented yet. The condition is either prior to representation or elegiacally late, pointing out how a civilization used to go about these things. By being about these combinatorial materials, Johns mentions them; he brings them up. In doing this he takes an inventory of the tools for representation. He looks over the possibilities.

It is between this stance of forecasting unlimited possibilities and the stance of monumentalizing and effacing a no longer active past that the individual works occur. Some are brightly colored, energetic works, but they have a hectic, forced gaiety. The greatest of the paintings have a somberness, even a solemnity. Having seized color as the essence of painting, Johns displays none of the sensuality of color that we find in Matisse or de Kooning. These are paintings from the winter of the history of color. The great painting *Periscope (Hart Crane)* of 1963 (Plate 5) devotes its three vertical bands almost to the funeral of Red, then Yellow, and, finally, Blue. A skeletal hand sweeps the paint into a semi-circular target or eye, or dark entrance to a tube at the top right of the work. The words refer to what has been foregone. He has made of painting a practice that can be itself effaced, yet carried out triumphantly as an act of making and effacing art. The museum strategies are part of the melancholy of art.

As individual works, each of Johns's paintings addresses the museum space in which it will occur. The work of the museum—effacing, aggregating, juxtaposing—already goes on inside the work itself. The act of seeing that will make up the consumption of the work by the public is already designed into the work itself. To look for a moment back to the example of the sword with which this book began, any Johns painting makes us aware that it is aware of the community of objects and the system of access for which it is intended. Objects before the invention of the museum were naïve about the very fate that such modern works knowingly discuss. Nonetheless, in terms of this community of objects, the painting is

a tool, like a sword or like a photograph on a driver's license. Each is an instrument within a highly specific social situation and occurs as it does because it is constrained by a set of acts. The sword is as heavy as it is and no heavier because it must be swung. The photograph on the driver's license is as small as it is because the license must be carried at all times in a wallet or purse.

The painting has been built for a museum world in which one of the features of each object is not design but redesignation. As a site of effacement and yet preservation of the converted energies, the sword in the museum has undergone a restoration of enigmatic presence. This same requirement hovers over the paintings of Jasper Johns. How can he return to the enigmatic condition of pure presence, the most ordinary facts of number, letter, flag, map, and target. Once this cargo has been loaded into the work, it has suddenly the standing of the other objects from the past for which this process was brought about by the action of time. They are there because they are the past. The works that are self-designed to be the future's past substitute painting for time. Both time and painting efface, but along different paths of action. As a result of this effacing, what might otherwise be no more than an object can take effect as art.

# chapter 4

# Sequence, Drift, Copy, Invention

Any work of art now occurs within a culture of intellectualized criticism. The close connection of the arts with the university, with sophisticated verbal analysis in art journals, with systematic ordering in histories of art, and in the one- or two-semester courses through which most young people first encounter art, are only several symptoms. Ingenious description and philosophical grounding come along with even the most modest work. In the early years of modern art, it was not unusual for the work of art to come equipped with, or even protected by, manifestoes, claims, self-explanations, and what we might look on in an advertising age as rather disingenuous and noisy self-promotion.

Today, the artist himself or herself does not need to provide this atmosphere of claims and explanations. A highly trained profession of observers and critics now delivers nearly instantaneous anchoring, philosophical defense, grounds of explanation and orientation for new work. It does so at such a speed and with such overall sympathy for the changes of the art world, that the artist can now rely on the output of these delegated manifestoes and so can be forgiven if she does not produce them herself. The essential task of this professional criticism is to historicize the present, to imagine it as the future's past, and by that act to give or deny value to the individual work or artistic career. The critic is the advance scout of a museum culture since his task is, so to speak, to get to the work before history itself does.

The existence of this climate of saturation for new works, in which assertions of philosophical importance and sequential inevitability confer legitimacy on the existence of the work, makes up one part of the verbal content of the modern work of art no matter how abstract or contentless, in the traditional sense, it may appear to be. However abstract the work of art, it is seldom free of the splash of modern explanation which is, in effect, a very long title that the work carries with it, a title known to some and not to others.

Criticism may seem only ironically a "content" since it is outside the literal boundary of the work, but this is why it is useful to see it as an unusually lengthy title. Even with traditional works of art the title was the one legitimate form of content that always occurred outside the surface of the painting itself. Technically outside, the title remains a part of the inside of the work, even though since it occurs in another medium—that of language—it involves a transgression against the eyes to which painting is addressed and against the very idea of the aesthetic in so far as the word refers, literally, to the senses.

The production of horizons for seeing works goes hand in hand with the manufacture of the works themselves. Apparently outside or alongside the work, this analysis is anticipated in the work and needs to be understood as a peculiarly modern form of content. The heavily worked frame that was a second external content for the traditional oil painting, a part of the content usually done by another craftsman, has for the most part disappeared, as has the pedestal which was external to and yet essential to the traditional statue. The painter now shares his labor with the critic who has stepped in to fill the shoes left empty by the makers of ornate frames and pedestals.

No part of the external content of explanation is more important than the sequence or series by means of which a painting can be legitimately historicized. On one side, this is what I have called the strategy of the future's past. The work of art must become, at some moment of the future, a step within a sequence that anyone living at that moment of the future will think of as its past. But on the other side, the terms "sequence" and "discovery" borrow from technology the more secure cultural certainty that art itself lacks as a detail within history. In the sequences of technology a measurable and obvious progression exists. It is the last outpost of Whig history. We are no longer certain that political history is made up of a series of stages leading to freedom, representative government, and a victory of reason over force. Likewise, we are

no longer convinced that in thought we progress from myth to religion to science. Only in technological history do we any longer believe that we can find an incremental progression in such realms as speed and power, strength of materials, mastery over energy and distance. In our society only a history that follows the rules of our basic history of technology can confer order and stability onto a realm of experience where only hopeful or analogical equivalents can be found for such historical notions as "ground-breaking invention" or "turning-point" or "breakthrough." Such terms are comfortable, even natural, in the history of transportation, of power, or of message sending. Taken over by cultural history they are weak and misleading analogues.

One of the features of many cultural realms is that they refer their own certainty outward or backward to a second realm in which their results can be checked. The language of breakthrough or invention seeks to do this for works of art by translating results in art into a vocabulary of technology. Even where there would seem to be internal criteria, as in the realm of technology itself, we still seek to certify the results by looking to another realm. For technology that other realm is the economy. In the case of any invention we might seem to be able to weigh the ingenuity or perfection of the discovery as well as its distance from standard practice. But in fact we reference our judgment to the economy. Only widespread adoption, social or political transformation, military victory, the creation of economic wealth or its shifts can really ground even this apparently self-evaluating realm. No matter how remarkable and obvious the airplane was as a breakthrough in the history of motion, it is only because it fit into a military strategy of bombardment in which the range of artillery could be extended by the aerial bombardment of distant targets, and later, in peacetime, fit into the transportation needs of societies too large to be adequately serviced by the rail network, that we could anchor the certainty of the airplane as an enormous breakthrough in human history.

## The Museum and the Vocabulary of Sequence

The orienting power of criticism and of the language of technical invention by themselves would have only moderate importance were it not that they execute the institutional requirements of the fundamental social space towards which art in the modern period orients itself, from which it draws its monetary and cultural value, and in which it intends ultimately to come to rest. That social space

is the museum. The intellectual and public ordering of art since the founding of the great public collections in the 18th century reached back to appropriate—or to loot—earlier systems of use for which the objects along with their symbolic or social means were originally intended. The museum resocializes and designs new uses for and access to, already existing objects, or, to be more precise, for already existing parts of social worlds that can be removed, transported, and assorted with objects of conflicting or alien uses. The museum is a home for portable objects. They must both have existed prior to their life in the museum (so as to be able to bring with them the cultural flavor of Rome, Florence, or Aztec Peru), but at the same they had to permit the act of lifting out and relocation that bridges, pyramids, castles, and cathedrals do not.

The museum is one of the best examples of a cultural process that is given too little cultural attention. Because of our normal historical or intellectual interest in traditions or in series, we think of them, finally, as dying out or simply deteriorating to the point that they are no longer of interest. Pyramids, Greek pottery, or medieval European cathedrals are examples of series that seem to arise, develop to a classic form, and finally disappear. It is for this experience that cultural history developed the traditional organic stages that occur for any tradition: a primitive phase, a classical phase, and a phase of decadence. These correspond to the childhood, adulthood, and old age of any cultural lifetime, and imply that every cultural energy works by its own internal clock, a clock that ends with the death of the sequence. Pyramids cease to be produced. But very frequently, sequences, instead of disappearing once decadence has trivialized or exhausted the possibilities, are swamped by the vigor of a new system that does not destroy, but rather reconfigurates and absorbs a transformed version of the fragments of the previous complete system.

The museum swamps, particulates, and reassembles the artifactual, instrumental, and symbolic object realms of the past and in the process it silences or effaces, or, as we might say, "forgets" large areas of meaning and use. To take another example: a local medical practice, Chinese acupuncture, for instance, might become one technique within Western medicine, but only on the condition that it be effective in ways measurable by that system, and distributable within the system of the new context. Medicine on the whole is, in this sense, a museum. It has looted all earlier practices from every society and tradition and reassembled those particles useful to it within the systematic realm of Western chemistry and biology. All other practices it discards.

Similarly, chemistry appropriates the fragments and the, to it, useful particles of the system of alchemy, but places those fragments alongside craft and trade procedures, or what we might call vernacular knowledge of all kinds. What chemistry, as a museum of such earlier systems does, is to efface or forget their prior ordered interconnectedness. A new significance and new place are created within its own system.

In intellectual life the same process occurs as in the world of practices. The incorporation of Hellenistic philosophy by Christianity particulated what was once a systematic order of ideas in order to lodge them within a new array of uses and values. We might imagine that since philosophy itself continued to exist side by side with Christianity, we might, at a later stage, recover or filter out the pieces of the swamped tradition that we would want to reassemble within philosophy. But as we approach what we take to be the original particle we now find that the very vocabulary—the word "soul" for example, that we would need as a translation for the Greek word "psyche" or the Roman word "anima," retains the stain of the very system—Christianity, in this case—from which we would like to free it. As this example suggests, it is in language that the museum relation to earlier meanings and orderings is most conspicuous. Most languages include, as English does, the swamped fragments of earlier cultures. With Etymology we try to give a history to this puzzling relation of appropriation, erasure, and residue within the meanings of words now used by us for purposes quite distinct from the history of uses in the past.

The museum relation is, once seen in this general way, a fundamental one within cultural history. Nothing is more puzzling and at the same time more fundamental than the refusal to Make It New. Cultural life goes on most commonly by means of the re-use of material that carries with it both resistance and memory within later systems for which those resistances and those memories provide both opportunities and absolute veto power over what might otherwise come into view as possibilities.

The museum in modern European culture, roughly since the time of the Enlightenment, was just such a conquest or swamping of the otherwise sequential developments of widely diverse object systems. Just as we can now look back at the great period of the rise of a world economy—for which the museum is a spiritual equivalent and partner, as the swamping of a set of local, self-contained closed systems that suddenly found themselves, as we say, "coupled" into the circulatory system of a very robust and expansive master system, so too, the household, civic, or religious sys-

tems of objects found themselves coupled, or more literally, bought out by the encompassing system of art. What used to be a ceremonial bowl in Nigeria or a boundary stone in China finds itself in the Metropolitan Museum in New York as part of the system known as Art.

The art system is to local object systems exactly what worldwide commodity markets of capitalism were to every formerly isolated economic unit. There is no world economy before capitalism, and there is no truly autonomous local economy after it. The same is true of the museum and the previously integral and isolated local systems of objects, utensils, symbols, and representations. After the museum there is an integrated world picture of the history of culture as well as a new discipline, Anthropology, which, we might say, pretends to express an interest on the part of the unified world culture in the remaining pockets of cultural difference. Like the missionary before him, the anthropologist is the first visitor, but not the last. After he appears, as Lévi-Strauss has shown in *Tristes Tropiques,* the culture is coupled to the master system and it is only a matter of time until it is looted and improved out of existence. The museum, as it develops in European culture as a result of the Enlightenment, is part of the universalizing zeal of Western culture, of which the intellectual project of anthropology is an arm. Behind the façade of a curiosity about difference, the Enlightenment project of universalization chips away from isolated systems just those fragments that can smoothly appear within the widest but still ordered cultural totality.

A study of the museum or a reflective account of how language, use, and meaning transform themselves over time would suggest that one of the most important historical categories is not intention or purpose, but unanticipated appropriation. That a Samurai sword exists as an example of "Far-Eastern Art" in a Boston museum in 1988 is an example of an undesigned use for which this particular sword may serve more successfully than it did its intended use in battle and in ceremony hundreds of years earlier and thousands of miles away.

That unanticipated appropriations are possible suggest that there is always a surplus of thus far unschematized fact in even the most narrowly defined objects, and, at the same time, that the durability of objects that outlast—as either words or weapons do—their original use invites an alternative to making or to invention. Once a new need is felt, a society always can choose between making and making over. Appropriation is always an alternative to the more wasteful act of creation.[1]

The stock of stories, retold over time, frequently outlasts the applications, that is, the moral, cautionary, or celebratory purposes for which they were first made. The new uses or meanings found for stories too interesting to let die after their intended cultural use is over are among the best examples of survival by the willing submission to reappropriation. Concepts are like objects in that they endure under conditions of ever new and often unforeseeable uses.

E. D. Hirsch has shown how the philosophical work of Saul Kripke on the instability of names, the gutting of use and reference, the drifting of sense and meaning in language, might provide a powerful cultural tool for the interpretation of what have to be acknowledged as preserved, but constantly altering entities, whether those be words or works of art.[2] In Kripke''s book *Naming and Necessity* there is a very striking solution to the problem of preserving meaning and specificity within objects once the central cultural drift of unanticipated appropriation is taken to be, not a marginal, but a central fact within any account of art, language, or systems of meaning under what historians have come to call *la longue durée*.[3]

The survival of words, objects, or practices beyond the cultural world within which they came into existence, and their reappropriation by wildly unexpected later cultural uses, are features of the existence of objects in time. Most cultural objects do not exist in what we could call their own time. They are immigrants or survivors, living on in new worlds and new positions within those worlds for which the intention of the maker never fitted them. Many a Civil War pistol is now a paperweight in a banker's office. The word "grace" survived Christianity and then aristocratic manners to find new usefulness in the description of dancers.

The chain of uses and unanticipated appropriations along which any object has passed yields for each object a second sequence, quite different from the before and after sequence of its moment of invention. Into the sequence of inventions the object is inserted. Along the sequence of unanticipated appropriations it drifts. By means of these two sequences a museum culture measures and locates its loot, anchoring it in time. In the concept of drift we have a way of widening the meaning of the idea of the "use" of an object so as to include the unanticipated appropriations that were not in its intention, and often not even within the horizon of the culture or moment that produced it.

## The Series

The most immediate way that we understand objects in time is by placing them within sequences and identifying the essence of the object by means of its position within the sequence or series of which we describe it as a part or member. The series is the most elementary technology of history.

It would seem impossible to imagine history without the construction, by however arbitrary or inevitable a process, of sequences and series. To talk of art objects in series means to grant the reality of the history of art and to assign to it, as we do, perhaps a greater reality than that of the free-standing individual work. It would be an understatement to say that the primary way in which we now take hold of art or interpret and understand art objects is by means of the machinery of a history of art which sequences each object and provides it with sources (ancestors) and consequences (descendants) beyond itself.

Since Monet, painters themselves have produced series or sets of works. Sometimes these are numbered, as in the case of de Kooning's Woman series. At other times they are clustered, as Monet's Cathedrals or Cézanne's paintings of Mont Sainte-Victoire. The series or set becomes a working tactic of the painter once he finds himself face to face with an intellectual world that articulates and surrounds his working life with a full-scale History of Art within which he is forced to see himself as an episode. The galleries and museums themselves will eventually hang his paintings in a row: before this and after that. In this act of location the individual work is implied to be following this and leading to that.

In the face of this historicization of his work from without, the painter creates series, at least in part, to gain control over the location of the individual work. With a series or set he makes a patch of history that gives his own before and after for each work which he knows will be sequenced in any case. The creation by artists of thousands of spurious or even serious movements over the last century and a half should also be seen as a strategy in the face of Art History by which the artists themselves, knowing that all work will be set in a context and defined by groupings, set out in advance to pre-empt the right of outsiders to cluster their works. The "Movement" could be called a defensive act on the part of artists in the face of the museum room which will cause their individual works to be seen alongside or across the room from some dozen or so other works. By means of a movement or series the painter takes the offensive early on to impose a certain room-cluster and

sequence or line of paintings on a wall onto that future which will consign each of his individual works to a roomful of works in any case. The Series and the Movement are, seen this way, acknowledgments on the artist's side that, once faced with the history of art, his only hope is to make up more than individual works. He has to produce patches of history so as to gain control over context; that is, over the nextness relation, over juxtaposition, cluster, before and after. Whether the individual work, the series, the movement, or some other unit is the working object of the modern period is among the things open to question in the history of the last hundred and twenty-five years, roughly the period of modernism in the arts.

## Copying As Making

In the preceding chapter I developed the claim that the act of effacing had to be understood as a primary act of making within art. Robert Rauschenberg carried out a clever parody of this crucial fact when he exhibited a sheet of almost blank paper with the title *de Kooning erased by Rauschenberg*. Whatever is most profound within art always occurs finally as a stunt, and Rauschenberg's gesture dramatized a whole vocabulary of sequence and series within art. Each avant-garde moment claimed to make obsolete most previous art. This obsolescence or devaluing of the past is acted out in a witty way by the eraser end of Rauschenberg's pencil. If the past stands in the way of new art, the best strategy would be to adopt the procedure of architecture. Every new building is put up on a cleared site, and to clear the site the builder tears down whatever earlier building he finds there. Architecture begins by leveling the past. But architecture does not go on making us aware of the prior occupant of its space, and this Rauschenberg emphatically does. He clears away specifically de Kooning and all that de Kooning stands for in the painting of the 1940s and 1950s.

Unlike the architect, Rauschenberg does not go on to use the ground he has cleared and leveled. He rests his case in the negative position. His act of erasure can be seen as the strongest possible effacement, and it is this that makes it, unlike the great works of Jasper Johns, a mere impertinence. But with this act he marks out the clearest possible technique for locating a work of art in a series, that of literal supersession. He names and produces the actual work that he wishes to follow and be understood as a reaction to. With an almost Zen-like economy he leaves both the de Kooning and the

Rauschenberg blank. The series is made up of two absent members who share a blank page.

Like many other clever gestures within modern art, this is at once a radical and an aesthetically uninteresting act. The description of it is better than the object itself. As a blank sheet of paper it makes no address to the eye, while its title makes a clever assault on the mind. Value is made by destroying value. The *Erased de Kooning* becomes a prize exhibit in the anecdotal repertoire of modernism.

The interest of the act depends on the trap that it designs to capture the idea of series and succession in art. In its extreme display of the everyday fact of effacement, this single-minded act of vandalism also brings into view the opposite, but equally literal, act that could be seen as the opposite of erasure, the act of copying. Where Rauschenberg's erasure left us with nothing, a paper that was neither de Kooning nor Rauschenberg, the act of copying always leaves us with two identical objects, the second of which follows directly from the first, succeeding rather than superseding it.

The cultural importance of copying was brought out in aesthetics in a remarkable book by George Kubler that was not at all concerned directly with the problem of art objects. Kubler's *The Shape of Time* had the ambition, at a moment when a self-contained or sociological history of art was dominant, to locate the history of art within what Kubler's subtitle called "the History of Things." Inevitably, Kubler's is an artisanal history, a history of work, rather than a history of thought or invention.[4]

Since Kubler's primary category is that of the series or sequence, we could say that his work tries to balance the modern authority of invention, originality, and breakthrough with a portrait of the more typical social process of repetition or duplication. This second process has been named, at least since the work of Pierre Bourdieu, the culture's total reproduction of itself into new generations of persons, things, practices, styles, clichés, recipes, and rituals.[5] Every culture has its primary goal in the reproduction of its life world. The first thing that it must reproduce is its population, but population is only, so to speak, the raw material that along with education, training, indoctrination, learning to cook a certain way, learning to repair or make housing of a certain kind, learning the history and rules of behavior, will when taken together guarantee the continuation of a life world.

This reproduction exists alongside whatever drive there is in the direction of such goals as invention, uniqueness, and individuality. These are always a small detail of an overall process based in the

fact that since neither persons, nor things, nor practices last very long, continuity both at the biological and at the cultural level is based on the absolute value of the practice of copying. Genetics as we now understand it is the study of the biological component of the process of copying.

Ordinarily, in thinking of art the word "copying" calls up the wasteful process of making a duplicate of something that will go on existing alongside the copy. But most social acts of copying aim not at doubling but at providing a successor in time. In making a copy we replace any person or thing nearing the end of its effective power with as close as possible a duplication. The copy fits in just where its predecessor stood. A farmer replaces a farmer; a soldier, a soldier; a table, a table; a cup, a broken cup. Although it is always possible to slip in an improvement or an invention, the more ordinary act is the act of copying and insertion. The traditional prestige of imitation or realistic representation is surely based on its candid acknowledgment that the most remarkable thing that nature does is to produce copies. In culture, too, the act of copying correctly so as to replace and reproduce is a far more important act than the act of invention. In every generation, the life world is replicated, even though the lifetime of a generation of tables is of a different length from that of a generation of men or the generation of loaves of daily bread.

With copying there always occurs a certain among of involuntary invention. Since copying can never be exact, every series, whether of persons or of things—even in the absence of a drive towards invention—every sequence or series of generations of copies is subject to what Kubler very powerfully calls "drift." The simplest experiment to demonstrate drift has always been the circle of ten or so people who pass around a whispered sentence, trying to hand on to the next person just the sentence they themselves have heard just one moment before. The drift of such a sentence under this minute number of reproductions where each person has no aim of invention or variation at all is often comic and usually startling.

Social life over time is necessarily iterated; it is, of necessity, a series. As a result, a balanced account of cultural life will include sequences and will mark the place of each individual as a position within the sequence, following this, but preceding that. Adding to this, the effects of repetition and invention, copying and innovation, but with the added feature of drift, or involuntary change built in, we have a powerful explanatory frame. The history of Greek vase painting, the technological history of the development of the steam engine, the series of vaulted Gothic cathedrals, the

history of modern painting become describable through similar linear histories. From the side of the history of art the terms "sequence," "copy," "invention," and "drift" make possible an alignment between the everyday production and reproduction of objects and the making of art.

The sequence or series that history commonly presents us with is not open-ended. Its real function is to describe with apparent precision the pre-history of a given end point. It is the vault system of the classic 13th-century cathedrals that controls the earlier episodes in which we are interested because they can be shown to have led up to this point. It is the mechanized cotton industry that is our explanatory goal that governs our attention to this or that earlier invention.[6] The perspective of the end point seems to redescribe the past as an ever nearer approximation of a given final state. Such an end-directed and partisan history is clear in the art criticism of the 1960s that rewrote or sorted out the work of the previous century in order to give weighted value to the literal, self-conscious, flat, abstract, and intellectualized work of the painters of the moment.

The very plausibility of such series always depends on the relatively short time spans that they make intelligible. By this I mean that our way of doing history by means of tight, end-directed series seems to be able to give us believable pictures of forty- or eighty-year time spans, like the time span from Impressionism to Cézanne to Cubism or the time span of railway history. Such series give us little hold on the longer durations of cultural life—what happened in painting between Giotto and Courbet, the history of chemistry from Newton's alchemical work to nuclear physics, or the history of communication at a distance between the letter and the telephone. Here only the particulation and swamping of series can let us begin to deal with the less teleological and less direct and rational relations over time. The series is an immensely satisfying short-term rational structure. The concepts of drift, particulation, and the swamping of series are essential if we are to control our temptation to believe that these short-term rational and purposive histories can simply be magnified to describe longer and more important cultural or historical episodes.

A second feature of the language of sequences is the chance to side-step the ever more troubling idea of the masterpiece. One alternative to a cultural history of timeless masterpieces (as the 19th century understood them) was a culture of what came to be called, by analogy to the technological world, breakthroughs. The breakthrough is a forward looking object that initiates a series of imita-

tions or replications. Kubler in his map of sequences notices what he calls Prime Objects that found a series. It is these Prime Objects that are replicated and copied. Technologically, the Prime Object is an invention like a new system of glazes, a new solution to the problem of vertical stability, or a new material like steel that makes possible (along with the elevator and inner-city electrical supplies) a new sequence such as the skyscraper in architecture. The patent system is designed to protect certain Prime Objects from all copying or adaptation that does not acknowledge the inventor. Although art has no patent system, the late paintings of Monet are frequently cited as the Prime Objects for the Abstract Expressionist painting of New York in the 1950s.

## Drift

The notion of drift stresses the unintended changes that occur over time. It is opposite in many ways to our ordinary construction of sequences in which it is the rational core, unfolding over time towards a solution or a final stability that fixes our attention. By building in the accidental, the genius of mistakes, the force of accumulated random changes, the idea of drift is closely linked to the unanticipated appropriations—the relocations and novel uses—that make up the long history of finished objects—that is, drift is closely related to the unintended later history of resocialization, the history of objects in museums.

"Use" and "series" are cultural terms that imply control, deliberation, intention. Drift lets in the opposite: the residue that just happened to be there alongside the use built into an object. Drift calls attention to change that was neither linear nor consecutive. At the other extreme drift is also opposed to sudden radical breaks within a sequence which we think of as mutations. Together drift and mutation are accidents of reproduction. They represent copying gone astray. Remaining as they do within the realm of copying, they are opposed to that other form of change that we call invention.

Kubler's use of the term "drift" derives from an analogy to language where the rate of change seems constant in such things as vowel shift and phoneme alteration. Within spoken language speakers and listeners form a sequence over time. For a speaker to be understood he must make a sound that a listener will recognize. For example, if the word is "plate" then it might be the case that the range of sounds around "plate" or near enough to "plate" that

would still carry the meaning might include "plate," "pflate," "Pleight," and dozens of other variations. This cluster of possibilities would each work. None would lead to a statement like "I don't understand what you want," when someone said "Bring me a plate." Nor would mistakes occur such that the person brought me a date or a plow. The range of sounds at any one moment of speaking history and in any one location would exhibit a small range as speakers attempted to copy one another in saying this common term. If the range included "plate" and "pflate" and "pleight" it would probably not include such sounds as "fight" and "plow" and "night." This means that the first set of sounds would all produce the effect that a plate was brought, whereas the second set would not.

The idea of drift suggests that at a later period the range might center on "pflate" and make such sounds as "flate" or even "fate" part of the new range within which understanding takes place; that is, all the sounds that lead to the object being quickly brought. Over many generations of drift, a movement of the range and the center can have occurred that is so great that none of the earlier sounds would any longer lead to a hearer bringing what we know as a plate.

Clearly many of the things that we study historically do make up sequences of this kind to which the idea of drift can be applied alongside the more intentional idea of invention. Greek vase painting, the vault system of cathedrals, the institutions of representative government, the interpretation of a Biblical narrative, or a form like the sonnet: each can be studied as a history undergoing progressive drift. Milton's use of the sonnet form involved a drift from Elizabethan practice that, once taken as a new center, makes logical the later drift involved in Wordsworth's practice which in its turn, as a center, makes possible the new range that included what Rossetti, Hopkins, and then e e cummings did, even though each of these might have been less acceptable without the new range made possible by each drift.

The spoken language involves a tight control over drift that we do not find in the object world. Speaker and listener must be close enough so that what the speaker utters is not heard as noise or nonsense. The instantaneous act of hearing and understanding does not give much room for a wide, active range at any one moment. However, since the language sequence endures so long, the drift, even of small intervals and increments, can in the end be massive. In historical time the almost three thousand years between Homeric Greek and the modern spoken language is not a very long

one. But center and range have been so many times displaced that the two languages have drifted far apart in spite of the stabilizing effect of a written literature.

It is not only the sounds of language that undergo this drift. The meanings or uses, even what in logic is called the extension of a work is similarly undergoing drift. Such a word as "town" or "animal" or "food" undergoes continual drift both in the center of meaning that we picture for the term and in the more marginal or ambiguous cases that we picture as lying just at the edge of its meaning. It is in this way that drift becomes an important concept for all of those acts that make up interpretation. With any one small sideways step we still seem to be in the same place. Clearly, after a while, although we still feel ourselves to be, each time after taking such a small step, in the same place, the sum of many such displacements is that anyone absent from the process would feel that we were in a different place entirely.

The notion of drift describes what takes place within interpretation in that, as we look back at a text like *Hamlet* or the *Iliad* or the Book of Job the range of things that the text might reasonably be said to mean drifts over time, each new sideways step making possible a new penumbra of things that now seem reasonable while leaving behind a part of the previous range as no longer plausible assertions. It is just such drift of conceptual meaning over time that is the subject of Saul Kripke's *Naming and Necessity*. He wants to consider the ways in which we hollow out the reference or meaning of a name or a term, the name Moses or the common nouns gold or water, for example, until we reach a point where so many of what we had once taken to be the minimal characteristics of the name or term have been removed that we would be willing to say, "Well, what you are talking about now is not Moses at all!" By posing a series of hypothetical questions in the form, "What if we learned that . . . ?" Kripke can replicate hypothetically the actual drift that takes place in the use or understanding of names or terms over long durations of time and as a result of successive and various historical pressures.

The realm in which this drift of meaning and extension is carefully recorded is in the common law, which becomes, as a result of its careful record keeping, the fundamental realm of evidence for questions of interpretation. The law itself is continually restabilizing the elementary words of social existence: property, murder, loss, equity, responsibility. Entirely new ranges of things come into existence that force a drift of meaning onto a term such as property. Is computer software property? Can new life forms produced

by DNA research be considered property? At the other side, things earlier considered property—slaves, for example—cease to be part of the range of the term. The adjustment, expansion, limitation, and control of the drift of such fundamental terms make up one of the central public functions of the law and legal interpretation.

The assumption behind these many uses of the idea of drift is that we can clearly identify sequences. There is a sequence of the sounds that over eight centuries are used to ask for what we now call a plate. This sequence will continue to drift into the future. There is a sequence of works of art recognized as sonnets, and there is a sequence of uses for the legal term "homicide" that usually, but not always, excludes killings done to enemy soldiers during wartime; that sometimes but not always excludes abortions, executions done by the state, medically performed mercy killings, and many other acts. The exact history of the drift of the term "homicide" would show that each new expansion or contraction opens up new adjacent possibilities that now have to be considered, and as those possibilities are decided the process of drift continues.

Many examples that we could give within either law or language would show that any new fact or any novel state of affairs is dealt with by a conservative attempt to describe it as part of a sequence that already exists. We prefer drift to the simple alternative of opening up a new category realm. This is evident when we think of the names that are given to entirely new objects. The name "space ship" assigns the new, unprecedented thing to the sequence of ships, thus making an analogy between the sea and the air by implying that we leave the land to cast off into the air just as we have for centuries left the land to cast off into the sea which surrounds the land in the horizontal dimension as the air does in the vertical. The new word "airport" in the 20th century locks in place the same sequence since it creates the name for the new, unprecedented thing out of a variation of "seaport" or simply "port." The word "port" itself shows that the sequence extends back in history to the oldest form of transportation of goods "portage" or carrying them on the back or head. Goods that can be so moved are "portable." The goods are changed from animal portage to ship at the "port." The sequence of portable, portage, porter, port, seaport, and airport shows the kind of sequenced historical network into which the new object is locked in place so as to provide a provisional understanding of it and a control over its novelty. The price of controlling the strangeness of new situations is the destabilization of the sequence into which it is inserted. Because the new object forces us to review the earlier terms and assign them a new

arrangement which can now include this further expansion. We produce a drift not only of the sequence but within the feel and meaning of each of the earlier terms that had a quite different internal order before the term "airport" arrived.

Frequently, the only way to build an entirely novel object into such a sequence is to assign it a name that has only negative content. The radio was first called the "wireless." A common term for the car, at first, was the "horseless carriage." The word "wireless" tells us that the radio is to be understood as part of the sequence of wired transportation of sound—telegraph, telephone—but now with the wires taken away. A word like "television" on the other hand sequences or domesticates a new technological fact by pretending that it lies within the perfectly familiar range of the sequence that begins with the telescope and proceeds through telegraph and telephone to reach television. Often what is named as though it were a new addition to a sequence—the Radio-Telescope, for example—seems to be a minor variation of the telescope just as the reflector and refractor telescopes had been earlier, while, in fact, it is so radical a departure that the sequence making habit is a betrayal of the facts. The new object does not actually lie within the range of possible drift for the sequence that we seem determined to visualize it as a part of. When the new railroads were referred to as the "iron horse" it did not mean that this was just one more variety of horse.

In sequence making we domesticate novelty. The choice to see the new fact, at least provisionally, as no more than a variant of development of a familiar range of facts with only certain differences is a profoundly conservative habit. It is in the act of naming or categorizing novel states of affairs that we can see that the ideas of sequence and drift are not merely historical or intellectually convenient categories. The drive to sequence the past, which we feel as historians, exists above all because this is the essential way in which society deals with that margin of the future as it becomes the novel component within the present.

The term "wireless" was short-lived. Once the object had imbedded itself within culture, the term "radio" came into common use. Now, the object was locked into the sequence that follows from "radiation" and "X Rays," a sequence that would later add radar onto the by then familiar radio. At first, in the act of transition, the merely negative word "wireless" with its link back to the telephone, where the voice went over wires, and from there back to the telegraph, in which the rhythmic interruption of the flow of

current that made up Morse code, passed along the wires, was the best way to position the object, even though all that remained of the sequence was its denial: wire-less. The term "horseless carriage" reassures a society that would like to see only improvement within existing categories and not radical departure from them. What seems at first only a small variation of the horse-drawn carriage, the subtraction of the horse, conceals the fact that in the long run the very category of the carriage was in the process of being abolished by what we would come to call the "car," the "truck" and the "bus."

If the ideas of sequence and drift are to be of use, it has to be possible to identify, as we look at the objects of the past, the sequences into which objects fall in spite of or in addition to those that the history of our language and name choices make clear. Sometimes this is obvious because the sequences appear as the solutions to a constant problem. The historical sequence of bridges would be one such unmistakable sequence, since the problem of crossing over water or over gorges gives rise to a fixed set of boundary conditions.[7] Later solutions occur as new materials such as steel cable make possible new designs, wider and longer spans, greater longevity, etc. The underlying problem remains constant. That is, it does not migrate or drift along with the solutions. In the larger matter of transportation, for example, the problems themselves drift. They recombine in ways that make it very difficult to decide whether or not, in the 19th century, the railway system is an extension of the canal system and the canal system of the highway system. Are the modern diesel trucks just the railway cars of seventy years ago, but now each with its own engine and without the requirement of special tracks? Should we see sequence, evolution, drift or break, revolution, and discontinuity?

The most radical inventions do not do the same thing in a slightly different way. Instead they bring into play an entirely new set of possibilities. Perhaps it should be said that at first they may seem to do no more than to do the same thing in a different way. The cotton gin made possible the cultivation of a hitherto unusable green-seed cotton and thus brought land into cotton cultivation that would have been impossible earlier.[8] Thus it solves a problem that only its own existence brings into being. The radio does not in fact belong to or continue any real sequence, any more than the telephone is just a speeding up of the letter or written message.[9] The 19th century chose to see the camera and the photograph as part of a sequence that followed from painting and drawing. The very name

"photography" means drawing with light. In fact there is no se-
quence that links the skills of drawing with a pencil, with crayons,
with pastels, to this new drawing with light.

Whatever the conservative preference within culture for se-
quences and for drift, there are inventions that can only for a short
time be disguised as no more than improvements of existing struc-
tures or objects. Drift occurs along a fixed problem. The cup or
glass container to provide a single person with the amount of liquid
needed for a drink is a fixed and inevitable human problem that
does not drift. The historical objects grouped in a sequence around
this problem, including the skills with clay, metal, wood, glass, and
plastic together make up a sequence of solutions and refinements.
However, the radio, the automobile, the photograph, the small
electrical motor are so oblique to the sequences that they appear to
continue that the new terrain that the invention makes for the first
time available or imaginable so outweighs the thin link to a se-
quence that the transformation of the problem is more fundamen-
tal than the solution to what might be identified as the instigating
event or need. Although we imply by the word "computer" that
this object continues from the adding machine and the abacus, in
fact the object initiates a new domain where none existed earlier.

In Kubler's *The Shape of Time* the history of objects that we
call art lies in between the sequences of tools with their slow trans-
formations and long temporal durations (the history of the ham-
mer, for example), on the one side, and on the other, the history
of fashions with their rapid transformations, abrupt discontinuities,
and short life spans. Kubler has focused too narrowly on the rate
of change. The real question is whether art objects are subject to
drift and to the controls of range that sounds in language, word
meanings and extensions, legal concepts, or tools are typical of;
that is, the problem-centered sequences such as those of bridges or
drinking vessels. Or, on the other hand, are they among the inven-
tions that transform the problem, redesigning the domain of action
as much as solving any problem.

## Designing a Place Within Sequences

Since the fate of every work of art is to come to be seen as part of
one sequence or another, the artist has an interest in controlling in
advance the direction of future understanding by proposing within
the work itself what we might call a set of instructions for how to
sequence it. Since the term "sequence" itself depends on our feel-

ing that a significantly large number of works or objects can be grouped in a certain way, what actual requirements does the sequence propose when we come to look at any one work of art? In Hans Georg Gadamer's *Truth and Method,* the work of art is seen historically in so far as it can be seen as the answer to a question.[10] To interpret it is to be able to phrase with as much complexity as possible the question to which this work might be seen as an answer. Gadamer's theory is the most significant philosophical treatment of art and interpretation in recent years. It is, therefore, indirectly an aesthetics of the avant-garde, and concerned with what is novel or an "advance" in each work rather than how a work carries out the expectations of certain classic models in an attempt to match the greatest works of the past.

What is historical about Gadamer's idea of the question and answer is that at any given moment only certain questions could be called pressing ones. These questions make up the horizon of the work. For any later interpreter or viewer of the work there is a quite different horizon of open questions. The engaging of these two horizons will naturally change over time as later generations bring quite different contemporary horizons to the work. None the less, it is by means of what is, so to speak, undecidable or open that we can even begin to think about what was in question in the past. This is radically different from what we might call the historical notion built into our traditional concept of the Classic. In that case a work from the past was said to be of interest to us in so far as it was a classic. Each classic work continued to appeal over time exactly in so far as it contained permanent truths or psychological matters that were independent of the moment it was produced. As the temporally local moment passed away, only those features would remain active that appealed to some unchanging human nature. To read or to look at that work in the present was also to let one's own contemporary world fade away so as to put oneself in touch with one's own deeper (that is, ahistorical) nature. Just where the idea of the classic makes the historical fall away and makes the local horizon an impediment to our contact with what endures longest and through the greatest variety of changing circumstances, Gadamer's question and answer model places those very features at the center of what the work is and how we come to intersect with it. We see by means of and not in spite of our own horizon.

In Gadamer's question and answer we can see a transposed version of what in the history of technology is called the problem and the solution. Every new object such as the arch, the elevator, the suspension bridge, has to be seen within technological history as

the solution to an obvious and definable problem. In technology what we mean by a solution is that an invention becomes the model for the overcoming of similar problems wherever they occur. The flying buttress and the arch are called solutions because their widespread use identifies an ongoing problem within construction. For technology the very meaning of the term "problem" lies in the fact that we run into the same difficulty again and again. With every wide river we run into the problem of how to support the span when it is carrying a heavy load of traffic. That is what the word "problem" means. Within art, on the other hand, there seem to be many questions or problems that only come up once. The puzzle about using the word "answer" or "solution" within art is just why, once these answers are found, they are not widely imitated. In fact, the whole problem shifts abruptly to some other set of concerns. Were the questions only interesting because they were unanswered questions? Our lack of interest in solutions within art even a short time after their discovery suggests that there was never anything that could really be called a problem. Cézanne's technique of building up form out of side by side strokes of paint is usually described as a solution or answer to the problem of regaining solidity for objects.[11] The loss of weight or substantiality was, in this description, a problem posed by the light-centered Impressionist paintings. If Cézanne's methods can be called a solution, why does its use disappear almost at once? Why did only he take it to be a problem? Why does a viewer of Monet's work today not find himself left with a certain hunger for solidity and with the question of just how solidity might be regained after the weightless pleasures of such painting?

What Gadamer proposed was that by means of the search for historical questions cultural history could merge itself into the one remaining progressive history, that of technology, that has survived as a Whig history into the 20th century. The clear linear meaning of progress within technology—longer bridges, faster transportation, better solutions to longstanding problems—is taken over as a vocabulary for a linear history of art. The work of Clement Greenberg or the recent book of Michael Baxandall, *Patterns of Intention*, display the question and answer method of technological history fully. In Greenberg's case there is also the technological historian's bias towards the present. The only history that can be described by Greenberg's technique is the pre-history of contemporary art, a history that is also a defense, even a form of propaganda for that art.

Gadamer's work led directly to what has been called Reception

Aesthetics which, in the work of Jauss stressed the concept of the horizon within which the work first appeared.[12] The work is taken to be not so much an answer to the questions within that horizon, as a breakthrough or provocation in the face of an ordinary, ongoing way of doing things. Such a horizon would be made up of what in craft terms would be described as the customary manner of proceeding. This would include the everyday materials, the ways of working with them, the values, forms, and ideological choices that the new work must break with. A work that simply satisfies the requirements of the horizon is commonplace or kitsch. The center of interest for any genuine and inventive work lies in the friction it creates with that horizon. The history of books that have been banned or prosecuted, Baudelaire's *Les Fleurs du mal* or Joyce's *Ulysses*, Machiavelli's *The Prince* or Galileo's Dialogues would naturally provide the most concrete evidence of works that have violated an horizon. Jauss's concept of a provocation against the horizon is closely wedded to the history of late 19th- and early 20th-century censorship, artistic shock, and the almost comic inefficiency of the European middle classes in policing the borders of its concept of respectability and normality. For Jauss, art is subversive or avant-garde in its inner-most nature and to interpret its power we have to look at just where it was felt to hurt or damage the coherence of the world in which it was produced.

Of course, in the absence of a society that engaged in legal or other forms of alarm whenever its norms were violated, we have to create retroactively a supposed horizon against which Shakespeare or Defoe worked. We lack, for most works of art any autobiographical data that would be evidence for the artist's own sense of the everyday or normative expectations against which the work of art was set up as a provocation. That is the reason that reception aesthetics finds it easiest to work from the opposite side—that of the society or horizon that, feeling itself challenged or even injured, denounced or struggled against the work. But normally we find ourselves with no explicit evidence from either the artist or from the horizon. What we in fact do in such analysis is to juxtapose the work of art with a set of typical or popular works of the moment as though these were its targets and made up the artist's horizon. The further back into the past that we go the less we are likely to know even this.

Paradoxically, since both Gadamer and Jauss have created a historical method that seems to be about our ways of dealing with precisely the pastness of works of art, it is with works of the interpreter's own present that either the questions and answers or the

horizon and provocation can be spelled out most easily. What seems
to be an opening into sophisticated history is in fact a history of
the present, the one moment in which there is little or no gap
between the horizon of the artist and the horizon of the viewer
other than the kind of gap that can be closed by information which,
of course, the critic and not any type of historian is needed to
supply.

## Series and Interposition

If we think only of the history of painting and of the gallery wall
which states the historical facts of before and after, norm and
breakthrough, we miss the actual psychological situation in which
all later viewers really find themselves. For this the architecture of
a city is a better model to keep in mind than the wall of a museum
along which we walk to encounter one painting at a time and one
painting after another. In architecture the series of buildings built
one after another, each responding to the surrounding visual world
as the architect found it at that moment, also exists as a spatial
array visible in one glance. When we look at any architectural ar-
ray we no longer know what was built first or what the look of the
place was at the time that any one building was built. In so far as
every building is a response to its setting, the very act of continu-
ous building keeps on erasing that setting and updating it so that
the very conditions that made any one building make sense at the
time can no longer be identified later in its long lifetime.

The skyline where we can see this array, is an invention of the
twentieth century. The tall building and therefore ultimately the
elevator made possible the visual space of the modern city. In this
composite space no one architect is responsible for what we see.
Time is jumbled and disordered. No one building has a visual site
that separates it so as to allow it to be seen against a site or ground,
as we always imagine a building to be seen. In the skyline of a city
no building has a front or a back. The façade no longer exists, each
building has its wrap-around surface some part or angle of which
we see from this or that view-point. Since buildings no longer have
a front they also do not have a defined approach.

If we imagine an English country house set in its grounds, de-
fined by an approach that aligns the viewer to a specific first sight
of it set in its landscape, and with its front or façade composed as
a rich text of symbolic details, we can see that this country house
is still in some residual way our norm for a work of architecture.

It makes the building similar to an easel painting in its frame. The frame of a building is its site. The most famous of these frames is the wooded setting with waterfall over which Frank Lloyd Wright built his Falling Water House for the Kaufman family. In its site, we imagine, only one building is in view. It stands alone in the world with the world assembled around it. The place of the spectator, including the place where she or he is to stand, is spelled out by the work itself, by what we call its approach.

With the skyline or the ordinary experience of a city street none of the familiar features of the aesthetic experience of an isolated English country house in its setting any longer exists. The building can never be seen as a whole. From every point of view we see only scraps of buildings that block out parts of each other. The background changes over time as ever new buildings are added. The architect under these conditions can only design parts of experiences and he creates a work that will participate in scenes that as yet do not exist. The buildings on either side of it may be replaced ten or forty years later by unimaginable buildings, both in scale and materials. No standing point exists from which to see just this one building because the crowded street often does not permit enough room to move back to look and see the object from top to bottom.

These problems of space and standpoint are dwarfed by the aesthetic implications of time and history as it alters the object of any possible experience of it. If one extraordinary building is built that differs in height, shape, complexity, material, and color from all other buildings around it, it will stand out as unique for only a short time. If it is twice as tall as all others, in only a few years buildings will be interposed halfway between it and the rest, then halfway between the two new intervals and so on until the gap has been filled in. Naturally, rival firms will build taller buildings and quickly it will be the second, third, or tenth tallest building in the skyline. Within a few years the architect's bold gesture will have been domesticated and his building will find itself in the middle of a certain range of sizes. No one will any longer be able to experience what was intended: the single spire towering above all else, standing apart in uniqueness, the landmark by which people point out location in the city.

This fact which is so obvious where size is concerned is equally true of any other feature that at first catches the eye by its striking difference from the background or norm of the streets where it occurs. A building that is strikingly white in the midst of dark green or black skyscrapers will quickly find that other buildings

interpose themselves along the range of contrast. Other white buildings will be built once the first has become famous. If white becomes eye-catching, other buildings willing to be secondary but also noticed will be built in white so that the eye after noticing the first will pass them them as something in the visual field that, at least, continues the whiteness. The uniqueness will have been destroyed. Other architects, noticing that brightness works in this environment, will ride on the success to insert other brightly colored buildings that, even if not white, will build on the theme that the white building introduced and so, from this other angle, interpose themselves between it and what was once a relatively somber, dark, and solemn environment. If the building has a rounded or trapezoidal shape in a skyline of rectangular boxes, other interesting shapes will quickly appear nearby thus destroying the uniqueness of this pioneer shape.

Over time the aesthetic meaning of the building will have been altered. In the beginning it was designed to be a bold contrast to a certain look the city had in 1958. But as other buildings fill in every available dimension of contrast with intermediate, opportunistic buildings, it will be normalized and occur along a scale of small differences in every possible direction and visual category. As part of this building process, many of the older buildings against which it was first set will have been destroyed, removed from sight.

What began as a break or breakthrough becomes a series with every possible niche filled in. The building that began with the individualistic gesture of standing out bravely against a background that it disdained or rose in superiority above, becomes because of its very success, an ordinary member of a crowd in which no one can any longer say which building was built first, or tenth, or last. A building often comes to be taken as the poor step-child of its own grandchildren.

The series re-normalizes the environment. The technique by which it does so is a reiterated, strategic interposition that over time fills in every gap between short and tall, black and white, simple and complex form. Interposition converts every enduring object into an ordinary one because imitation and variation erode the uniqueness of the object.

Every type of work that has at first this boldness and distance can protect that uniqueness for only a short period of time. The striking paintings of Mondrian or Pollock or Monet quickly find themselves surrounded by objects that occupy the intermediate positions between their methods and the norm from which they at first seemed so distant. Usually this is described as though it were

a feature of commercial culture in which imitation, commercial exploitation, and replication convert art into kitsch, the unique into the tediously familiar. In fact the basic process of the series is only speeded up by a commercial or capitalist culture. The process itself is one of the most fundamental facts about aesthetic experience itself.

Mondrian's style will quickly turn up in advertisements or as wrapping paper for gifts. If it is striking enough, it will become a craze and turn up everywhere for a short time. Theater sets, the covers of magazines, and the painted sides of buildings will all produce variations that live off the quantity of energy built into the Mondrian style, but at the same time they will produce a boredom with it, a feeling that it is everywhere and commonplace. Too often repeated, the pleasure will be exhausted. The over-socialization will in the end make us find Mondrian himself boring, sunk among the world of interpositions he himself generated. When we finally get to him we will have seen it all before, because although in his own time Mondrian was the first thing like this that any viewer had seen, for all later viewers he himself is likely to be the tenth or ten thousandth variation of the Mondrian style that any new viewer born fifty years later has encountered. Paradoxically, it is just because it was at first so stimulating and fresh that a style will undergo this interposition and variation that will result in its exhaustion as a sensation.

It is not the commercial or parasite culture that instigates this clustering and overcrowding that strips uniqueness by surrounding it with near twins. As the architectural example showed, it is one inevitable consequence of the work of all later artists to produce the destruction of the visual world against which the original artist first imagined his work seen. All later work undermines and erodes the very visual space—the horizon—within which the work imagined itself existing.

Once Monet had invented a canvas covered with short, mechanically similar brushstrokes that sit side by side, he found himself quickly surrounded by Pissarro, van Gogh, and Cézanne, whose practices made his invention part of a cluster. The small dots of Seurat are only one final act normalizing what was thirty years earlier a strange and striking practice. An American viewer of the 1970s might have seen the mystical tiny strokes of the paintings of Mark Tobey before ever seeing a Monet. Even in the painter's own lifetime the principle he invented disappears within a visual environment composed of tiny variations of itself.

Monet's invention, in the next stage, stands opposed to and

contrasted in the viewer's imagine with the flat simple planes of color of Matisse and others who reacted against the nervous, finicky strokes. Once this has occurred it no longer matters who was first or what gap there was between how Monet painted and how his predecessors, Corot or Courbet, did. Now he finds himself within a scale of completely occupied niches. Painting itself then goes on with Matisse and Picasso to interests in line, drawing and to large flat patches of color that distance themselves from the fussy, short visible strokes that had become a crowded field of representation.

Later we might, as scholars, ask who was really first and what horizon existed against which this academically established pioneer worked. But in actual experience, a young viewer of paintings a century later is more likely first to have seen and come to love van Gogh or Cézanne and only later in his or her personal history to have arrived at Monet. Each viewer's personal cluster starts from its own accidental history once all the work is known and selectively available. Many Americans are likely to have reached Japanese composition by way of Degas and not the other way around.

Within a series, the ideas of breakthrough and interposition are complementary. The space opened up by any novelty that is noticed will only lead to the rapid undermining of that novelty by interposition. The very idea of the gap or strangeness of a unique style is a short-lived phenomenon. Uniqueness is a transitional phase of a system whose basic drive is towards re-normalization of differences and the rapid exhaustion through repetition of any stimulating difference.

This fully filled-in series makes possible what we call beauty and it is the fate of everything that we start out thinking strange, powerful, new, and even violent to become, in this sense, at last, beauty. A re-normalization occurs around every novel object. Within objects there is a decay of strangeness. What begins as violence eases into power and comes to rest as beauty. Serenity is the outcome of a growing familiarity brought about not just by time and repeated experience of the single object itself. We find ourselves at last comfortable with Picasso's *Les Demoiselles d'Avignon* and with the paintings of Jackson Pollock just as we did earlier with Rembrandt's painting of a side of beef or with his stark unflattering portraits so different at first from the official portraits they distinguished themselves from.

The decay of strangeness occurs through the interposition that factors and subdivides the unfamiliar into small enough doses. Few paintings have ever seemed as violent, sadistic, and misogynous as Willem de Kooning's series of paintings of Women in the 1950s.

Thirty years later de Kooning was spoken of as though he were too pretty a colorist, too voluptuous a descendant of Fragonard and the French 18th century. Usually it was implied that the painter had gone soft, but in fact the change was equally drawn from the retroactive calming into beauty that is part of the effective work of the series in art.

Our ordinary description of a series of works or of that larger series that we find in a museum or in a textbook of art history brings out the intellectual effect of the series. It creates intelligibility. The works explain one another. An equally important fact is the aesthetic consequence that results from the fact that no building can be the last building. No artist has the last word. Every later word or work will factor out the differences and use up the strangeness of the work, domesticate it, and, in the end, civilize it into beauty.

Taken together the terms "sequence," "drift," "copy," and "invention" provide the tools for arranging individual works of art in a series. Naturally, they also provide the blueprint for the artist who designs his works within a culture where these tools will assign or deny value to the works that he or she produces. In the following chapter a single work by Frank Stella will be taken as an example of the strategy of the series as it has come to dominate the production of art in a museum culture. The strategy of insertion within a sequence is complementary to the strategy of effacement that was the subject of the previous chapter. Jasper Johns and Frank Stella have been used as examples because they are representative of both the sophistication and the energy of contemporary American painting, and because American painting itself has never known any other conditions than those of a society of museums and factories. Where other traditions were transformed by or set themselves to resist these two cultural facts, American art came into existence within the sheltering conditions of modernity and came to reflect those conditions with unusual candor, pleasure, and greatness.

chapter 5

# Frank Stella and the Strategy of the Series

Frank Stella has so often worked in sets or clusters of works, that to describe his career, we are invited by the artist to attend to the master sequence in which the individual series have followed one another. As of 1988 the master sequence runs from the series of *Black Paintings* of the late 1950s through the shaped canvases of the next decade, to the explosive constructions of the 1970s and 1980s, reaching in 1988 a series of extraordinary works based on Melville's novel *Moby Dick*. As if following a step by step logic, Stella began with artistic zero, from near-empty, flat, black rectangular canvases, works so austere that they seem to aspire to be a part, not of a temple of art but of some 20th-century monasticism of art where silence has been added as a fourth vow to poverty, chastity, and obedience. Thirty years later he has gone on to produce constructions that lie halfway between paintings and sculptures, constructions that feature writhing snake or wave-like shapes, bold sculptural organizations of those shapes, color so popular and circus-like as to seduce the viewer almost into a sphere of fun rather than beauty, and an illustrative, realistic content of whales, harpoons, boats, crashing waves, and sea-chases. Starting from a set of gestures that, we might say, turned off the lights within the theatrical stage where the personalities and energies of such abstract expressionist painters as de Kooning and Pollock had stormed

and raged, Stella with his *Black Paintings* declared a night of rest for painting, but only, as it turned out, to dramatize the unfolding of his own sunrise. The *Black Paintings* set out, and here I am using the language of historical sequence, to close the door on Abstract Expressionism in American art, and to answer the one permanent question within history: What next? These works stand in Stella's career as pure and complete gestures of beginning, just as the paintings of the American flag do for Jasper Johns. Both painters began with a negation of the whole realm of personal experience as a content for painting. Thirty years later both had abandoned abstraction or the replication that had in Johns's case served the same purpose of abstraction.

For Johns the representational content within the works had become mysteriously personal, almost Proustian. At the same time, in painting as he did in 1987 the four large works on the classic theme of the Four Seasons, taken as the four stages of a life, Johns had bound his work to certain norms defined by the classics of our culture. In the same year, Stella began to create a series of paintings based on the central classic of American energy, *Moby Dick*. The titles of his individual painting-constructions matched the titles of the chapters of Melville's novel. The Baroque energy of Caravaggio's work, about which Stella has written as a spatial model for the type of energy that he would like to see build into the modern work of art, has its best American instance in Melville's chaotic and turbulent novel.

What ties Stella to the museum categories of the future's past is not that his career, now only at its mid-point, has made these dramatic changes, but that it has done so by means of a process of development or drift that can be traced in its smallest variation, a process for which the works themselves appear to exist as a carefully arranged documentation. In a career of high-speed, always intriguing fresh starts, Stella has produced some of the most thrilling spatial inventions in the history of modern art. His work sets out to dazzle and to seize the moment. The push to make it new and race on to the next possibility drives his work at times into a frenzy of energy, a garish circus pace of ever changing razzle-dazzle, while at the same time there has hardly ever been a painter in the whole of American art whose work has had such clear intellectual cunning in the face of the intellectualized art world made up of criticism, the university teaching of art, the art market, and the destination of the museum.

In the form of series his works are ready to be swallowed whole by art history. The artist himself has provided a blueprint for fu-

ture museums that will devote rooms to the ordered forward march of his life's work. For the Museum of Modern Art retrospective of his work between 1970 and 1987, the catalogue lists the works by means of the following series: *Polish Village Series, Brazilian Series, Diderot Series, Exotic Bird Series, Indian Bird Series, Circuit Series, Shards Series, South African Mine Series, Malta Series, Playskool Series, Cones and Pillars Series, Wave Series.*[1]

Stella has, by means of his productivity, variety, and energy of invention created one of the most prominent careers of this generation in American art. In fact, so tidy is his creation of an "art career" or a patch of future art history that one question is whether he has not preferred to create an art career rather than art. The answer is, in my opinion, that Stella has, like Jasper Johns, produced some of the most important work ever done in American art, and he has done so, as Fra Angelico did in Florence, within the language of art that his own culture provided. That Fra Angelico painted his works on the walls of the monks' cells of a monastery, using the materials, subjects, and size that he did only tells us that art had a systematic reality within which his works occur. That Stella's work addresses and adjusts itself to the purposes of public entertainment and instruction on the scale of the walls of the Museum of Modern Art tells us no more than that those are the conditions of the profession of art in our time. They do not tell us that it is any more or less difficult to find the path to major work now than at any earlier time. These are the marks of worldly painting, that it knows and fulfills the open institutional locations of its own culture whether those are the monastery and church walls of Florence in the 14th century, the private homes for which Degas or Manet painted in 19th-century Paris, or the grand rooms of the Museum of Modern Art for which Stella and Johns design their work today.

## The Order Among Works

The very premise of Stella's career has been systematic advance or at least the feeling of an advance, of problems encountered and problems solved, of a rhythmic alternation between abrupt mutation and patient elaboration. His work radiates the feeling of challenging novelty along with what we might call rational step-by-step progression. It is within the work of a knowing, sophisticated, academically trained and articulate painter like Stella that the latent

force of sequence has arisen to become the guiding principle of a life's work in art.

Nothing could display more clearly an art driven by the strategy of sequence and invention than the existence of pairs of paintings so nearly alike as to be twins. That very likeness becomes the frame in which the few inventions or breakthroughs within the second of the two works can strike the viewer and become, so to speak, the direct subject of the work. Frank Stella's *Cones & Pillars II* of 1984 (Plate 6) and his *Diavolozoppo,* also of 1984 (Plate 7) pose this unique topic of twin paintings in an unmistakable way. The two works share so many details that they might best be seen as two works made from the same kit of parts, but with the later painting making us aware of just what the artist himself found disappointing about the earlier one. *Diavolozoppo* is more bold in color with an almost lipstick-color of pink replacing the sober aluminum kidney shape of *Cones & Pillars II*. The sunlight yellow scribble at the left balances and underlines the gaiety of this sensual stroke. A tiny cone replaces the drab little rectangle that juts off the right side of the earlier work, and the cylinder is now balanced by the equally complex and intriguing cone that becomes its antagonist. Once we look back at *Cones & Pillars II* from the point of view of *Diavolozoppo* we can see the first as a work made timid by a fear that these diverse pieces could not be held together without toning each of them down. The more bold second work lets each part sing out with a full, lyrically individual note, confident that the whole will still hang together. The drama has been increased and a lyrical ease has taken over that now makes us aware that Stella looked at the finished *Cones & Pillars II* and found it drab, hard-working, successful as an organization, but lacking in a certain joy. The five or six major changes stand out just because they exist against a background of so many common features that clearly continued to satisfy the painter. The changes take us into the mind of Stella as he took a critical look at his own, just completed work.

If the second painting could be described as adding some finishing touches or even corrections to the first, then why do we have the two works at all? To use a traditional vocabulary, isn't *Diavolozoppo* the successful masterpiece for which *Cones & Pillars II* is just one among many studies along the way, a preparatory sketch, a non-work abolished by the final work of art that finished the process? After all, the many early drafts of one of Keats's Odes are abolished as real poems once the final work has been written. We

cannot imagine printing the set of drafts as a "series of poems."
At one level this is just what Stella does in declaring both *Cones &
Pillars II* and *Diavolozoppo* to be distinct paintings in a series. Nor
is this a difference between poetry and painting. Leo Steinberg has
studied exhaustively the many stages of Picasso's work on *Les De-
moiselles d'Avignon*. Each of these preliminary works disappears,
confessing itself a non-work, once the finished masterpiece exists.[2]
We also have a remarkable set of photographs taken by Rudolph
Burckhardt of the various stages of de Kooning's *Woman I*.[3] The
single canvas was painted over, scraped down, repainted, filled in,
and once again painted over, hundreds of times. By making the
one physical canvas the arena of this long struggle, de Kooning
chose to deprive us of the "series" of stages of this work that in
Stella's case makes up the goal. By effacing and superseding, Pi-
casso or de Kooning signals that the object of his work in this case
is a masterpiece in the traditional sense, a single work that rele-
gates the process that led up to it to an inferior status, that of a
series of draft stages. On his side Stella is delivering an equally
clear signal. His product is not the distinct work but the series. To
look at a work requires us to have around it other instances from
the same series so that we can see the basic vocabulary out of which
each utterance has been made, but also so as to see in isolation the
few differences that add up to this painting's thought and its critical
response to the last. Painting happens out of dissatisfaction with
the last work. Like an industrial designer, Stella is always improv-
ing his model.

By working with series Stella turns over to his audience what
Jauss has called the horizon for each distinct work.[4] *Cones & Pil-
lars II* is the horizon for *Diavolozoppo*. The precise distance or
breakthrough can be measured. The fixed elements that recur from
work to work are obvious, as are the set of interests and questions
that Stella raised about those fixed elements. Two by two, the works
are also question and answer, problem and solution. The brightness
and pleasure of *Diavolozoppo* makes us feel the rather sweaty dil-
igence and lack of ease of *Cones & Pillars II*. The track of the series
as a whole, ranging over the dozen or two dozen works that Stella
has clustered together, puts us in contact with the painter's own
critical stance, his afterthoughts and newly opened possibilities as
he looked at any one finished work. The clues to this critical, self-
analytic phase of work we see directly in the work that follows.

In other words, Gadamer, Greenberg, and Jauss could hardly
have imagined that an instance like Stella would so quickly turn up

and present us with a career that so fully articulated the design for a history of art that their work had spelled out. Gadamer, Jauss, and Greenberg in combination have written the aesthetics for an art that has two key features. First, they have designed the aesthetics not for isolated works but for the history of art, for works that have submitted to historical ordering and arouse historical interest and historical problems of interpretation and understanding. Theirs is a profoundly historical aesthetics. Second, each of them has in separate ways responded to a century of successful modernism within the arts, a period of avant-garde strategies and victories. What Gadamer and Jauss do is to apply retrospectively an avant-garde meaning to all previous art. As a result, the profound current to this aesthetics is that it is at heart a way of winning the whole past of art over as a pre-history of the avant-garde with its struggle against its self-proclaimed enemy: bourgeois self-satisfaction. The restlessness of the first thirty years of Stella's career is almost a hysteria of progress, breakthroughs, and the search for fresh starts and new directions.

Stella is not at all a kind of ingenious master-builder executing the architectural plans that a generation of critics and philosophers of art had brought to a classic form. Both artist and critics have responded powerfully to the great pressures of a museum culture. If a work must in the end fit into the institutional logic of a museum, then its very production has to build in the hard facts of its institutional future. Since the museum is a linear history, the artist is enjoined to produce history, both in the development of his own career over the decades of his work, and in the side-by-side relation between any two of his works. No painter since the creation of the culture of museums has so candidly produced, not works of art, but patches of art history as Stella has since 1959, and at the same time, no painter has been able to wring excitement, pleasure, and even the sense of an acrobatic adventure out of what might seem an almost academic program. He has brought back a wildness, an energy that risks vulgarity and clowning, an appetite and a strangeness to American art that has its only precedents in the work of Pollock and de Kooning. How this calculating, almost scholarly production of sequences, inventions, questions and answers, horizon and break-through can co-exist with a primitive and gaudy energy lies at the heart of his work. As Jasper Johns is the genius of the museum strategy of effacing, Frank Stella is the master and, we might even say, ring-master of the museum strategy of the manufacture within and alongside the work of art of the location

in history for the work. Stella has learned how to make a work inevitable, that is, historically necessary to what any imaginable future will acknowledge as a distinct place within the past.

## Patches of History

Before turning to *Cones & Pillars II* which I will use to describe the strategy of sequence, it is important to see the local patch of history within which Stella finds himself. Like Johns's work Stella's begins (when we accept a historical vocabulary) with the triumph of American Abstract Expressionist painting in the aftermath of World War II. Since history works by negation, as well as by development, the flat and deliberately uneventful, even contentless paintings that followed the widely acclaimed works of de Kooning and Pollock of 1947–55, take effects as covered or painted-out objects. Jasper Johns's *Flag* of 1955 might, among other things, call to mind a flag that drapes a coffin. The *Black Paintings* that Stella produced late in the 1950s define a state of affairs in which we might imagine that a certain turbulence, some aggressive and complex, state of affairs, still went on existing within the canvas, but now deliberately obscured by the painter, just as the objects in a room continue existing once the lights have been turned off. Nothing of what exists in the room can be seen, but, of course, everything is still there.

Stella's early work shows the history of this covering up and then reopening of the material and even the energy of the Jackson Pollock period, and Frank Stella himself, as his career has unfolded, has more and more cast himself in the role of the successor to Pollock, and behind Pollock, to Whitman and Melville, in that history of American Culture where a kind of populism and energy define the American masterpiece.

At the start of his career Stella produced his series of *Black Paintings,* then a range of works with fussy and minimal straight-ruled lines. His minimal content along with his elegant posing of the question of the differences and overlap between sculpture and painting by means of the shape of the canvas: each of these stages closed down (to speak in the vocabulary of sequence and reaction) the energy and highly personal, almost psychoanalytically intimate force of the postwar period. Stella goes about this project the way an academician would. He operates by means of carefully premeditated, isolated acts each of which addresses, within a cleared arena,

a single detail of the nature of painting. One feature after another steps forward and is nudged slightly.

One of the typical early works is a canvas (Fig. 10) with a tri-angular wedge driven into one corner; by means of color the sur-face accommodates this intrusion that violates the ordinary rectan-gular shape. The triangle makes a slight, clever break with the ordinary expectation that we bring to it. This small break is a per-fect image for what Stella does. He is like a modern writer of son-nets or rhymed couplets. That is, he works within a convention-bound form; a lawful, rule-driven form. He breaks the rules, one at a time, but always by means of an ingenious exception that in some way saves the rule even in the act of breaking it. Each rule is broken, neatly, elegantly, but only so as, even more powerfully, to remind us of the rule, to accept the rule, to establish the force of the rule.

Here the rule is the rectangular canvas, broken into by the tri-angle in such a way as to "save" the canvas by means of a painted surface that allows us to enjoy this metrical irregularity. The break has been ingeniously accommodated. This is an example of his in-tellectual wit, his grace, but also of his conservative, even academic, form of pleasure. Stella, in effect, lets off steam for the process of painting as a whole in his generation. The pleasure of creating ex-ceptions to rules depends on a strong memory of the rule. Each exception is thus part of a sequential question and answer, or rather, each exception is an answer that stops the conversation dead. Philo-sophically, each of these works is a counter-example. It is as if, in the background, someone were to say, "An easel painting must be either in a rectangular or, occasionally, in an oval shape." Stella seems to say, in his slangy way, "Oh, yeah? Just watch this." And the canvas with an invading triangle at one corner is produced as his counter-example. Stella's work, like the black canvas at the be-ginning of his career, has favored terminations. As a painter he always elbows his way to the front to put in the last word.

The shaped canvases of the 1960s made up one phase of what has been the dominant question within Stella's work as a whole, the question of just how far a painting can go in the direction of sculpture while still taking effect as a painting. To put it another way, how far can the ethos of the still-life within painting with its freedom to assemble the contents of painting without any narrative or allegorical purpose be extended to take in the elements of art itself rather than apples, oranges, bottles, glasses, bowls, mandol-ins, sheets of music paper—the traditional objects that make up the

Fig. 10. Frank Stella, *Moultonboro 111* (1966). Fluorescent alkyd and epoxy paint on canvas. Collection of Carter Burden, New York. Copyright 1991 Frank Stella/ARS, New York.

representational content of the still-life. As the final chapters of this book will claim, the still-life is the hovering background genre for many of the most important episodes within modern art. It plays the part that landscape played in 19th-century painting, and it is the one form that imposes what we might call an industrialization of the picture space by carrying over the technological attitude towards objects and parts into the working practices of art. The ethos of the still-life, with its testimony to the dominance of the painter's hand and mind over his freely chosen, assorted materials, is the ethos that governs Stella's work. Where Cézanne produced the masterpieces of the still-life as a relation to nature, Stella, coming within the long tradition of constructed, semi-sculptural still-life that had begun with Picasso around 1910, produced the equally powerful masterpieces of a still-life relation to art itself. His are the masterpieces of assembly. In a climactic work like *The Spirit-Spout* of 1987 (Fig. 11), a work from the *Moby Dick* series, Stella has reached after the primitive power and grandeur of Melville's great work, but also after the astonishment and wonder of Caravaggio or Géricault's *Raft of the Medusa*. He not only reached in the direction of this scale, but he delivered the same level of intensity, drama, and wildness within his own work.

## Cones & Pillars II

One feature of the series is to isolate, just as the evidence of individual strokes or decisions do within the work, the exact breakthrough or invention that each work supposedly contains. The series, then, reinforces the stress on the single-minded time scheme of thought rather than the longer durations of labor and replication that can be seen as fundamental to traditional works of art. Frank Stella's *Cones & Pillars II* announces in its title with the numeral "II" that whatever other sequence this work might belong to, it is, as far as the artist is concerned, the second work of a series that deals with the three-dimensional shape of the cone and with the architectural object, a pillar. Since both cone and pillar are three-dimensional objects, Stella's painting or construction proposes itself to any knowing contemporary as very much a work of art that occurs within the horizon of what might be called, simply, the flatness question that Greenberg and others have proposed as the fundamental question, the Kantian question even, for painting of the last hundred years. According to this theory the core of the difference between painting and sculpture lies in the single flat plane of

Fig. 11. Frank Stella, *The Spirit-Spout*, 1987. Mixed media on etched magnesium and aluminum. Knoedler Gallery, New York. Copyright 1991 Frank Stella/ARS, New York.

the painting, a plane that is bounded by a four-sided edge and hung on a wall across from the viewer. These facts make up the horizon for our expectations about what might or might not be a painting in much the same way that the ability to go inside it defines a certain fundamental condition of architecture.

Stella's *Cones & Pillars II* could be called an answering painting. The questions that occur in its background are those discussed in the theory of art in the 1960s and 1970s. Typical questions among these would ask: What boundaries are there between painting and sculpture? What can be done in painting after the flat or overall canvases of recent years so as to recover aggressive energy for painting? What parts of the inventory of representational effects are still useable? What is the relation between "real" and Realism, between actually being, for example, a circle, and being a representation of a circle? Within the slightly longer sequences of 20th-century art, Stella's work directs itself towards cubist or constructivist works. If it has ancestors they are most likely the works of Picasso done in the 1910s in which Picasso mixed drawing and other indications of things with certain real things and at the same time constructed sculptural elements that lifted off the picture plane towards the viewer. Having abandoned the recessive space that realism had worked out behind the "window" of the surface of the canvas, 20th-century works have often been interested in leaping out at the viewer and colonizing the space just in front of the surface of the picture, the space between the picture surface and the viewer. Stella's work has this interest in lunging out towards the viewer rather than drawing him back through a window to a scene that illusionistically feels as though it occurs behind the picture surface. None the less, this outward thrust is equally an illusion, except where an object or part of the work is literally attached to or in front of the painted surface.

These are a few of the questions and problems to which the work might be said to be an answer. At the same time they spell out its horizon. One of the most intriguing features of our use of sequences in explanation is the fact that we end up always representing any one work as very late in its sequence, usually we claim that it arrives at just the point where so much has happened that a certain dead-end has been reached. The sequence always seems to be fatigued, even exhausted at just this point, then rejuvenated and renewed by the new direction that the work shows us. That new direction is always a way out of a sterile or stalled position. Joyce's *Ulysses* is said to occur just when the conventions of the novel are "used up." The atmosphere of such explanations is made up of a

feeling of lateness. We seem to be always arriving on a certain scene where all the possibilities have already been used up and worn out. Boredom seems to be just around the corner. We have seen it all before. This paradoxical lateness is one of the oddest components of avant-garde theory. It is the background to the very desperation of the struggle to make it new.

Before locating it within a sequence, it is important to describe the work in some detail. Stella's *Cones & Pillars II* (Plate 6) combines just this feeling of "the latest thing" and a background of lateness, even of assumed boredom with a series that has already overstayed its welcome. It seems designed to wake us up exactly because it is situated within a certain story that we might be thinking has been going on too long. The freshness of the work is telegraphed to us in its craftsmanship. Like the works of Klee and Picasso it occurs within the time scheme of thought and invention and not the temporality of work. There is, first of all, an artisanal roughness, even a crudity to many of the parts. The shapes look rapidly executed, especially the cut-out shapes like the aluminum ovoid. The workmanship disregards finish, except in those cases where mathematically exact shapes or curves are either present or represented. Stella wants us to make an opposition between the mathematical and a certain personal clumsiness.

The object as a whole feels something like a contraption. As a totality, its parts just barely cohere, and that is certainly one difference between a machine and a contraption. The parts seem always about to go their own way. On the other hand, we might say that they retain their individuality while participating in a short-term joint enterprise of a certain kind. The black and white pillar, the unpainted aluminum ovoid shape, both seem to make only the smallest or cleverest gestures at trying to live together socially, to notice the existence of the other parts. They seem held together here as one thing by the painter's will to make them work together no matter how great their internal differences. Diverse in materials, in scale, in integration, the object seems either miraculous or fragile.

One question that the work itself seems to put to the judgment of the viewer is: Can something like this take effect as a painting? At the same time the larger question stands behind it: Just how far can this occur as one object? We find ourselves facing this object. It does have a front, and defines for us a specific place from which to view it while denying the possibility that we might walk around it. But what we face is more like a dissection, an opening up of a painting to see what we call "the works." It has the feel of a sur-

gical operation: a short, dangerous time in which the body has been opened to reveal the messy guts and organs that usually make the surface work. To move away from the medical or creaturely example, which Stella's coolness does not encourage, we might say that we seem to present at the movement when a mechanism like a car or a Xerox machine has its outer cover removed so that a repairman can get into the works.

The painting has set itself at the farthest extreme from the finished, artisanal object of the past whose surface and layering protected the secrets of craft and work. The painting does this because it wants to take the lid off—as the little flap is lifted off the column—in order to talk about the secrets and representational techniques that make up the repertoire of art. How does a painter make an object appear to rise off the surface towards us as this pillar does? What can a system of lines do when they vary in thickness and in closeness to one another? What do color and paint do to the flat surface on which they lie? What are boundaries, edges, and shapes, especially when we see them break off?

To the ordinary viewer the painting does not represent anything. Even the pillar is rather an ideal object or a comic-book pillar than an illusionistic rendering of a pillar. But the less the painting says about reality, the more noisily and strenuously it quotes, refers to, alludes, chats, or makes jokes about two things. First, about itself, its material reality or literal reality and its presence in front of us. These have the form of an intended serious answer to the flippant and annoying question that the artist can in advance imagine his viewer saying: "What is going on here!" Second, the chatter of the painting is about its relation to the sequence, both personal and historical, in which it is inviting or instructing us to insert it.

Stella has put together something of a catalogue of painter's tricks and devices that adds up to a pedagogic demonstration of effects and techniques, an unfolding set of variations on its central elements. It is a lesson plan in the many languages of representation. At its core are two facts: a white circle and a square painted canvas. Both are partly literal and partly represented. The white circle we know symbolically because it is outlined with a black continuous line, but for at least 90 degrees of its perimeter it is a literal, cut shape as well, playing off, as we travel around its circumference, the literal fact against the cultural system that lets us know culturally that something like this is meant to be a circle. At the represented, but not real, left bottom corner of the square canvas the real curve becomes a merely represented circle drawn for-

ward to a crescent and with a painter's illusionistic shadow behind it that makes it appear to lift away from the canvas.

The square canvas edge is literal only at the bottom right-hand corner. The upper right edge is violated by an extra piece that goes past the point where the familiar world of the painting ought to end. The stuck-on extra piece at the upper right-hand corner seems to exist to let the dark painted line have enough room to come to an end. The left vertical edge of the square canvas is a line rather than a fact, occurring about two-thirds of the way across the work. It is the edge of what would have been the traditional square canvas if the work hadn't burst out further to the left into an almost entirely new system of round shapes and round edges. If we look closely at this line that makes up the left edge of the square we can see that it only begins at the bottom as a drawn, thin black straight line. Partway up it becomes an implied line, the boundary where two different systems of painting and drawing meet. Finally, it is lost near the top of the painting where it is tangent to the perfect white circle and merges with its round outline drawn in the same thin black line as the edge had been when it started its journey at the bottom of the canvas.

The entire left side of the canvas seems to have blossomed out into an extra, circular addition that loses its mathematical accuracy as it nears the top where, by means of green paint, it is connected visually to the upper right side of the painting, telling us that this is—whatever its broken sentences and incomplete or competing systems—all one painting.

Just as the painting goes outward in two dimensions by means of conventions that are incomplete or interrupted, so too it plays with or describes for us the conventions of a third dimension. Here the primary actor is the black and white pillar that rises off and out of the canvas by means of a traditional representational device of hatched black lines. Even further forward is the lid-like top of the column that lifts itself off into space and is shown in perspective, as though this pert painting were taking off its hat to us. The skin of the column seems likewise to have peeled itself off down into the painting where it curls up near the bottom. The bottom of the column is also opened up for us to look at its inside. This opened column has its own black and white, mechanical system of representation. Refusing color altogether, it seems like a character that has wandered in from another play, or perhaps from another comic book, since its zip and energy raise the expectation that we might find nearby those small thought bubbles with "Gosh!" or "Wow!" written inside.

A variant to this system occurs in the trough or fold that we see in the mostly painted right-hand side of the work. The left side of the fold, or cone, depending on how we see it, raises off the canvas behind it and seems bent at an oblique angle to its other half, which is roughly painted over near the right side. Why can we speak of ambiguity about whether what we see here is a cone or a trough-like fold? The clues from two different schematic representations are built into the same object. If we begin from the pointed top of the object which touches the left edge of the canvas, we can travel down the object for a while imagining that we are looking at something that the artist intends to be a cone. As we near the bottom we do not find the curved edge that would complete a cone. Instead we discover something contradictory that tells us that we have been looking at a trough. But when we start from the bottom we are clearly looking at a fold or trough that goes back in space, and as we travel up the object we lose that feeling slowly, somewhere in the middle. To start from the top or from the bottom of this cone-trough is to produce two entirely different assumptions, each of which loses certainty in the middle and then reaches a contradiction at the other end. Since a cone would round itself up, off the canvas towards us, and a trough would go back from its edges, the two possibilities are impossible in combination. The painted-in shadow towards the middle encourages us, as we start up from the bottom, to see it as the back edge of a trough, but this too is more emphatic at the bottom than at the top.

We might say that the trough does not reach the same level of refutation as the cone did as we neared what ought to be its base. Is this a cone at all or is it only that Stella's title with its own representational system of words leads us to expect a cone as we start down from the pinnacle of this object only to be disappointed at the base?

These represented three-dimensional objects, whatever their paradoxes, are supported by Stella's use throughout the work of the whole bag of tricks of overlap to make us read certain shapes as in front of others, covering parts of others, or passing behind elements that are allowed to continue. The crescent comes in over the curl, then over the background of mottled, painted surface, and finally over the paper-like fold or trough. We see its represented shadow falling onto each of these. Near the shadow we also find the shadow of the curve, and even a shadow for the edge of the trough. Each shadow is a signal within traditional representational systems that the element is lifted off the surface and stands out in front of its own canvas. It is both on and in front of the canvas or

picture plane at the same time. Each of these elements is therefore in front of itself. On the left side, the kidney-shaped aluminum piece is literally off the canvas, not simply represented to be so, but it lies behind the canvas, as the overlapping flap of the column and painted green line inform us.

We see in the painting a great play with a set of systems of representation, all of which break off or break into one another. The actual white circle, its ovoid perspectival representation in the flap that looks like its lifted-off top, the painted semi-circle, the bottom semi-circle of the canvas that gives way to a compromise as it changes from drawing to painting in the upper left, the crescent which is a spatial piece of an implied circle, and the awkward, rounded metal part that is the least pure, least mathematical, but most real object: in sequence each of these functions like one of the apples in a Cézanne still-life. They create a set of variations on a reference shape which for Stella is the pure white circle instead of the fully represented, free-standing apple of Cézanne. But what is varied here is not only shape, but the system of implying shape. It is as though Cézanne put the word "apple" in instead of one painterly apple, and attached an apple peel to the canvas instead of another, and wound up with a photograph or mechanical drawing of an apple to take the place of yet another.

The many systems in play are not set side by side, they are joined experimentally by means of places where they modulate into one another, like the cone, that, as the eye travels down, snaps back into space and reads as a trough. To point out only one further of these ambiguous moments, I want to consider the two sides of the column. The top edge or side is indicated by a black band, but when we look for the other edge we see a wider black band which flows beyond the cylinder at the top. The edge we have to imagine is somewhere in this wider black band because the rest of the band makes up part of the unpeeled linear paper from the cylinder that travels down the canvas to its curl. Somewhere in the middle of this black band the mind imposes an edge in order to read the cylinder as complete. We see, in other words, a number of things that aren't really there. This is one product of any one representational system. It creates, by means of a few clues, an eagerness on our part to supply many others as we do here for this missing edge.

We can speak of the work as a whole as a canvas that broke out to the left, over-stepped its boundary, but then was driven back by the great active swirl of the curved lines that narrow to a point back in the square world of the original rather modest and soberly

square canvas. That plain tan canvas, painted over with white we can think of in its dimensions, shape, and rather unenergetic painting as almost a humble object. It serves as the world onto which all of the energy is built, and from which the energy escapes only to return. The canvas is a floor—as understood by a gymnast.

The literal metal oval, which in our normal system would read, because of its brightness, as located in front of the canvas, with the gap reading as its cast shadow, is literally back behind the surface and then blocked from leaping out by the little painted arm that works like a railroad crossing semaphore. This painted arm matches in shape and technique the small painted arm that extends beyond the otherwise straight right edge of the canvas. The arm is literally part of the flap or hat, but since two representational systems are used—green paint versus black and white, compass and straight edge drawing—they are detached from one another in our mind.

Systems join, as the black curved lines join two distinct pieces into one at the bottom, or they divide, as with the flap and its extended arm. It is to this task that the central ingenuity of the painting is devoted. Here, in other words, we find ourselves with the painter's list of ideas or moments of delighted seeing. What he holds out for us to enjoy one by one are the ways of assigning or associating objects to one another so as to create fit. Here I will list just a few of these:

1. The most divisive material, the bare aluminum ovoid, is literally fitted into a corresponding hole in the painted canvas. On the right side of the aluminum piece it is carefully aligned with the canvas.

2. The painted aluminum crescent is matched by means of its black lines to the painted lines beyond it which almost meet, line by line.

3. The most troubling spatial object, the three-dimensional column, is peeled and rolled flat by means of common tricks of representation so that it seems to travel flat, parallel to the picture plane until it curls up at the bottom.

4. The white round disk is domesticated by means of a set of variations until it opens out as the curved left edge of the work.

5. The folded trough (or cone) at the right with its vanishing points, converging lines, and reminder of familiar space, however paradoxical, is touched by the crescent and fit in by means of its black lines to the opening out of the canvas on the opposite side.

6. The many literal facts, such as the raw canvas, the alumi-
num disk, the literal shapes or edges all prepare for the literal
or representational march forward into the third dimension
towards the viewer. Only in representational tricks does this
thrust forward take place, literally only the back space is oc-
cupied, and this by the aluminum disk.

Often, although we can make point by point judgments so as
to see one or another system working in local neighborhoods we
cannot compare elements at a distance. The white flap at the top of
the pillar reads as in front of the lower, smaller flap at the bottom,
but the latter tells us, because it is adjacent to the dark green paint
that it must be far in front of so dark a background. Two elements
that are not connected, as these two are by the pillar, are even
more difficult to hold in sight at the same time. The bottom flap of
the pillar and the semi-circle of lifted, painted canvas that we see
just to the right of the aluminum ovoid, should be, because they
are so similar in shape, comparable, but so different are the sys-
tems in which they are represented that the eye cannot hold them
in place at the same time.

The space is filled with tricks or problems where literal and
representational meet. Many details become indeterminate that
would, in any one system, be supplied by the imagination filling in
the gaps. The painting blanks out wherever systems meet. Finally,
there are radically different facts presented to perception when the
work is examined close up and then at a distance. When we are
within a few feet of it, it is clearly a sculpture or assembly. From
the other side of a large room, it seems to be trying very hard to
be a painting. Naturally, when seen in a flat reproduction, the work
seems even more painting-like.

## Spolia and Academic Art

From this description so far, Stella's work is an example of pas-
tiche. It takes over fragments from other works or styles and shuf-
fles them together. In his book *Art Forms and Civic Life* the his-
torian L'Orange has described the Roman practice of working with
fragments of earlier systems, the practice of "Spolia."[5] The Ro-
mans took over the fragments and broken pieces of Greek architec-
ture and built with them without regard for their original purpose.
Stella has made here what we might call a Roman painting, one
that loots and assembles the earlier European civilization. We should

Plate 1. Jasper Johns, *White Flag*, 1955. Encaustic and collage on canvas. Collection of the Artist. VAGA, New York, 1991.

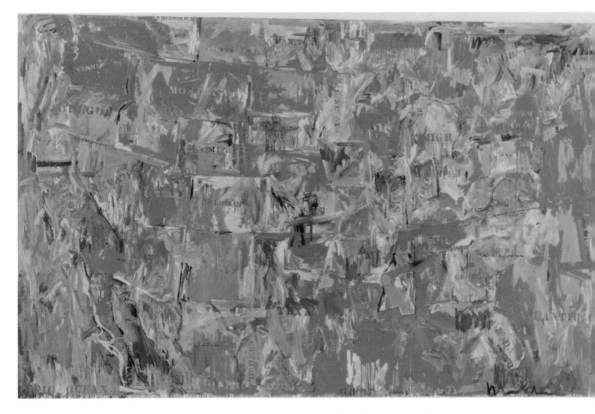

Plate 2. Jasper Johns, *Map*, 1961. Oil on canvas. The Museum of Modern Art, New York. Gift of Mr. and Mrs. Robert C. Scull, 1963. VAGA, New York, 1991.

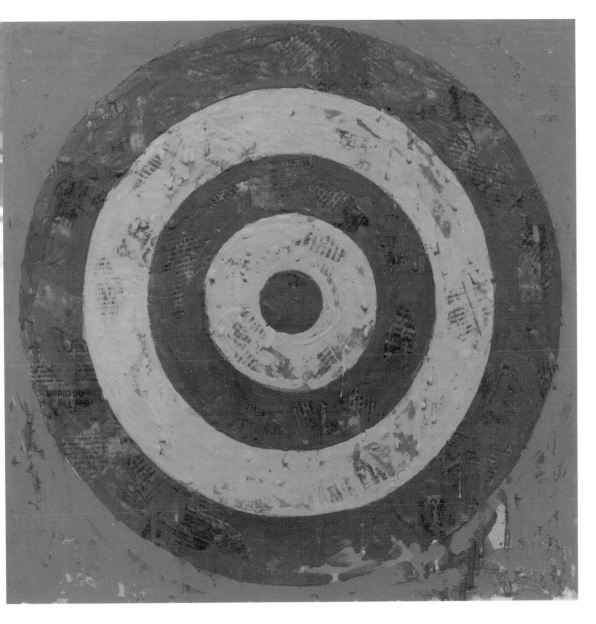

Plate 3. Jasper Johns, *Target*, 1974. Encaustic and collage on canvas. Museum of Modern Art, Vienna. VAGA, New York, 1991.

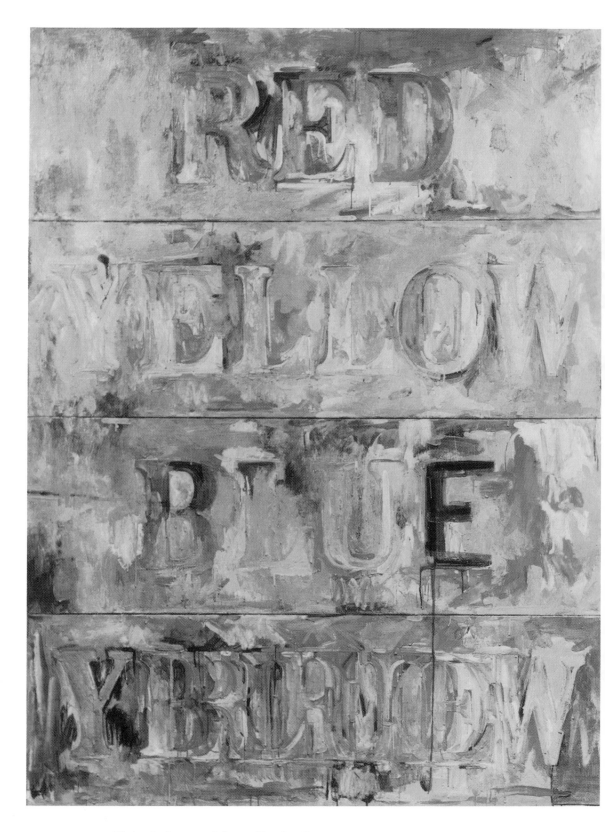

Plate 4. Jasper Johns, *By the Sea*, 1961. Encaustic and collage on canvas. Private Collection, New York. VAGA, New York, 1991.

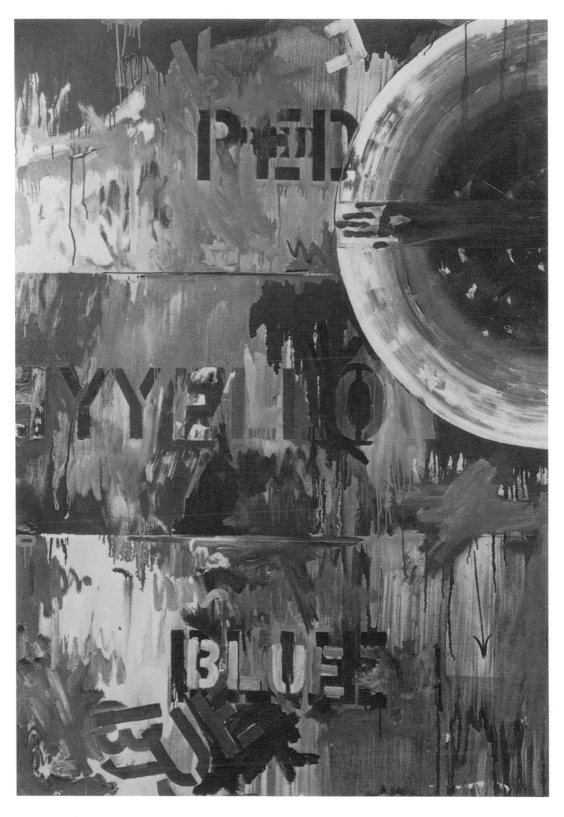

Plate 5. Jasper Johns, *Periscope* (Hart Crane), 1963. Oil on canvas. Collection of the Artist. VAGA, New York, 1991.

Plate 6. Frank Stella, *Cones and Pillars II*, 1984. Mixed media on aluminum and canvas. Whitehead Institute Art Collection, Massachusetts Institute of Technology, Cambridge, Mass. Collection of the Artist. Copyright 1991 Frank Stella/ARS, New York.

Plate 7. Frank Stella, *Diavolozoppo*, 1984. Mixed media on canvas, etched magnesium, aluminum, and fiberglass. Collection of the Artist. Copyright 1991 Frank Stella/ARS, New York.

Plate 8. Jackson Pollock, *Number 13*, 1949. Oil, enamel, and aluminum paint on gesso ground on paper, mounted on composition board. Copyright 1991 Pollock-Krasner Foundation/ARS, New York.

Plate 9. Jackson Pollock, *Autumn Rhythm: Number 30, 1950.*
Oil on canvas. The Metropolitan Museum of Art, New York,
George A. Hearn Fund, 1957. Copyright 1991 Pollock-Krasner
Foundation/ARS, New York.

see this as an academic masterpiece, but also as a magician's display of all the old tricks. Like certain poems of T. S. Eliot that are a feast of quotations and quotations within quotations, Stella's painting is a deliberately "Modern" work, meaning by that term, a work of the early 20th century, the artistic world of Stravinsky, Eliot, Picasso.

At the same time it is a work of art that is strangely hypothetical, almost an "as if" painting. By this I mean that it is a demonstration of the ways that Stella might go about making a painting if he wanted to. It has some of the relation to the actual painting of the past that the consideration, in a philosopher like Kripke, of what are called "possible worlds" has to the philosophical work of the past.[6] We have to imagine his saying. "Suppose I wanted to lift something off the canvas, well then I might do this . . . or this . . . or . . . this, but then I would find that I would have to do . . . and . . . , but then I wouldn't want to do *that!* In language we call this the subjunctive, the mood of possibility and even of counter-factual possibility.

And yet with this wealth of systems of representation, the artist's sly goal is to break out of each one, or to let us witness the moment in which he grew bored with it or felt its inadequacy, for something else that he wanted to do. In this Stella is the opposite of a painter like Picasso who has left us a record of each separate moment of discovery or solution. Instead, Stella leaves behind the traces of his moment of abandoning systems, finding their shortcomings. His canvas is the record of his short-lived excitements that led in every case to boredom. Nothing is ever interesting enough to last for long. The ordinary square canvas with which we seem to start in the lower right-hand corner interests us for a while in its commonplace painting—light over dark—but then breaks out as we go out along either of the edges until finally we arrive at what should have been its mirror image (the missing upper left corner of that same canvas) where not only are we in the middle rather than at the end, but find ourselves face to face with a pure white circle. Of its four corners the original canvas has only one real corner (bottom right), one hidden corner (bottom left), one extended corner (top right), where the arm juts out to let the green stripe finish, and one pure white circle (top left).

The painting is an afterthought or Spolia to the languages of representation. They are used and set in collision to demonstrate the freedom from them even in the moment of using them. The energy and pleasure, what we ought to call the "fun" of the painting, occur in each of those moments when the painter trades in one

way of representing for another, as on the more painterly right side of the canvas where he goes from white over dark at the mostly white bottom, to dark green over white at the mostly green top. On the same side he also trades in painting for the geometrical lines of a black and white system on the trough or cone.

The broken-off quality of each of these languages takes us back to what I would call the academic quality of the painting. It is something of a visual lecture to future art students in which Stella says: "Suppose you wanted to do this, well, you would. . . . but you wouldn't really want to do it!" The work is like a map giving directions to cities that don't exist any longer on the earth, Babylon and Carthage.

Stella's painting occupies ground partway between painting and sculpture, between abstract and representational, between black and white representation and painting. An energetic and brassy work it pits against one another as many possibilities as it can think of. Like a number of modern works, Ezra Pound's *Cantos* for example or the works of Robert Rauschenberg, Stella's object is a museum in miniature, looting and then assembling the past by means of quotation. Organizationally, he sets out to show that a coherent effect can be elicited out of what is a remarkably diverse set of parts, pieces, or scraps of what, might have been, somewhere else and under other conditions, details of whole, unified works.

The strategy for sequencing itself that Stella employs is not to make his work a solution or an answer but to make it an aftermath. Located within itself are all of the bits and pieces of the artistic history that it is the successor to. Quite solemnly the painting steps forward to declare itself "Next."

Three types of time are referred to within the work. First, the painting locates itself within the horizon of problems and interests of painting in the United States from the 1960s to 1984. This horizon includes the matter of flatness; the problem of the literal; the shaped canvas; the boredom with the uneventful quality of many overall paintings; the attempt to prolong abstraction without giving way to content and representation; the complex 20th-century flirtation with objects that are half-painting and half-sculpture; the cubist construction as a break with essentially flat concerns; and, finally, the slangy energy and vulgarity of pop culture which high art always seemed in danger of missing out on because of its solemnity and elegance. Together these make up the horizon that, as we might notice, the painting itself, in complicity with the writing about art over the last few years notifies us that it will use as its reference point. Would any such horizon seem definable or of in-

terest to someone looking at this work seventy-five or 750 years later? By being so clearly a part of an immediate horizon the work takes the chance that it is really a form of chatter or gossip rather than talk. But that is the chance that it seems willing to take. In its own time a very knowing, witty work, it may come to seem in a generation or two like many works of 18th-century satire: filled with too many local references and jibes to be any longer funny or even fun.

The second form of time within Stella's work is the evidence of the many brilliant moments of inventiveness. The instantaneous record of thought, including many clever or merely "bright ideas," is what the work as a whole cobbles together. The painting races from one bright idea to another, caring less about fit or passage than it does about fertility of thought. The rapidly given evidence of lively perception, coincides here with a second record: the record of his boredom. Like the disordered room of a child with too many toys, the real record here is one of having played with each thing for only a few minutes before reaching for another to stop his own fall into boredom. The work is anti-artisanal exactly to the extent that it is careless about these stunts or paradoxes once it sees that it can fit them in somewhere.

The most important temporal feature is the third. The work looks like an invention or a breakthrough. Certainly Stella himself thinks of it as breaking out of the rules of what were until recently the game of painting. Although the work sequences itself so precisely as it gossips about what the problems of the moment are, it lets itself also be ready to abandon its position in this sequence whenever in the future that sequence as a whole might seem about to lose interest. The work could then find itself beginning to drift among other traditions, back even beyond Cubist constructions. Perhaps at some point our entire modernity will be seen, as various works drop out, as one long variation on the Baroque in which energy, audacity, astonishment along with a certain fatigue and belatedness are the essential features. Into this long history the painting is prepared to fit itself as part. A work such as *Cones & Pillars II* might best be said to be clever about time and about the possibilities that it cannot anticipate but hopes to be essential to our comprehension of. The strategy depends on making the work both an aftermath and an anthology, a discourse about the past and about art itself. The work is then ready for time. Its past is secured within the work itself. The painter will soon provide its future in the nearly identical, but lyrically richer painting *Diavolozoppo*. A few years later the effects and topics of this work will hover, almost memory-

Fig. 12. Frank Stella, *The Spouter Inn*, 1987. Copyright 1991 Frank Stella/ARS, New York.

like over several of the works of the *Moby Dick Series*. In *The Spouter Inn* of 1987 (Fig. 12) the cone and rectangular canvas will put in what might be called guest appearances within this new drama of the sea, the whale, and the rival American masterpiece. These works are the future, the next stage, of the march into the future's past.

PART II

# The Work of Art and the Practice of Hand-made Space

# Pins, a Table,
# Works of Art

The arts, as Paul Valéry once remarked, were developed by men whose power of action upon things was insignificant compared with ours.[1] The seven wonders of the ancient world are dwarfed by seventy commonplace social things now built every year. It is hard for anyone who has driven a car to work every day across the George Washington Bridge to find anything very astonishing in the Pyramids. The scale of the gigantic has become banal, and the sheer impression of size on which so much turns in traditional art, along with the pleasure of exactness greater than that achieved in everyday goods, has been converted into the easiest of social effects. Valéry points out that none of the physical components within art can remain unchanged by this change in the scale of power.[2]

Within the arts this inflation of everyday power has no consequences for literature, music, or dance since language, the body, and the instruments of music are essentially unchanged. It is within the production of things, that is, within sculpture, painting and architecture that the results of our multiplied powers of action are clear. But even within these material arts there are clear differences. As a social art that has always involved groups of people working together and using the most advanced machinery of the society, architecture, while changed, is in the end changed least. That buildings rise higher only points out the fact that they always might rise, just as the gates of Babylon or the medieval cathedrals did, above the ordinary scale.

For sculpture and painting the case is entirely different. Each of these is, unlike architecture, a material but individual art. The object is produced by a single maker using only his own skills, where in architecture the locking together of hundreds of skills is and always has been the norm. Division of labor, specialization, and managerial co-ordination were always working practices in building. The modern industrial system can be said to have applied these traditional work methods for gigantic projects to such small objects as shoes, bread, and pins. Those who developed the arts did so within societies where the craft system by which everyday objects were made was duplicated in the system for making what we now call art. The working life of a shoemaker, a potter, or a weaver was continuous in scale with the life of a painter or a sculptor.

The simplest illustration of Valéry's claim is the contrast in time and power over things between a copy of Raphael's *Transfiguration* taken with a Polaroid camera and a copy of the same painting executed by a highly skilled copyist taking months of time and using skills that took decades to develop. In the same way, when Vermeer paints a likeness of a scene that he has composed with the help of a camera obscura, he makes use of a power of action over things that is little changed from the beginning of human history. Once we replace his camera obscura with a Polaroid camera the problem of a likeness has shrunk to a negligible, unskilled, and everyday situation. This does not imply that Vermeer's goal can be reduced to that of a likeness, but it is true that in painting traditionally, and even more in drawing, a major motivation for the level of skill was the taking of likenesses. While we now stress the interpretative side of genres like the portrait, clearly it was to possess a likeness rather than an interpretation that portraits were above all commissioned. After all, how profound can the interpretation of a stranger (the artist) be of a person whom he comes to know only for a few sessions in the role of a motionless sitter? Where likeness was the goal of the traditional portrait, the camera abolishes the genre by its almost embarrassing advantage over the skill and patience of a man working with brush and paints.

Since the Industrial Revolution the making of art objects has come to float free from the background system by which everyday objects are made. The increased power of action upon things of which Valéry spoke is a result of such well-known facts as the division of labor, the replacement of tools by machines, the exactitude of machinery that makes perfect measurement and highly finished surfaces possible, and the addition of steam and electrical power to the manufacturing process. Precision might seem at first

to be only an aesthetic effect, but it is mathematical exactitude that makes possible the new system of the multiplication of small identical parts that can later be assembled into final objects far larger and more complex than was imaginable under any other system. The Pyramids themselves were only possible once squared blocks of stone could be trimmed with accuracy. The exactitude that lets the girders and rivets of the George Washington Bridge be locked together as a safe and nearly permanent structure is no different except in scale and refinement. Taken together these features of our system of mass production have pushed to the margin of social importance any products made by the traditional craft system. Mostly they have become willfully nostalgia pastimes, hobbies no different and no less archaic than autumn deer hunting with bows and arrows in a society of supermarkets.

These two facts—the multiplication of our powers of action over things as compared with the past, and the severing of the individual, craft style of production that is still intrinsic to the making of painting and sculpture from the wider social system of production by which most everyday objects are now made—are as rich in consequences for modern aesthetics, and are as centrally present within the content of modern art, as is the coming of the museum with its institutional pressure on objects whose strategy lies in the hope to become the future's past.

Within the psychological repertoire of aesthetics the gap between what we now have to see as the "insignificant" power of action over things of people who not only developed the arts, but also developed the specific pleasures that went into the experience of art, touches profoundly the part played by the experience of wonder in aesthetic pleasure. Wonder in its many variants of surprise, awe, sudden delight, astonishment, and marveling lay at the heart of the psychology of beauty. The wonder that was felt in the face of the size and height of Trajan's column in Rome, or at the intricacy of ornament in the Book of Kells, in minutely carved ivory or in the smooth finish of a marble statue, was not marginal but essential to the experience of them as objects of beauty and power. Wonder in art could be called a feeling of pleasure in a material surprise.

The many varieties of this material wonder are now most commonly felt outside art. The delight of polish, of shining metal, of intricate complexity in a small space, or, at the other extreme, of gigantic and awesome structures: these are now our everyday experiences, available in the face of such commonplace objects as steel ball-bearings, the inside of a computer, or the sight of a Concorde

airplane flying overhead. Wonder has been rehoused outside the temple of art.

One explanation for the part played by an aesthetics of shock and an aesthetics of strangeness within the avant-garde art that coincides with the Industrial Revolution has to be seen as the search for stimulants powerful enough to replace the experience of wonder which has been captured by the everyday, technological world no less completely than that same world had captured the quite different pleasure felt in likeness and realistic duplication. In so far as we are talking about an aesthetics of material objects, a rivalry between works of art and the spectacular unfolding of the realm of everyday objects of all kinds is now one of the basic facts within what we might call the psychology of rare experiences. Wonder can only exist in so far as it is an unusual and even an unexpected experience. Shock or strangeness are also only possible as rare and unexpected experiences. The competition between art and the alternative sources for rare experiences, as well as the rivalry to capture or dominate the production of one or another category of rare experience, is one of the givens of modern aesthetics.

The surrender of wonder was a more damaging loss to art than the transfer of realism or likeness to technological reproduction. The catalogue of the variety of surrogates for wonder as a compelling and pleasurable experience in the face of a material object is the essence of the aesthetics that we call modernism within the arts. The experiments with provocation, disgust, anger, shock, banality, and strangeness have passed in review, before an incompletely convinced audience, the many poor cousins of wonder. It is in this transfer from aesthetics to everyday life of the experience of wonder that one of the central results of Valéry's contrast of an insignificant power of action upon things and a modern effortless and extravagant power of action upon those same materials and things appears.

## Model Objects

When we find ourselves face to face with a work of art it is within our world of objects and limited by our feelings about objects that this experience takes place. A culture in which objects are few, or one in which objects are commonly divided into things touched only by men or by women, or a culture in which the sacred objects are unmistakably distinguished from profane objects—each of these cultures has locked into place competing possibilities into which

any new object must fall. So it is with our own industrial culture that has multiplied the numbers of things and filled in the variety of objects almost to the point of a system as extensive in variety, as wasteful in numbers, as the system of nature itself.

Implicitly we locate any object by means of model objects that focus our vision in the world of things. These central or typical objects testify to our sense of work and use, to our hierarchy of worth in objects and our elemental feelings about the relation of the world of things to the human world. Since the beginning of mass production we have applied two false sets of expectations, two false model objects, to the modern work of art in order to create the largest possible mental distance between the work of art and the world of everyday objects. We bring two models in our hands when we approach the work of art: the first, the museum object which we use to define the destination of works of art; the second, the craft object which we use to define the origin of the work of art. Trapped between a false model of its destination and an equally false model of its origin, the work of art hovers free of our attempted descriptions. Neither the museum object nor the craft object has been questioned as a guide to the logic of the work of art in the modern period. Nor have the framing institutions of the museum and its partner, the modern factory, been explored to locate the definitions each imposes on the nature of things.

That we have experienced changes of a fundamental kind in our relation to objects because of mass production and the economy of commodity exchange is, I think, generally accepted. Hannah Arendt summarized the widely held, but I believe fundamentally wrong, claims against mass production when she wrote in *The Human Condition* that modern society breaks down the difference between labor and work, between objects of consumption and objects of use. The modern solution ". . . consists in treating all use objects as though they were consumer goods, so that a chair or a table is now consumed as rapidly as a dress and a dress used up almost as quickly as food. . . . The industrial revolution has replaced all workmanship with labor, and the result has been that the things of the modern world have become labor products whose natural fate is to be consumed, instead of work products which are there to be used."[3]

This world of rapid creation and rapid replacement, of unskilled repetitive labor, has as its sole exception the artist who, in Arendt's words, remains "The only worker left in a laboring society."[4] In Arendt, and the entire tradition for which she can be taken as a summarizing vernacular figure, the frame of model objects with

which we are to understand our world has three parts. The work of art, almost certainly visualized as a framed medium-sized easel painting, is implicitly the standard for objecthood, the apex of a pyramid that has beneath it two classes of objects: objects of use, for which her implicit example is a table; and, second, objects of consumption, for which the best example is a loaf of bread. In fact, the use of the table as a model object in the 19th and 20th centuries usually points to the way in which, or so it is asserted, all objects were once made but no longer are. In many descriptions, only the work of art now fulfills the conditions once so common that every ordinary object of use, such as a table, partook of the value and humanity now visible only in works of art. The table is a contentious model object, one used to indict or quarrel with modern objects, for which the classic model has been, since the time of Adam Smith, the collective object, pins.

The interlocking and exhaustive model objects—pins, a table, and works of art—have created a vocabulary that misstates the nature of art and creates a false separation of modern objects of art and contemporary objects of all kinds. This false separation, in its turn, is based on the equation asserted between traditional craft objects, of all kinds, and works of art. The models of origin that we have for the modern work of art are deeply misleading.

## The Table

The table as an archetypal object has a history that goes back at least to the tenth book of Plato's *Republic,* where it is also contrasted to the work of art.[5] For Plato, the craftsman making an object such as a bed or table has in his mind a complete idea of the object he will produce. His table is then an imitation of that idea. One reason that this idea in the craftsman's mind of the complete object is important is that it is this idea that lets him know when he is finished. Once the thing in front of him looks like the idea that he has had in mind from the beginning he can quit work.

A painting that pictures a table is then an imitation of an imitation. In Plato the art object, far from being the even more real example of an object is at the third level of diminishing reality. Plato's stress on the craftsman's ability at every partial moment of work to carry in his imagination a complete image of the finished product ratifies the wholeness of work. Modern attempts to suggest radical alternative model objects, such as Kevin Lynch's important work on the city as an object, still demand that we be able to form

an intelligible image of the whole in order to experience place, neighborhood, or city as an object.[6]

Plato's table became in 20th-century philosophy of science the recurrent central example of the disturbing gulf between everyday experience and scientific description. One of the standard, popular expositions of the revolution in modern science, Eddington's *The Nature of the Physical World*, offered a theory of two tables.[7] The first is the table of common sensory experience and use; the other the swarm of forces, charged particles and mostly empty space that is the table of scientific description. Eddington divorced everyday experience from the ultra-objects of science in a way that paralleled the split between common objects and the work of art. In doing so he has tampered with one of the model objects of the European mind. Rousseau, for example, when searching for a trade for his ideal pupil, Émile, concluded that only carpentry unites the most desirable qualities of work. By carpentry Rousseau means the production, within the home workshop, of medium-sized objects such as tables.[8]

The table enables us to visualize a direct, relatively calm transition from material to maker to user. The material is wood and remains visible in the final product. No fire has entered into the production. The transformation of the material is Aristotelian: the craftsman gives form to matter. In the form of the four legs, the original vertical form of the tree is recollected. By contrast, one of the primary characteristics of modern objects is that the material is itself the end product of a set of processes. In most cases these processes erase origin. Glass and steel are obvious examples.

As the material is carried forward into the product, so too is the maker. The more idiosyncratically conceived the object in design, conception, ornament, and imagery, the more specified or identified the person of the craftsman is. The uniqueness of the object reflects the individuality of the maker. We find him present as a residue in the work and can identify him by the "signature" of his style. "This is or could only be the work of X." On the other hand, the level of craft sophistication, virtuoso display of difficulty, intricacy, and time-bearing labor depersonalizes the maker and describes the common skill level of a given cultural moment and profession, the tolerance for protracted and precise work, the carelessness or quest for perfection that generally obtains, the lavish or meager use of materials, the availability and state of technical control of the various states of the material. The unique and the impersonal are deeply connected in the craft performance.

The table, like any example of a craft object, must be of middle

size, like a sword, an urn, or a necklace. As the scale of an object increases it becomes impossible for a single creator to dominate, form, and embellish the entire object. There is, in other words, a given radius to the human will. Jewelry defines the lower limit of this radius because of its miniature size—often just above the minimum where smaller objects and details cannot be controlled by the human hands and eyes. Yet jewelry remains small enough to be comfortably within the radius of total calculation and finish. At the other extreme are objects that challenge the radial limits of the will, as does, for example, nearly all the work of Michelangelo. Leo Steinberg has described the astonishing promises Michelangelo made in signing the contracts for the tomb of Pope Julius, which called for numbers and sizes of statues seemingly beyond human capacity.[9]

The conformity of a table to a relaxed and yet significant challenge to the craftsman's will is one reason why it provides a human measure. The notion of the radius of the will is an essential one. In the history of ideas it parallels the moral notion of responsibility in the field of actions. Where we act we are held responsible for the results of actions only computed to a certain distance. Aristotle called this a complete action. We hold a gunman responsible for crippling his victim but we do not then credit him with the fact that the crippling of the victim enabled him to devote himself to chess and become a famous master or to the fact that the son of the crippled man became an inventor of improved wheelchairs and then, when driven out of the market by improvements made by competitors, despaired. The radius of the will in action, and with it the notion of human responsibility, is highly localized. It is this same fact that is defined by the radius of the will in the creation of objects. In the modern situation the objects tend to be either far larger than that radius; or so small as to excite no measure of human power. The table, and with it the entire world of traditional craft objects, was uniquely adjusted to the radius of the individual will in a way that the George Washington Bridge or a computer chip is not.

The scale of the table involves a second important element. While the time-bearing character of craftsmanship is one of its most esteemed factors (a table, necklace, sword, or urn can represent tens or hundreds or in a few cases thousands of hours of congealed labor), there is a temporal limit that enters. First, the working life of a craftsman is limited to forty years. That in itself is a limit to how intricate the work can be. But only in marginal cases like the Sagrada Familia Cathedral of the architect Gaudi is this in itself important. The more common limit depends on the fact that in order

to create skill there cannot be one, life-long project. The life of the craftsman must subdivide to create enough repetitions of the total process to result in skill. The temporal limit seems deeply related in the human psyche to restlessness and its opposite, the desire to take one's time. Most craft projects involve a nearly repeatable unit of time, more than a day, less than a month. Once again, in the modern period the essential acts of making are speeded up, by subdividing the temporal processes and locating them side by side in space. The week-long project takes less than an hour, often less than a minute. At the other extreme, society undertakes gigantic, many years-long projects that are central to its notion of work. The two extremes, outside the radius of time defined by the table, are the central locations of action.

The investment of work measures directly the mixing of the self with material that made up John Locke's famous definition of property. "Though the earth and all inferior creatures be common to all men, yet every man has a property in his own person; this nobody has a right to but himself. The labour of his body and work of his hands we may say are properly his. Whatsoever, then, he removes out of the state that Nature hath provided and left it in, he hath mixed his labour with, and joined it to something that is his own, and thereby makes it his Property."[10]

As has often been stressed, Locke's equation builds outward from the property that each man has in his own person to the property he achieves by mixing his labor with the world. The inevitable equation of making and owning, the uniqueness of the maker matched to that of the owner, is a key element of the table as a model object. That owning in this case is combined with using, and using for a single conspicuous purpose is equally important.

Opposite the creator of the craft object stands a split sociological partner-term. First there is the one for whom the object exists, owner or user or, preferably, both. The one family who will sit at this table to eat their meals, the one woman for whom the necklace is made, and the priest who alone is permitted to lift and consecrate the contents of the chalice (even though he does not own it) are examples of unique owners or users. Use or ownership creates a unique focal point across the object. The uniqueness of the object points backward to the individuality of the creator but also outward to the individuality of the owner or user. The uniqueness of all three (object, maker, user) is always simultaneously at stake.

The remaining partner-term, however, is not unique or single, or implicated in the intention of the object. This third term includes all those who see the object. The table exists for the eyes of

visitors, conveying information about the family, their wealth, taste, size, and so on. The woman wears the necklace for others, and it becomes a part of her turned towards the world at large. An urn containing the ashes of its intended user still has images painted on the outside and a great deal of its meaning is turned towards the observances and needs of the survivors or, later, the needs of the connoisseurs of urns. Certain objects lack this third group: objects made to be entombed with the pharaoh are literally as dead as he is. They turn no face to the world.

Now, it is out of this third group that the audience is brought into being. They are over against the object and in touch with it as something that is not a part of themselves, something from which they are excluded. The anonymity of the modern object can have to do either with the vanishing of the craftsman-maker in his individuality or with the loss of the owner-user in his individuality. The feeling of anonymous objects is that they do not belong to anyone, nor did they come from anyone. They are just there in the world. They never did belong to us (the audience), but now the belonging relation is gone from the design intention of the object. This feeling of a lack of belonging is most often described as a lack of intelligibility. With modern art the claim not to "get it" or understand it is a surrogate for the feeling that it does not belong to us or to anyone. Such objects are the inverse of Egyptian tomb objects (for someone but not appearing to anyone) because they appear to everyone but can be said to be for no one.

The final characteristic of the table is that it lasts without change of state for a time longer than an individual human life. This feature Arendt, for example, calls making up the world.[11] The table is a carefully chosen example precisely because its endurance is not tied to maintenance or repair, and yet it has a finite life span. This endurance becomes a covert argument for the work of art as the primary object, because works of art are those objects that we have committed ourselves to preserve with as few changes as possible forever.

Of course, the use of the craft characteristics of a table as a definition of work in all its details implied the ultimate priority of works of art. In Arendt's case this priority is made clear. The artist is the only remaining worker in a society of laborers.[12] By the mid-19th century he has also become the only example of a worker who in any meaningful sense can be said to produce only for his own requirements. No longer working for patrons of commissions, he produces, at his own pace, objects defined by his own imagination, fulfilling his own needs alone. Only he perceives that something of

this sort is missing from the world, and only he is in a position to supply it. Self-employed in a world of larger and larger groupings of employment, he completes each work unaided. In this he differs from artists historically. Division of labor, the factory system, had traditionally played an essential part in many kinds of painting, just as it still does in architecture. If all work is the mixing of self with the material world, only the artist manages this mixture in such proportions that the self is not merely a trace but the prominent fact organizing every detail of material no longer subject to the claims of purpose. As work in general bears fewer and fewer traces of the person of the maker, exactly those forms of art most self-intensive dominate our definition of the work of art.[13]

In the portrait that uniqueness of personal being that had always been the formal organizing principle of the free-standing work of art appears within the work of art as its subject matter. The intense discourse of individualities, that of maker and owner, here becomes the content of the work itself. In fact it is within the 19th century that the ultimate form of the portrait, the self-portrait, and particularly Rembrandt's series of self-portraits, came to be identified in the common mind as the ultimate examples of art and objecthood. In the self-portrait the uniqueness of the self and the uniqueness of the subject are identical, the artist becomes his own employer, and the painting individualizes itself as an object by risking as its subject the undeniable uniqueness of the artist himself in an overt form. The self-portrait is the ultimate form of objecthood and work as well as the apex of imaginable works of art. In the Rembrandt self-portrait there is no world, the background is empty; neither place nor objects exist to compete with the self, identify it, or locate it within social space. The unique, worldless presence of the self is congruent with the unique worldless presence of the object. In such work all reference to others is missing. The artist alone imagines and completes the work for his own purposes, needing no imagery from the world except his own face. No user exists, no owner is possible, no purpose can be imagined. The ultimate anti-image of ordinary social work has been brought into being.

The capacity of the self-portrait or of any free-standing object of a middle size to embody the feeling of the self was, in the age of individualism, one of its essential characteristics. Once ordinary objects are no longer free-standing, complete, and middle-sized they no longer easily fulfill their role as images for the self. The primary expansion of objects in the technological period has been either in the miniature or the gigantic. The traditional scale of objects was in close relation as some small multiple or large fraction of the

volume and weight of a human body. In a traditional society the range from jewelry (the smallest objects) to houses (the largest) defines a relatively small scale and one that would, if we were to rank the numbers of objects, utensils, weapons, and buildings by size and frequency, outline a scale neatly positioned about the ratio of the hand to the human height (the two fundamental numbers)— what can be picked up and what can be faced or entered. A complete, ordinary sized object, such as a table, seen close-up, the distance approximately that we ordinarily stand for conversation with another person or while looking at a work of art, takes effect as a surrogate for the self. We correctly speak of a weapon, a chair, or a grandfather clock as having personality. As complete objects they become images for the completeness, simplicity, and stability of the self.[14] A basic set of ordinary things, each in its place, encourages the self to recur in a familiar form. The opening of Proust's *A la Récherche du temps perdu* describes this function of the world of things exactly.[15]

To understand the extent to which the table appears only as a concessive (since it acknowledges use, and a separation of maker and owner) surrogate for the work of art and an attack on the nature of social work rather than a description of it, we must contrast the table to the dominant image of work in the period from the Renaissance to the early 19th century. The table is one of three terms that define one another: table, pins, and works of art. The pins, as I will demonstrate later, define the realm of ordinary social work within the factory system. The work of art, more and more highly valued in the 19th century, indicts from its utopian position the value of all other work within social life, and the table becomes the device for pretending that most characteristics of the artist's work were in fact widespread in previous societies.

## Clock, Cosmos, Work of Art

Prior to the division of imagery into these three terms the major example of work and objecthood in philosophical and theological writing after the Renaissance was the small clock or watch.[16] By briefly describing the implications of this image I hope to isolate more precisely the negative, provocative elements of the table and the work of art. Carlo Cipolla's excellent study *Clocks and Culture* describes the history of the diffusion of the clock in early modern Europe. But he deals only briefly with its widespread use as an image.

". . . in the course of the sixteenth and seventeenth centuries the clock as a machine exerted deep influence on the speculations of philosophers and scientists. Kepler asserted that 'The universe is not similar to a divine living being, but is similar to a clock.' Robert Boyle wrote again that the universe is a "great piece of clock work," and Sir Kenelm Digby wrote again that the universe was nothing but an immense clock. In the framework of the prevailing mechanistic *Weltanschauung*, God was described as an outstanding clock-maker.[17]

Like any good image, that of the watch miniaturized relations. Physically, the watch was a minute model for the universe as understood by Newtonian mechanics, and as the finest marvel of human craftsmanship it seemed worthy to stand alongside the finest example of divine craftsmanship. The proper scale of human will to divine will seemed almost magically represented without either humbling the human effort through a contemptuous instance or losing sight of the difference between finite and infinite radius of the will. The watch represented human pride and humility simultaneously in an essential early modern form. It embodied as well the blend of rationality and mystery, of competence and awe, in exactly Newtonian proportions.

The average person inspecting the works of a watch still experiences amazement, pride, wonder and mystery, the ability to see how it works here and there mixed with a curiosity about what exactly this or that wheel does, yet contained within a confidence that each and every wheel exists for a purpose and must be exactly this size and have just so many teeth. The frame of confidence that co-exists with a happy mystery of details, an accuracy to thousandths of an inch and precise numbers of gear teeth coinciding with a relaxed inability to explain what one knows is explainable: this psychology of the examiner of a watch is more precisely what is carried within the image. Mystery and reason, accuracy and indefiniteness, complete pervasive purposiveness and a progressive but so far incomplete understanding of the details of purpose, human ability to see oneself and God along the same continuum as artificers while expressing at the same time the magnitude of difference (which is nonetheless a magnitude and not a qualitative difference): these are the elements of the image.

It is in the history of the dominance of the watch that the most complete harmony is expressed between nature and its artificer, God; social products such as watches and their artificers, the workers; the works of art and their makers, artists. The clock dignifies the world of objects by embodying the quality of things to stabilize

our relations to the grandest of natural facts (time in this case), ordering and humanizing, making imaginable and concrete a nearly ungraspable and partially inhuman realm.

Finally, the clock is the embodiment of that necessary scientific element, the closed system, the limited, self-contained, repetitive state of affairs essential to empirical science. In this sense the closed case of a watch, the boundary between the inner works and the world at large, is one of its most fundamental parts. The case is identical to the test tube that is the wall between the exact phenomena being studied and the world at large.[18] The test tube, the walls of the laboratory, the frame of a painting, and the case of the watch are essential elements of self-completeness that represent the very essence of any "thing" in the scientific world.

The many striking examples of boundaries in the early modern period of objects demand a similar contemplation of something in radical separation from the world at large. The curtain that rises and falls in the modern theater, the covers of a book that separate a discourse in a way that can never be done in a culture of oral performance, the frames that surround paintings and make them the quintessential visual objects, after the 17th century all reflect not only the notion that an object must be free standing, isolated, but the more essential scientific notion that only closed systems have order and explainable identity.[19] The glass wall of the test tube or laboratory beaker is the fundamental wall of this sort, and the closed watch case is its most significant image.

## From Pocket Watch to Pins

In the late 18th century a wedge is driven between the watch and nature and in the 19th between the watch and the work of art. Henceforth the three realms of natural objects, objects of human making, and objects of art demand separate and distinct examples. In fact the three realms come to be defined against one another by means of pins, tables, and works of art.

In Kant's *Critique of Judgement* the watch is the example used to free nature from the more limited notion of purpose dependent upon an outside craftsman. Kant differentiates objects in which the parts have purpose in relation to a whole (a watch, table, or work of art) and are given that purpose by an outside craftsman, from objects that have self-organizing being. "In nature parts and wholes, parts and parts are mutually cause and effect, purpose and instrument for one another; there is no outside idea or artificer. Things

in nature are self-activating."[20] Seventy years later Marx will sever the watch from the work of art as Kant had earlier divided it from nature. Marx in an iconoclastic act makes the nearly sacred image of the watch (just as Eddington did with the sacred image of the table) the very image for mass production and division of labor. "In watchmaking, that classical example of heterogeneous manufacture, we may study with great accuracy the above mentioned differentiation and specialization of the instruments of labour which arises from the decomposition of the craftsman's activity."[21]

With the word "decomposition" Marx begins the process of counter-imagery for what was once the essential image of making and composition.

> A locomotive, for instance, consists of more then 5,000 independent parts. It cannot, however, serve as an example of the first kind of genuine manufacture, for it is a creation of large-scale industry. But a watch can, and William Petty used it to illustrate the division of labour in manufacture. Formerly the individual creation of a craftsman from Nuremberg, the watch has been transformed into the social product of an immense number of specialized workers such as mainspring makers, dial makers, spiral-spring makers, jeweled hole makers, ruby level makers, hand makers, case makers, screw makers, gilders. Then there are numerous subdivisions, such as wheel makers (with a further division between brass and steel), pin makers, movement makers, *achèveurs de pignon* (who fix the wheels on the axles and polish the facets), pivot makers, *planteurs de finissage* (who put the wheels and springs in the works), *finisseurs de barillet* (who cut teeth in the wheels, make the holes of the right size, etc.), escapement makers, cylinder makers for cylinder escapements, escapement wheel makers, balance-wheel makers, makers of the *raquette* (the apparatus for regulating the watch), *planteurs d'echappement* (escapement makers proper); the *repasseurs de barillet* (who finish the box for the spring), steel polishers, wheel polishers, screw polishers, figure painters, dial enamellers (who melt the enamel on the copper), *fabricants de pendants* (who make the ring by which the case is hung), *finisseurs de charnière* (who put the brass hinges in the cover, *graveurs, ciseleurs, polisseurs de boîte,* etc., etc., and last of all the *repasseurs,* who fit together the whole watch and hand it over in a going state. Only a few parts of the watch pass through several hands; and all these *membra disjecta* come together for the first time in the hand that binds them into one mechanical whole.[22]

The location once occupied by the watch is replaced ultimately by the work of art and the accompanying primary objects, the table and the mass-produced pins. The essentially nostalgic content of

the asserted virtues of craftsmanship in the 19th and 20th centuries must be underlined. The watch, in its day, was the single most advanced and dramatic example of human invention. To evoke so traditional an image as the table, and so unrepresentative at that, betrays its advantage as an indictment rather than a representation.

## Repair and Making

The virtues of the age of craftsmanship cannot, of course, be found in the revival of now outdated crafts like weaving, the making of wooden furniture or the home-manufacture of shoes for peasants in the manner of Tolstoy. Nor is the artist the one remaining example of authentic work on the model of the craftsman. In fact, the place in modern society where the virtues of the world of crafts remain intact lies in the repair professions. Although two hundred men and women may be involved in the manufacture and sale of a watch it would customarily be repaired by one self-employed worker with whom I must enter a direct one-to-one relationship. Cars are assembled by thousands of people located perhaps in another country from me, but my car is repaired by one man living in my neighborhood, and this is the ordinary situation. While each worker in the production of a television set has no sense of the whole, the single repairman has mastery of the functions and even over the most common malfunctions of the entire unit. Independent, working with knowledge of the whole object, obtaining the satisfaction of a definite accomplishment from each act of work (since the broken object now functions once again) the everyday repairman embodies most of the moral and psychological benefits asserted to belong uniquely to craft work. Even further, he is forced to analyze, to diagnose, to act on hunches, to deal again and again with the unexpected and to overcome unforeseen difficulties in a way that makes him improvise in an intelligent way to solve any given problem.

Where he is self-employed his stock of tools can commonly be bought as a reasonable investment, just as the traditional carpenter's could. He works at his own pace and his individual jobs follow one another, each taking a matter of hours or days, seemingly the perfect time block for meaningful work. Nothing could demonstrate more quickly that the idealization of the craftsman in writings about work in the 19th and 20th centuries is close to an empty piety used to indict the nature of work altogether in the modern world than the fact that this idealization has never once been ac-

companied by the celebration of the very large element within the work force, repairmen, who embody so many of its characteristics. The very low social prestige of repair and maintenance by comparison to making in our society is a sign of its frontier spirit in the world of things.

## Pins

A decisive image of modern work appears in Adam Smith's *The Wealth of Nations*. Alasdair Clayre in his study *Work and Play* has shown that it was a reading of Smith and in particular of his description of the mass production of pins that led to Hegel's description of work in the *Jena Philosophie* and in the *Phenomenology of Spirit*.[23] Since Marx's early philosophical writings depend on the terminology Hegel developed for work, ultimately Smith's imagery, defined by Hegel, serves as the base for modern terms such as alienation and reification. Smith's historic description therefore lies indirectly behind the power of the idealization of the table and the work of art as counter-images of work. The description is worth noticing in its entirety.

> The trade of a pin maker: a workman not educated to this business (which the division of labour has rendered a distinct trade), nor acquainted with the use of the machinery employed in it (to the invention of which the same division of labour has probably given occasion), could scarce, perhaps, with his utmost industry, make one pin in a day, and certainly could not make twenty. But in the way in which this business is now carried on, not only the whole work is a peculiar trade, but it is divided into a number of branches, of which the greater part likewise peculiar trades [*sic*]. One man draws out the wire; another straights it; a third cuts it; a fourth points it; a fifth grinds it at the top for receiving the head; to make the head requires two or three distinct operations; to put it on is a peculiar business; to whiten the pins is another; it is even a trade by itself to put them into the paper; and the important business of making a pin is, in this manner, divided into about eighteen distinct operations, which, in some manufactures, are all performed by distinct hands, though in others the same man will sometimes perform two or three of them. I have seen a small manufactory of this kind, where ten men only were employed, and where some of them, consequently performed two or three distinct operations. But though they were very poor, and therefore but indifferently accommodated with the necessary machinery, they could, when they exerted themselves, make among them about twelve pounds of pins in a day.

There are in a pound upwards of four thousand pins of a middling size. Those ten persons, therefore, could make among them upwards of forty-eight thousand pins in a day. Each person, therefore, making a tenth part of forty-eight thousand pins might be considered as making four thousand eight hundred pins in a day. But if they had all wrought separately and independently, and without any of them having been educated to this peculiar business, they certainly could not each of them have made twenty perhaps not one pin in a day; that is, certainly, not the two hundred and fortieth, perhaps not the four thousand eight hundredth, part of what they are at present capable of performing, in consequence of a proper division and combination of their different operations.[24]

Smith's choice of pins decisively charges his description and carries for two hundred years a precise set of instructions for the emotional comprehension of division of labor. Tiny and sharp, pins are a common subject of anxiety. People fear accidentally swallowing a pin or stepping on a pin that has been inadvertently dropped. We speak of states of tension as being on "pins and needles." The material of the pin, steel, is itself the end product of a process of violent fabrication on a massive scale. Between the gigantic scale of the steel mill, with its enormous temperatures and furnaces, and the minute scale of the final shaping of the pin a chasm exists. The scale of the gigantic and the minute come together in the pin. Smith's image of some sixteen human beings surrounding and contributing to the correct shape of a single pin creates a disproportion that seems to violate the humanity of the workers, that the same violation can occur with extreme rapidity 4,800 times a day only multiplies the violation. Unlike the watch or the table the tiny pin can never be a source of pride. The workers seem foolish to spend their lives on a pin. The quantum of labor is too small to challenge the radius of the will, less than ten seconds per worker per pin. Repetition is substituted for development. The pin itself is not an object of direct use, like a table or a watch, but rather another tool or machine. It can be used to pin up a hem, attach a photograph to a wall, but in fact it is not a necessity at all. When used it will form a part of something. It seems pretentious to call a pin a thing at all. It is in fact a part that is being produced. We naturally prefer to speak of pins in the plural. Their analogy is to leaves rather than to a tree, that is, they fall naturally into those objects whose natural occurrence is in the plural, atoms or leaves, and for which the singular is a kind of nakedness. The pin has no uniqueness, each pin resembles every other, and forms a part of the world of equipment described by Heidegger: the sector of the world that exists

for use without attention and only appears as *something* in a field of consciousness when it is missing or has broken down.[25]

Smith has chosen the pin because, as Marx and later commentators have often pointed out, his concern is with trades that can potentially exist either as handicraft (the one pin per day of the craftsman) or as organized within the factory system (48,000 pins per day per ten workers).[26] Marx adds that in his own day the ten workers have been replaced by a single machine making 145,000 per eleven-hour working day. "One woman or one girl superintends four such machines, and so produces nearly 600,000 needles in a day and over 3,000,000 in a week."[27] The workers multiply only temporarily and in the end the single worker is replaced by a woman or girl, unskilled and with neither strength nor tools.

Veblen, with his droll sense of archaic resemblances, describes the worker's relation to his machine in this final stage in terms of pastoral. "In a general way the relation in which the skilled workman in the large industries stands to the machine process is analogous to that in which the primitive herdsman, shepherd or dairymaid stand to the domesticated animals under their care, rather than to the relation of the craftsman to his tools. It is a work of attendance, furtherance and skilled interference rather than a forceful and dexterous use of an implement."[28]

The standard description, that of Lukács, for example, would stress that where the craftsman relates his will and strength to the object by means of the tool, the worker in mechanized and rationalized industry stands in a contemplative attitude. The worker is an observer: "The contemplative stance adopted towards a process mechanically conforming to fixed laws and enacted independently of man's consciousness and impervious to human intervention, i.e., a perfectly closed system, must likewise transform the basic categories of man's immediate attitude to the world: it reduces space and time to a common denominator and degrades time to the dimension of space."[29]

All descriptions of the assembly line and Taylor revolution stress the conversion of actions that used to be consecutive into actions that are simultaneous but next to one another in space, the conversion of time into space. Paul Valéry's point about the loss of time in objects, what he calls a modern unwillingness to face any action that cannot be abbreviated, (as Impressionism abbreviated—by means of its technique of applying strokes of paint side by side,—the laborious process of drawing, coloring, and glazing again and again that made up the earlier process of painting) should more accurately be described as a impatience with any of the elements of

time that cannot be converted into space, or with any form of succession that cannot be replaced by juxtaposition.[30]

Since Marx's machine produces three times as many pins as Smith's ten workers, a dark equation is created in which the one machine replaces thirty workers. The image contains the modern horror of the production of things leading to a continuous world of processes in which the human is no longer imaged and finally disappears altogether. The choice of pins as the output that we picture spewing from the machine like some unstoppable natural process, leads to a final essential characteristic of the example. Although the machine is producing objects for use, they are of a size and a commonness that while the lack of them can be significant, the possession of them would never be considered "property." Without a maker whose stamp they bear, giving pride to no worker who has accomplished their creation, they are equally without owners. They drift in the world, forgotten, overlooked, lost, uncounted in a box. At incredible human cost they seem to have added nothing to what anyone would notice as Arendt's "world."

If we imagine the total stock of objects in the world and distribute them according to whether they are too small or too large to be owned, then Smith's pins are an ominous and disturbing fact, as disturbing as if we were to learn that the number of insects in the world was increasing exponentially on a yearly basis. The multiplication of objects, the flooding of the world with things is often described as an essential characteristic of technological society. There is almost a dark poetry of numbers at stake in the listing of the millions of pins, televisions, ballpoint pens, shoes, hair dryers, and so on, and this list is often invoked to argue the trivialization of individual things by the flood of objects quickly made, casually used, and discarded rapidly into the stock of junk. However, this multiplication of free-standing objects, while significant, is not decisive, for it represents no more than the wider availability, the democratization, of traditional princely wealth. A treasure hoard, a collection, of superfluous novelties and refined gadgets of every kind has always existed for the pharaohs, war lords, and mandarins of society. That this formerly minute class could be expanded to include nearly everyone within society is one of the demonstrations of 20th-century manufacture. But to extend this hypertrophy of possessiveness and ownership is not to change its nature in any significant way. The model for all such objects is jewelry. Anything attached to the body or juxtaposed to it has its value elided with that of the body. All free-standing objects are forms of self-adornment, and the analysis of such objects, including works of art used for self-

adornment, is perhaps best seen in the work of Veblen, writing at the moment when the expansion of useless objects for private ownership seemed the essential trait of modern mass-production.

However, the significant difference in objects does not lie at all in the diffusion of excessive and marginal kinds of ownership. In fact the most significant expansion lies in those products owned by no one: road systems, bridges, airports, information systems of all kinds, the apparatus and structure of the major corporations and governments. As Galbraith and others have shown, it makes little difference whether the ideology of the society claims that such things are owned by stockholders or by the people (meaning by that term not simply the actual living citizens, but the polity of future citizens, potential citizens, and so on).[31] The construction of the integrated total system of objects, owned by no one, is in fact the major revolution in things brought about by industrialism. We sometimes call this system of objects the infrastructure of society. Adam Smith has described the jump from one pin per day made by a craftsmen to 4,800 made by division of labor, and Marx in his day can extend this to 3,000,000 pins per week by one girl supervising a machine. The advance does not lie in the numerical increase of insignificant pins, presumably one per month for every English family. It is not the pins but the pin-making machine that has been made and locked into the system of trains to transport the pins, canals and docks, supply systems for power to run the machine, mining and fabricating industries to produce the wire that will be made into pins, etc. To stress the number of pins is a technique for expressing in terms of possessible objects the results of a system essentially creating a larger and larger proportion of non-possessible systematic things.

In the city of New York nothing, no collection of things owned by any individual, has any of the power to excite wonder and images of self that the entire city of bridges, buildings, electrical systems, information systems, water systems, and airports has. No refined gadget owned in private by any individual is even a thousandth part of the marvel of hundreds of diagnostic machines owned collectively in the city's hospitals. The effect of this dramatic change is to devalue ownership itself, or rather to deprive ownership of its classical uses for demonstration of individual uniqueness, magnificence, and perfection.

The model objects that we bring to this ownerless assembly obscure both its nature and the expressive relation to the skill and temperament of a craftsman all shift our attention from the actual details of the systems and objects by which we now find ourselves

surrounded. A first step in comprehending any novel situation has always been to model it as a variation of the situation it replaces. Democracy could at first be described by saying that in a democracy every man would be a king. But, of course, kingship itself has been abolished, not simply distributed more widely.

In our model objects for the industrial world we have similarly reached back to the abolished world of craft objects that imply both the individuality of the maker and the equally important individuality of the owner. This has led us to picture art as an antagonistic object, a counter-object displaying both the aggressive individuality of the maker and the parallel, and equally strenuous, individuality of the owner whose advanced taste and daring it seems to embody.

## Art Objects and the Quarrel with Mass Production

In his well-known letter of 1925 to his Polish translator, Rilke described the new American objects in this way. "Even for our grandparents a "House," a "Well," a familiar tower, their very dress, their cloak, was infinitely more, infinitely more intimate: almost everything a vessel in which they found and stored humanity. Now there come crowding over from America empty, indifferent things, pseudo things, Dummy-life. . . . A house in the American understanding, an American apple or vine has nothing in common with the house, the fruit, the grape into which the hope and meditation of our forefathers had entered. . . . The animated, experienced things that *share our lives* are coming to an end, and cannot be repeated. We are perhaps the last to have still known such things.[32]

Repeating the analysis of Tocqueville almost one hundred years earlier, Rilke, with the high-cultural disdain that would energize craft movements and quests for authenticity of all kinds in the 20th century, underlined the feeling that the new objects, released in a flood of mass production, were not "real objects," were not "authentic." If we primarily visualize mass produced objects as the 19th century often did (that is, as clever substitutions of cheap material disguised as the more expensive hand-worked materials of the past, identical objects but now available in quantity without quality, like the small ten-cent plastic comb made to look like bone, or plaster castings treated to simulate marble) then the equations of Rilke and Tocqueville have a logic. But this image is, of course, tendentious.

Furthermore, the areas of life touched most quickly by the rev-

olution were not the marginal areas of social existence but the most intimate and resonant sectors of material life: clothing and housing, food and medicine, transportation and communication. The body and the self, the voice distorted over a telephone, the image in a black and white photograph, the clothes on the body, the housing in which we find ourselves, the transportation systems within which we move ourselves or our images or our messages from place to place: these, as Siegfried Giedion has shown in his classic work *Mechanization Takes Command,* were precisely the areas invaded and transformed by mass production with its key features of assembly line, standardization, the new system of interchangeable parts, the division of labor, as well as the new efficiencies of scale and replication.[33] How we deal with sickness—the hospital and pharmaceutical industries have always been at the frontier of machinery, substance invention and technological experimentation; how we entertain ourselves—a second area where technology and mass production have been especially active and totally effective: that so many fundamental areas of experience were quickly conquered is a sign of the naturalness of the material revolution that Rilke is describing as at once "unreal" and "American."

The societies most quickly saturated by these "inauthentic" and replicated objects were societies in which a contrary process, a heightened drive towards authenticity, became the strenuous program of culture. Museums became more and more central exactly in cultures touched most deeply by the factory system. The British Museum in London and the Metropolitan Museum in New York represent a new kind of institution. No longer did they provide a "visible history" of the culture itself: that is, a visual display of objects rich with symbolic, local significance. These institutions are instead storage areas for authenticity and uniqueness *per se,* for objects from any culture or period whatever that were "irreplaceable" or singular. Museums are counter-institutions to the factory within civilizations of mass production. As objects became more short-lived and geared to obsolescence, or rather to an ongoing series of inventions and adjustments that produced as one side effect obsolescence, the museum became more skilled at preservation, that is, at keeping selected things in a state what would never deteriorate or change. Such things feature the surface look of the old, the "archaic," in contrast to the surface look of newness and freshness that is the essence of social objects undergoing constant improvement. Museums, at just the moment when Rilke was writing, were beginning to expand their collections to include African, Oceanic or other so-called primitive objects. Such objects have the greatest

chance to be included as art, as "authentic," in so far as they have the look of the primitive, the hand-made, the magical, the sacred, or the symbol-laden. The museum, in this stage, is simply an institutional expression of the usefulness of art as a counter-world to the world of the factory with its mass-produced objects.

Two features of the museum's pressure on the objects within it deserve special attention. Both are puzzling as elements of authenticity until the social context of mass production is included as a frame of reference. First, the museum orders objects systematically as part of a history, a world-view, a style or a biography. It converts objects into parts of a series. One of the deepest effects of mass production has been to replace the object with the series of ever improved "models" of the object. A society driven by what has often been called the "invention of invention" reconceptualizes each thing as only the latest version within a series subject to indefinite future improvement. The series of forms, inventions, or improvements within the product world is imitated by the series of movements of styles within the art world in a museum culture. The so-called radical, avant-garde claim, made by so many movements, to have made all earlier art obsolete is a direct appropriation from the language of products and inventions. The museum articulates and gives social validity to the priority of the series over the individual work, defining the meaning or importance of the latter as its position within or importance to the sequence in which it occurs.

The second feature of the museum's pressure on the object within it is to drive the object towards abstractness. The final stage of abstractness lies in a condition of pure enigmatic presence. In earlier chapters I have described how the museum effaces the object, removes its features, just as a coin rubbed in many years of use loses its images and is no longer a coin, but simply a disk of silver like any other piece of metal.[34] We could say of the effaced coin that it used to have a specific monetary value and could circulate and function within a certain economic system, but that outside the borders of that system it was just "metal" and not a working coin at all. Of the effaced coin we should say that it has undergone abstraction. It is no longer culturally specific. Nor will it any longer work in transactions at a bakery or newsstand.

For the museum, the abstractness that results from the effacement of specific religious, political, or personal symbolic features is, along with the series relation, the key feature. This process meant that, in its quest for authenticity, or, as it might be put, non-social authenticity, the museum culture in a factory world was inevitably

tied in the long run to exactly the kind of abstract, imageless art that the 20th century produced. More directly, we might call abstract art "pre-effaced art," or the production of objects that do not require effacement prior to their appearance in this new kind of collection.

It is this group of abstract or pre-effaced objects that are, in certain ways, the goal of the museum structure itself. They provide the core of examples for the declamatory authenticity that is the social goal of the museum's answering argument to the factory. Since the objects of everyday life are most clearly understood by means of their uses, the museum objects are not only not useful, in the ordinary sense, they are also free of those images or cultural values that might have been part of the work of moral or social instruction and uniformity. Effaced or abstracted, the works of art make up the primary anti-objects of the world of mass production. At the same time, there remains a deep bond between effaced art, with its requirement that we be able to respond to an art cleansed of social, religious, or personal reference systems, and the culture-free objects that are the inevitable goal of mass production. The small portable radio that can, in Peru, pick up the broadcasts from Lima, or, in China, the words on Beijing radio; in America, pop-music or a baseball game; in England, the BBC: such an object is culturally abstract. The universality of culturally neutral technological objects that can be installed and made use of anywhere replaces the variety of locally specific but elsewhere useless objects. This suggests that the internal drive towards effacement is equally essential in mass production and in the superficially antagonistic world of the museum.

## The Theory of Antagonism

In the 1950s, some thirty years after Rilke's letter, a series of key essays were written for what was widely recognized at the time as the shift of the center of the art world from Paris to New York and the simultaneous floodtide of a second wave of American objects—this time high cultural objects—that involve cultural questions of market, hegemony, and the destruction of local production systems on no less a scale than that brought about by Boeing airplanes, IBM computers, or American winter wheat.

The essays of Clement Greenberg and Meyer Schapiro legitimized American painting, laid claim to its successor role to the most compelling and intelligibly ordered movements from the time

of Monet through Cubism and the best work of the 1930s and 1940s, and created an open-ended defense that easily accommodated itself to the painting of the 1960s and 1970s that succeeded the generation of Pollock and de Kooning.

I want to consider Greenberg and Schapiro for a moment because together they display the two lines of argument that have dominated American criticism and defined the essence of the work of art as, on the one hand, an anti-product, an inversion of the terms and conditions of mass-produced objects (and this is Schapiro's implicit argument) or as an authentic historical object, a candidate for membership in an ideal "museum of art" (and this is Greenberg's central frame of reference). The museum object in this case is simply a more sophisticated, more cleverly disguised contentious object to the reality of everyday production.

Meyer Schapiro's 1957 essay "Recent Abstract Painting" is a classic statement of the art object as a device each of whose details can be understood as the negation of the ordinary social process of work and object production.[35] The overriding antithesis for Shapiro is between the impersonal realm of ordinary objects and the personal realm of art objects.

"Painting and sculptures," Schapiro wrote, "are the last handmade, personal objects within our culture. Almost everything else is produced industrially in mass and through a high division of labor. Few people are fortunate enough to make something that represents themselves, that issues entire from their hands and mind, and to which they can affix their names."[36]

Because our ordinary work is unsatisfying and impersonal the work of art by inversion must represent ecstatic and satisfying work; it must be "more passionately than ever before the occasion of spontaneity or intense feeling" exactly because ordinary work lacks spontaneity and feelings.[37] Because normal objects are impersonal, the art object must become conspicuously intimate; because the normal work process conceives accident only as the breakdown of a smooth pre-conceived plan, the work of art must feature the signs of luck, accident, improvisation, and their successful exploitation for order and pleasure. Where the surfaces of normal objects show a smooth regularity like that of polished metal, glass, or plastic—a uniformity of texture from place to place that yields the characteristic smoothness or evenness of mass production—the work of art from Monet to the present must "stimulate the artist to invent devices of handling, processing, surfacing which confer to the utmost degree the aspect of the freely made. Hence the great importance of the mark, the stroke, the brush, the drip, the quality of

the substance of the paint itself, and the surface of the canvas as a texture and field of operation—all signs of the artist's active presence."[38] Since closed forms are a feature of the product world "the art of the last fifteen years tends more often to work with forms that are open, fluid, mobile; they are directed strokes or they are endless tangles and irregular curves, self-involved lines which impress us as possessing not so much of things as of impulses, of excited movements emerging and changing before our eyes."[39]

The gigantic size of these paintings Schapiro interprets as a way, both for the working painter and for the audience standing close to the work, to block out the environment altogether and experience the work as endless. Even the obscurity or difficulty of telling what the work is about, that is so common a response to abstract work, he reads as a counter-thrust to a society in which the communication arts are central and perfected to a degree that makes the work of art refuse communication, refuse the social channels of intelligibility. Schapiro's very interesting theory of unintelligibility, the willful refusal of communication, has as its implicit counter-image something like the advertisement in which semantic details are radically integrated so as to give instantaneous, un-conflicted communication of values, feelings, and proposed self-images. Because the science of the unified message is one of the highly developed characteristics of the world of objects, Schapiro sees for art the privileged alternative of impeded or refused communication. As Schapiro's summary states: "All these qualities of painting may be regarded as a means of affirming the individual in opposition to the contrary qualities of the ordinary experience of working and doing."[40]

The art objects Schapiro describes are quarrelsome, deliberately challenging objects, a system of significant gestures out of which, by a process of simple negation, the normative signs of the working culture can be read. It is crucial to see how easily a reading could be given of the same details that would make them parallel, rather than contrary, to the ordinary world of objects. The unintelligibility of an abstract painting can seem the opposite of a world of communication or it can seem one deepened expression of the unintelligibility—for most people—of the machines and complex objects of ordinary social life. An advanced piece of medical technology or the inside of a common household radio is at least as puzzling to an ordinary person as a Jackson Pollock painting, and even more threatening to his sense of himself as a competent adult who knows how to use the objects of his culture. The size of the typical modern painting can be said either to eliminate the environment, as in the Schapiro analysis, or instead, as I would argue, to parallel it

since the primary aspect of the new built environment is its gigantic scale, its aggressive dominating presence (a characteristic description for both the New York environment and the New York School of Painting).

Schapiro's account makes of art a heroic last stand, but a last stand with many of the features of strenuous, extraverted energy and overwhelming presence that are the characteristic features of the noisy, overwhelming material world against which the art is said to stand.

Whereas for Schapiro the making of the object and the general social background of work is the context of the work of art, for Greenberg, on the other hand, to consider the finished work as a part of an ordered past, would define it completely. The work of art *is* its place in the sequence of art history which is itself seen as an explanation, like the history of invention.

Greenberg's essays, collected in his 1961 book *Art and Culture*,[41] have dominated the interlocking worlds of museums, the university teaching of art, the art market, and its collectors and gallery owners to a degree that is unprecedented. It would be hard to find in the history of American art a critic whose categorical and rigorous taste has so clearly imbedded itself. The explanation for this lies in the fact that the central category for Greenberg, far more important than the individual work, is the history of art itself. Naturally this has immediate appeal for the rapid academic translation into the systematic courses taught in our art departments, but it has at the same time a deep relevance to the now fatal connections between the art market, the role of collectors, and the primacy of the museum.

What Greenberg provides is a way of immediately valuing an art object in terms of its potential future as a part of a museum collection. The goal for an artist is to design a work that is inevitable to what the future will see as the order of the past. Without an "example" of this kind of work, the intelligible, ordered past (as museums demonstrate it) would have a gap: therefore the work becomes necessary, that is, invaluable.

In other words, where Schapiro is an ideologue of rebellious, contrary objects, Greenberg is a theoretician of possible future museums, and since collectors are simply holding operations for the museums to which they will eventually donate their collections— no major collector at this point collects so as to pass on a family treasure to children and grandchildren—the value of works in the market itself depends on a guess as to what importance they will have as part of the future's past of authentic objects. For Greenberg

the painting proposes the series of which it is a member, and by its membership it makes itself authentic. Since I have already described in earlier chapters the central features of the museum and its authentic objects, I will omit here a more detailed description of Greenberg's strategy.

Where Schapiro makes the art object a rebellious antagonist of present objects, chiefly by building in prominent archaic traces of the hand-made, individualistic, unsystematic, and unique hand-crafted object world of the past, Greenberg goes even further by visualizing the object—even in the eyes of the artist creating it—as not a "present" object at all, but merely a candidate for the past, a non-object unless it becomes a detail of what will, some time from now, be the history of this moment, which we who live in it happen to call the present.

The quarrel with the industrial present that appears so unmistakably in Meyer Schapiro's account of abstract art suggests that the act of enjoying a work of art takes place almost as an act of protest and subversion. In his description we might imagine ourselves to be practicing a radical stance every time we stand in front of a painting by Jackson Pollock. The heart of the protest lies in our intuitive comprehension of how the object was made. One undeniable fact about modern art is that its audience is unusually aware of just how it was made. For one thing the ever changing and sometimes bizarre novelties within the work (or lack of work) aspect of the art object force our attention towards the process in a way that traditional works of art did not. The tiny dots of Seurat no less than the drips and string-like poured lines of Pollock set the making process in front of us, especially in so far as it is an idiosyncratic or a proud invention. It is equally true that we become conscious of Monet's process or of Cézanne's or of the welding process of David Smith in so far as the background world of everyday objects are or are not commonly made in just those ways. In the case of Monet, Cézanne, Pollock, or Robert Rauschenberg we are conscious of a working process unique to art, but with the welded sculpture of David Smith or Anthony Caro we stand within processes comfortably within the ways metal is used and put together in the industrial world.

The quarrel that Schapiro locates as the heart of the vitality within the abstract painting is a repetition of the very argument present within the model object of the table, but now located within works of art themselves. In the chapters that follow I will first look at one further model object, the traditional one within culture, the masterpiece, an object which like the pins, the table, and the ab-

stract work of art in Schapiro's description, stands over against a world of everyday making. Finally, I will turn to the features of made everyday objects that suggest that a sympathetic imitation and not an antagonistic counter-statement offers a more accurate path towards an account of the experiential features of modern works of art.

# Art Works and
# Art Thoughts

Pins and tables, along with works of art of the size and investment of time represented by a Rembrandt self-portrait or a Cézanne landscape, are model objects that we tacitly use to measure and categorize the larger world of made things. As the preceding chapter has tried to show, an object like a table invites us to see the modern work of art as, in part, valuable in proportion to the number of conditions of everyday work that it manages to contradict or invert. Meyer Schapiro's analysis of postwar American abstract painting had a premise of this kind implicitly in mind. The extreme individualism of the product, the uniqueness and uselessness of its intentions, the exaggeration almost what we might call the flaunting of archaic craft values and procedures, all call attention to a deliberate inversion of and distancing from the norms of production and the special values of commonplace objects in the modern period of mass production and replication. The craft object, like the museum object, defines a boundary across which the work of art is seen in an antagonistic, denunciatory relationship to contemporary work and contemporary objects. Modernism is, in this sense, the dream life of the factory system.

A fourth term needs to be added to pins, a table, and works of art to complete the challenging models that, from the side of production, act, just as the museum does from the side of destination, to drive a wedge between the work of art and everyday objects in the modern period. The final model object is the traditional, de-

manding category of the Masterpiece. Because this term originates
within the world of skill and work it testifies to the time-bearing
features of objects. The object in a sequence or series is designed
to be aggregated into larger groupings. We might say that, as the
analysis of Chapters 4 and 5 concluded, objects designed to fit into
a series, whether of questions and answers, or of the progressive
unfolding of a problem, are objects designed to be incomplete. The
masterpiece is, among other things, the quintessential complete and
finished object. While it includes evidence of skill, work, and time,
it is not designed to fit into time. We speak of masterpieces as
timeless because we imagine that the small set of masterpieces drawn
from whatever historical moment can be clustered together in the
imagination and experienced in any order as instances of perfection
and fullness. More importantly, the category of the masterpiece is
singular, just as the museum object is inherently plural. Each mas-
terpiece stands isolated in space, containing time, but not in time.

When we attend to the question of why modern works of art
stand as deliberately outside the category of the masterpiece as they
do outside the category of utility, one answer results from consid-
ering the content, but content understood in a different way from
the subject of the work or the realistic representation within the
work. If we think of the content of any object as the effort, thought,
skill, or time required to produce it, then by content we mean the
evidence that the work presents about itself or, in some cases, con-
ceals about itself as an artisanal object. Time, thought, skill, or
labor can be said to be stored in the object and subject to a viewer's
attention, recognition, or pleasure. By considering the traditional
category of the masterpiece in terms of this question of what stor-
age we attend to within the work of art, we can see that an object
can be designed to testify to either a history of work or to a history
of thought. It is by means of this opposition, this imposed choice,
that the masterpiece becomes a final antagonistic object, from the
side of production, for the modern work of art.

## The Calais Masterpiece

In the year 1576 apprentice cooks in the French city of Calais who
wished to pass on to journeyman status were required, just as the
members of all trades were, to produce what was technically known
as a Masterpiece to demonstrate their expertise. Today, perhaps
only the academic world remains medieval enough not only to be
still awarding the title Master of Arts or Master of Science, just as

one could once be Master Chef, Master Carpenter, or Master Lock-smith, but also to retain, in the Ph.D. thesis, something of the traditional ordeal of the Masterpiece.

The very term "masterpiece" was most at home in the guild, trade, and craft traditions of the Middle Ages. Painters, for example, were eager to separate themselves from the traditional crafts so as to be considered artists, and for that reason were reluctant to use the term. Walter Cahn in his recent study of the history of the idea of the masterpiece has traced out the revolution within the term by which this originally artisanal concept migrated into high culture until it took its place within what has been called the "modern system of the arts," a system firmly established in the 18th century.[1] In alliance with the early 19th century's concept of genius, the term "masterpiece" came later to stand, in the realm of objects, for something equivalent to Hero, Saint, or Genius in the realm of personality. The masterpiece, like the hero or the saint, was evidence of the nobility of the human spirit. It is one of those terms in which we see most clearly the force of the modern concept of a distinction between the mass of ordinary objects or persons, on the one hand, and the exalted few heroes or masterpieces, on the other. Such terms as "genius" or "masterpiece" betray an underlying unspoken horror of the crowd, the newly enfranchised democratic masses, and the stronger and stronger grip of the everyday and the ordinary for which mass production was the key in the realm of objects. The growing importance of the terms "genius" and "masterpiece" in the 19th century, in the aftermath of the French, American, and Industrial revolutions, points to the anxiety of the hidden counter-terms.

The medieval and artisanal force of the term "masterpiece" pointed in another direction entirely. It called attention to the time bearing features of objects. The Calais cook was expected to display skill and mastery that implied a knowledge of the full range of the standard tricks of the trade. He had to know the common procedures of his craft and to boast a familiarity with the ways of working with its usual material substances. The required masterpiece for an aspiring cook in Calais was as follows. As Walter Cahn has quoted it, the cook must prepare: "A turkey in rum and vanilla sauce; three partridges in a paté; a milk-fed kid roasted on a spit; a boar with lard; a tart with jellied filling decorated with fleur-de-lys of different colors; a basket made with candied sticks inter-laced and variously colored; a lion carved in jellied cream; an imitation bunch of grapes made of jelly; and an almond tart."[2]

Since we have to hope that the cook and his judges sat down at

once to eat this artisanal masterpiece, we can feel confident that one of the time-bearing features of this achievement was not the intention that it would, once finished, be preserved in that state as long as possible in some imaginary museum of culinary works of art. The cook's masterpiece does not include an intended future towards which its details are organized. Unlike many of the objects that we consider works of art, this elaborate feast is not designed to outlast the maker, to survive him and become part of what we know as the past. These are precisely the traits that Hannah Arendt would list in her chapter on the work of art in her book *The Human Condition.* The Calais chef is not contributing to what Arendt calls the durability of the world, one feature of which is made up of just that set of things that outlast the maker.[3] To make a table is different from making a loaf of bread because the very premise of the second is that it will be used up and destroyed so as to prolong the life of the man or woman who baked it. The table, if well built, and lucky in its history, can become part of the durability of the world for tens of generations that are born, draw their chairs up to the table to eat, and then pass away and are replaced by others in the same seats at the same table. The loaf of bread is Arendt's example of human labor; the table, of human work. As an even more exalted category she keeps the work of art as an object as far above the table as the table is above the loaf of bread. The dimension in which that distance is measured is that of a future towards which the object is directed, as though our art were not for our pleasure, but rather a kind of explanation of ourselves to unknown future conditions of humanity.

At first this Calais production seems to lack not only the direction towards the future, but also the feature of extended labor, the time-bearing feature of the past that complements the durability oriented towards an imagined future. The entire meal would have to be prepared in a day or two. Thus what we have come to call, since the work of Ricardo and Marx, the "congealed labor" present in all of these various jellied concoctions could be no more than a matter of hours. Even the wonderful sounding "lion carved in jellied cream" would have to be quickly executed in the dangerously fragile material which might at any moment become a creamy soup. In this brevity of execution, the cook's masterpiece would be different from those required of such trades as carpentry, goldsmithing, lock making, rope making, or the modern Ph.D. thesis, where the assigned projects might take a year or even more. So lengthy had they become, that they finally had to be limited by

royal edict in France to no more than what could reasonably be done in about three months.

In each of the other trades, including painting, the intricacy, size, and resistance of the materials would themselves be evidence of the many hundreds of hours of labor built into the finished object. Such mixing of labor with material has commonly defined, since the time of John Locke, our notion of ownership and rights. Quantitatively, the more investment of labor, the more obviously the material has been transformed from the state in which it was found, the more the object has entered our social and legal sphere of rights and property. Property rights, however, begin with the right of he who first finds or notices a thing. A man walking along the seashore who finds a pearl in its shell can call it his. Our modern notion of the found object as a work of art plays with this same notion. Even the act of noticing something not seen before is a mixing of our labor with the object. Locke's argument will cover Picasso's *Venus de Gaz*, an upright standing pair of burner rings from a gas stove, which he and he alone first noticed as a goddess-like object if lifted from the horizontal to the vertical plane.

What is unworked is unowned. Tocqueville, for example, followed Locke's argument to claim that in North America the native population did not "own" the land. "Although the vast country that I have been describing was inhabited by indigenous tribes, it may justly be said, at the time of the discovery by the Europeans to have formed *one great desert*. The Indians occupied without possessing it. It is by agricultural labor that man appropriates the soil, and the early inhabitants of America lived by the produce of the chase."[4] Surprisingly, to our ears, Tocqueville calls this rich and fertile land "one great desert" using the term to mean deserted, not uninhabitable. It is deserted because it is unworked, unimproved in the 18th-century sense of the word. By mixing time and labor with the land, the settlers removed it from nature and made it theirs. Significantly, landscape gardening was commonly listed as one of the fine arts in the 18th century at the moment in which the great colonial appropriations of the so-called unimproved lands of the earth were taking place. In gardening each man practices the act of possession. Rousseau in *Émile* teaches his young charge the meaning of labor and property by starting a garden and then finding it, weeks later, torn up.[5] That landscape gardening was one of the Fine Arts for this brief period was driven by the underlying colonial fact.

In the case of the Calais cook, the literal absence of prolonged

labor only makes more evident the temporal feature that the test is designed to display: virtuosity. The accumulated skills that can now be rapidly synchronized, the evidence of training and practice: it is the lengthy education in all its duration and application that is given proof in the "imitation bunch of grapes made of jelly" or the candy basket. What skill means here is a combination of duration, repetition, and standard practices—recipes, as they are called in cooking. Most of the artisanal contracts or descriptions of the work that specify what will be acceptable as a masterpiece require that it be done "in the accustomed manner." It is decisive that what the cook is not called upon to demonstrate is his originality or inventiveness.

First of all, the very meaning of craft or of competence is, in many subtle ways, at war with the notion of originality. Habit, practice, precision, the steady hand, the repetitive stroke, are all basic elements of skill. To give evidence of them is to testify to many tedious hours of practice. On the other side, and perhaps even more important, originality or invention commonly has an instantaneous quality to it. We speak of the answer or the original idea as "just coming to me suddenly. There it was. It came out of nowhere." Because of this instantaneous quality, invention or originality can never embody or witness the investment of time in the way that the careful following of standard practices can. It is often very difficult to tell just how long an original object took to make. Whereas a copy, an exact duplication, testifies in the closeness of its details, to the time and to the skill of the counterfeiter, or maker.

The link between, on the one hand, originality and flashes of inspiration (that is, quickness of execution or instantaneousness), and, on the other hand between artisanal skill, replication, and non-originality, and the proud display of patience and time put into the product, are links with very important implications for the modern system of art. The question can be put in this way: to what extent is an art system that is driven by the requirement of originality inevitably driven to produce works with less and less artisanal quality? Must such a system produce works in which, in order to make the moment of originality more and more conspicuous, the resulting final object must be rapidly executed as the trace or evidence of the instantaneous moment of originality? This too is a time-bearing feature of objects, even if opposite to the time of labor or invested skill. Must such modern works take on the time frame of thought rather than that of labor in order to testify to the speed with which they were executed as the essential proof that they capture something unprecedented and novel? Must the time-bearing features

connnected with craft and work—one feature of which is repetition—disappear because they are incompatible with the requirement to produce only evidence of invention and the lively play of thought and impulse?

Within artisanal work, just as in modern everyday production, the basic distinction is between standard work and what is called "quality work." In quality work, constraints of time, expense, and material are removed in so far as possible. What results is the best possible product of the customary techniques. Quality work is not the result of experimental practices, but rather of redundant and exceptionally safe, over-guaranteeing of reliability and endurance. The distinction between standard work and quality work is radically different from that between ordinary work and inventive work. Quality work does not demonstrate originality, but rather patience, precision, and care. It is more likely to be conservative technically.

In a passage that Walter Benjamin singled out, Paul Valéry gave a picture of work of this kind when he compared such masterpieces with what he called "the perfect things of nature such as flawless pearls, full-bodied mature wines, truly developed creatures" which he spoke of as "the precious product of a long chain of causes similar to one another."[6] Valéry is describing processes whose essence lies in repetition, like the smoothing of a rock over time by the action of water. The evidence of such processes is frequently found in the glow of a perfectly smooth surface. It is characterized by polish, by evenness, and by the look that work in metal would typically have been expected in the past to have—a bright, even polish. It is seen in the look of smooth, carefully worked marble, or in the look of a Vermeer painting with its many layers.

One of the most common features of the art of the past hundred years has been its rough surface made up of harsh, even crude or simple strokes. Valéry's comparison, on the other hand, is between tedious and incremental natural processes and the work of traditional art. "This patient process of Nature was once imitated by men. Miniatures, ivory carvings, elaborated to the point of greatest perfection, stones that are perfect in polish and engraving, lacquer work, or paintings in which a series of thin transparent layers are placed one on top of the other—all of these products of sustained, sacrificing effort are vanishing, and the time is past in which time did not matter."[7] Of course, the opposite is meant by Valéry, because time did not matter, one took time, and within the work what above all mattered was that it had taken time.

What Valéry associates with an almost religious drive for perfection and an accompanying human patience that approximates the

idea of eternity, can be, as I am suggesting, referred back to the logic of originality. From Valéry's point of view, the Impressionist technique in which strokes of paint are set side by side serves to abbreviate or speed up the traditional painter's system of glazes. "Modern man no longer works at what cannot be abbreviated," Valéry concludes.[8] The factor of time is understood in only one way since the advent of mass production: speed. For Valéry the essence of mass production can therefore be summarized as abbreviation.

But his description misses the key detail. Wherever cumulative process is pushed into the background, the moment of invention comes to the fore. The visible strokes of Impressionist painting technique form a record of impulses or thoughts. Each decision leaves its own trace. Technique does not obscure the path that it has taken, as, for example, the finished surface of a Vermeer painting does, making the process a mystery.

Historically, it is a decisive fact that procedures were held secret within artisanal work. Each new apprentice was only over time taken into those secrets which he, in turn, was sworn to protect from outsiders. The existence of craft secrets thus favors a final surface that would deny the viewer the knowledge of the process. The polished surface cannot be deciphered by the uninitiated, but each new apprentice within the trade would undergo initiation not only into the secrets of the trade but also into the means by which work could be executed and the secrets kept secret at the same time. It also takes further secrets to keep the secrets hidden. Thus the shining even surface of Vermeer.

In the modern period the crude, easily imitated work processes of Monet, van Gogh, or Jackson Pollock are proudly displayed on the surface itself as a way of announcing that anyone can have them because the work process is no longer the secret of the work. What is withheld in the modern work, as artisanal processes and trade secrets were in the traditional work, points to (without revealing) the center of value.

For Vermeer the final steps that the painter takes seal the surface which is itself made up of a series of semi-transparent varnishes which only in combination produce the color that we see. The process by which it has been done is hidden. The finished work is what we call a "black box." After Monet paint is commonly applied wet in side by side strokes. What the viewer sees is the aftermath of the process itself. The craft secrets, the anatomy of the painting itself stands right before the eyes. In traditional terms, what we are seeing is the "inside" of the painting.[9] With modern

painting there are two distinct visual experiences: the first, when we stand between one and six feet away, reveals the history of strokes. The second, when we stand at a distance of 20 to 40 feet, allows the magic to reappear as the strokes are blended by the eye at a distance.

To move in close is to share the point of view of the painter himself, who is always standing—obviously for technological reasons—less than an arm's length from the canvas as he works. Standing close enough to be, as the painter once was, less that an arm's length away, we see the individual strokes out of which a tree, a passage of sky, a rock, or house are made. Touch, in a Cézanne painting, is transparent as it was not in Vermeer, Raphael, or Piero della Francesca.

In the case of the Masterpiece of the Calais cook we can see that baking and cooking are also traditional crafts in this sense. When we look at the finished pastry we cannot reconstruct how it was made or even what the ingredients were. The publication of recipes, as opposed to keeping them secret, allows duplication, but notice that there is still, in cooking, a hesitation about whether or not to give out a recipe that would allow others to replicate one's feats. Cooking is a traditional and complex craft, obviously the oldest one in civilization, and it is a craft that stays at least in part within the tradition of the mystification of means. One sign of this is the pleasure in effects—the soufflé, for example—that the viewer is astonished by and unable to supply an explanation for unless he or she has been initiated into the secret. The carefully blended aromatic sauce in cooking is exactly a mystified final result, a product of many unknown steps and many no longer identifiable ingredients, like the surface of Vermeer.

The modern transparency of means within art has its counterpart in the fundamental requirement within scientific knowledge that any result be replicable by any and every other scientist who follows the procedures. The process cannot be kept secret. Each result must also include a description of the means by which it was obtained. There can be no craft secrets within the conditions of modern laboratory science, and modern art has followed this notion of transparency.

It was a commonplace for people to say, when they first saw the paintings of Jackson Pollock, "I could do that!" Of course, this only points out one of his goals in the painting: to make you see just how he did it, in what order the colors were applied over one another, where they were dripped, where poured, where brushed, where splattered. When seeing the ingenious Picasso sculpture of a

Fig. 13. Pablo Picasso, *Bull* (bicycle parts), 1942. Original from seat and handlebars of a bicycle. Copyright 1991 ARS, New York/SPADEM.

bull (Fig. 13) made from a bicycle seat and handlebars the most obvious first thing to say would be: "I could have done that. I even have all the parts at home." The second thing to say is: "But I didn't do it. It never occurred to me to do it. I never saw the possibility of the image of a bull in a bicycle seat and handle-bars." It is at that point that self-directed modesty returns and the viewer's admiration for the art is directed away from materials or the

process of making and towards the true difference between spectator and artist.

In this case the transparency of the means—simple juxtaposition—and the fact that everyone already owns the materials only calls attention to the act of seeing, which is now made distinct from the craft secrets, skill, and even from any investment of time in carrying it out. He did it in five minutes, we feel sure, or less. The effect of transparency or replicability is to isolate the idea of genius and the fact of seeing. The artist does not step so far in front of the spectator that the spectator cannot follow. With Picasso's bull everyone can see at once just what it was that Picasso saw. We might imagine his ideas being so oblique to our own that we simply couldn't follow, just as we cannot follow a brilliant new argument in Quantum Electro Dynamics. In the narrow space where the artist is a few steps ahead, but not too many, he can produce just those works where we can immediately see what it was that he saw while at the same time acknowledging that we could not have seen it for ourselves. We do not have to puzzle over it or wonder what he is getting at. Our own suddenness matches his. Artist and audience both live in the time scheme of a flash of thought. In such an act Picasso defined the relation between the moment of original seeing, on the one hand, and, on the other hand, seeing what someone else saw and isolated for us to see. In modernity this pair of acts allegorizes the pleasurable relations between artistic genius and its worshipping audience of ordinary consumers of culture.

To make scientific experiments repeatable or works of art duplicable seems to democratize what had formerly been an esoteric, secret-bound, elite group, whether of alchemists, potters, bakers, or painters. The real effect is to make clear the absolutely unduplicateable part, which lies in the moment of seeing. Transparency has the paradoxical result of serving to prove the romantic idea of genius which is an even more mysterious secret than any craft secret.

The visible stokes, touches, smears, gouges, cuts, or joinings of edges within the modern work of art can most often be noted individually as the traces of countable episodes of action. It is this that Chapter 5 described in detail for Frank Stella's *Cones and Pillars II.* The steps, or thoughts, are preserved because they themselves—as the set of inventions within the object—are the subject itself, the facts by which the artist wishes to be judged. They make up what we might call the "evidence" of the work. In the modern

work we find evidence where we used to find reference; that is, representational content.

This production of traces or evidence explains, I think, one of the features of modern artistic careers, that is, the striking number of distinct individual works that the artist produces. One consequence of an enormous output is that a smaller number of hours or minutes of work are allotted to each finished object. In the final months of his life, between January and April 1940, Paul Klee completed 366 separate works of art, an average of three per day. Altogether, in the final three years of his life Klee produced 2,372 paintings and drawings; 1,253 in 1939 alone. Picasso frequently produced more than a thousand works a year, often a dozen in a single day. Only by withholding his works could his dealer keep him from driving down the value of his works by "overproduction."

At a superficial level a list of Klee's 1,253 works of 1939 simply points out, as does Picasso's almost uncatalogueable output, the modern refusal to throw out anything so valuable as even the least interesting product of the hand of Picasso or Klee.

The large number of works also points to the refusal to make a distinction any longer between a preparatory study and a finished work. As the twin paintings within Stella's output demonstrate, we have abolished the category of the sketch. At the same time, most of what we consider finished works take place with the rapidity and improvisatory spirit of what used to be called a sketch. Every work is, as Picasso's career demonstrated, equally a sketch and a finished masterpiece. The current museum practice, even with so classical a painter as Degas, of exhibiting together works at every possible stage of finish, undermines or disregards the very idea of finish itself. We do so in order to be able to track the thinking—that is, the originality, the unexpected paths and directions, however aborted—of the artist's mind. That mind itself has become our topic and not the work.

The almost uninterrupted (except for sleep or pleasure) output of Picasso's hand in his later years makes his work seem almost the output of one of those hospital monitors hooked up to trace the slightest variation in the brain waves or pulse of an unusually interesting patient. Each work of Klee or Picasso, by scaling down the time, more clearly isolates the one impulse, thought, or transformation of practice or imagery that called it into being and of which it remains the permanent evidence. In recent years it has not been unusual to hear it said that the notebooks or sketches of Leonardo da Vinci or Rembrandt are more interesting that many

of their finished works because, in the sketch or drawing, the process of thought is visible. The spontaneous movements of the hand, the impulses are directly registered.

An art based on the line, on drawing, in effect, as Klee's, Picasso's, and Jackson Pollock's have been, is an art uniquely suited to recording impulse in a continuous way. A line can be erased, but every remaining line is a thought trace. All monitoring machines produce a line drawing as their output, and since the pencil never leaves the paper the machine produces a record, without gaps, in which changes are preserved for every hundredth of a second of time. In the linear work of Picasso, Klee, or Pollock gaps remain, but what we find on the surface are the turns and singularities of thickness or of pressure that in their order and uniqueness monitor the quirks of thought in an exhaustive way.

Of course, it is just these quirks of thought, these instantaneous features that the massive, time-consuming, skilled secrecy of a finished work is designed to imbed and conceal within a formal, even finish. When the Italian painter Giotto was asked for a proof of his mastery, he simply drew, free-hand on a page, a perfect circle. No rapid or unprecedented scribble could have served as proof of what he meant by mastery. He produced in this simple, familiar, regular form a finished thing that was a proof of control and skill.

The originality and fertility of invention that Picasso and Klee demanded of themselves were directly reflected in the rapidity with which their works were done. The individual works are the gestures of that spontaneity. To work at or to polish any one original impulse would deprive the painter of many others that might occur were he only to set himself once more in front of the blank canvas or page. Among many painters the blank canvas brings with it a certain dread. The first irreversible strokes are like the departure for a long journey. The blank canvas has some of the solemnity that the excavation has at a building site. For Picasso and Klee just the opposite was true. They returned as often as possible to the blank page, liking best of all the first strokes, which, quickly brought to an end, let them face again the pleasure of the blank canvas or page and the drama of the first mark.

## Art Thoughts: Klee and Pollock

The art work became an art thought by many paths, but the process is uniquely clear in the modern drawing where the artist, as Klee put it in his pedagogic manual, "takes a line for a walk." In

Fig. 14. Paul Klee, *Beschwingte Hexe*, 1931. Guggenheim Museum, New York.

Klee's *Beschwingte Hexe*, a drawing of 1931, the Witch occurs almost as an accident within lines that have a mind of their own (Fig. 14). The mind that is their own is the artist's with its whims and graces. An ordinary first glance at the drawing will orient itself by means of the face of the Witch, especially the eyes and mouth, as well as the nearby hand and fingers. If the eye starts with the figure in this way it works out from the center of the drawing, taking in the other hand, and searching for other parts or clues to the physical details of the body of the Witch. This way of reading the drawing sees the Witch entangled in what looks like string that swirls around these familiar facial and bodily features. But soon the question appears: why do so many lines, as seen from this concentration on the central face, fly out and exit off the page at the left and at the bottom edge?

With this question we see that the drawing is not meant to be read in a glance that takes it in as a whole, but in another way entirely: one that sorts out the string-like lines and follows one at a time, starting from the line's entry onto the scene of the drawing. By doing this we retrace the motion of the hand that drew them in the first place. This second reading opens up the work of art as a work of thought.

The drawing allows most of its lines to begin or end at the edge of the page, and these end points invite us to look at lines as a way of looking at the image. I have lettered the lines A, B, C, D, and E to make it easier to describe the contact with thought that this discrete set of lines makes possible. Each of the five lines would have been drawn by Klee in a second or two.

Line A loops its way across the page without bringing about any part of the portrait of the Witch. It seems almost like a landscape line recording hill tops or marking the line of a horizon. The ends of the line occur at the edges of the drawing as though what we can see here was only a part of a much longer line that brings about other effects in some quite different space. The line section visible here through the window of the drawing has the feeling of a mid-section, glimpsed but not completely given. It makes us see each line the artist draws as only a cut piece of the indefinite string of line always occurring in the brain and muscles of the artist.

The second line, B, differs by ending (or beginning) inside the drawing, near the witch's arm. It mimics the gentle curve of line A, but comes to an end without contributing to the portrait of the Witch any more than the line that merely passes across and through the work (line A) had done. Only the other three lines build up the features that let us recognize the drawing as having a face, two hands, the shoulders and torso of a human body. These first two lines create the twin relation that occurs within the lines and comes to reflect the symmetry of the body, its pair of arms and hands, its two sides, and two eyes.

The lovely line C is the only single-minded thought within the drawing. It begins and ends within the page and it does a single task, defining the arm that we see on the left. To look at this arm as a part of a human body and to look at it, or rather to trace the line from beginning to end like a journey, are two quite different acts. If we follow the line we see that it moves rapidly and gracefully straight across the page, then turns and falls until, at its lowest point, it begins the rapid up and down, nervous movements that portray the four fingers of the hand. Then with a graceful turn for

the wrist, the line rises, crosses to the left, and at that point no longer represents any anatomical detail, but rather reverts to the freedom of a pure line with a will of its own until it curls back delicately and makes an end. The path of line C is partly representational and business-like. At other moments, mostly at the beginning and the end, it has the freedom of action and direction of an abstract work.

The fourth line, D, repeats, but in a mirror, the path that made the first, downward hand, in order to represent the upraised hand on the right with its five fingers. After finishing the arm and hand the line goes on its way and adds a shoulder before crossing back past line A (and in this journey to the left it does not represent, but acts out its own caprice), then reverses itself sharply. This reversal which looks almost like a letter V on its side is literally a change of mind. The line recrosses the page in the opposite direction, then reverses itself quickly again and comes to an end just above the last finger of the hand it had earlier drawn. This pair of changes of mind (marked with an X in the drawing) are quite different from, for example, the changes of direction that indicate an elbow or a finger. They are pure thought, even pure caprice, and they point to a second of time in which the artist decided to do something else from what the line seemed about to do: exit, like lines A and B at the left or right edge of the drawing.

The four lines so far described occur in pairs and mimic each other's actions. The fifth and final line is the climax of the drawing, and it has no twin or partner. Line E begins inside the work, and as we see in the finished drawing, it begins inside the head or brain of the Witch. By beginning in the brain of the Witch it makes a sly play on the real origin of the line: the brain of Paul Klee. This starting point prepares us for a line that is a brilliant invention, a dazzling thought.

The line slopes down to make her chin, then adds a mouth and rises to make a nose, then falls until it turns around at the mouth (and in this motion represents no new feature) then rises to represent two horn-like shapes, almost a lobster claw, then swings out and returns to make the right side of the round face until it suddenly changes direction and races across the hand to end up at the shoulder on the right. This line is entirely different from the simply atmospheric lines like A and B that do no work, and it is just as remote from the efficient line C that set out to draw a hand and arm and did so in terms of our child-like image of the drawn hand. The line C alludes to our everyday schematic account of an arm, hand, and fingers, and although it does so with elegance, it does no

more than activate our power to recognize the signs of an arm or finger.

The brilliant line E invents a whole new vocabulary for the face, one that has traces of other than human presence within it. The two horns can, along with the left eye, look like a rabbit or a bull seen in profile while still doing their work as part of the Witch. Because of this line the eye to the left on the page can be either the left eye of a full face or the right eye of a smaller face seen in profile. The line itself, as it follows its own twists and turns, produces a face as though by magic along its own incidental way. It is this line that is not merely a trace of thought, but thought itself, accomplishing within a few seconds the record of an entirely fresh account of how a human face might come about within a line. To see this, it is only necessary to take the walk along the line from its starting point to the end at the shoulder. No encompassing glance at the drawing as a whole can unfold this realm of time and action which is the very subject of Klee's piece.

I have not mentioned the two small circles that define the eyes. These are also lines, but they are purely instrumental and clichéd, every child's idea of how to indicate an eye. In that they are different even from what I have called the business-like line C which also, but only in its middle, fills in our cliché of a hand with fingers. The eyes are not even, in the terms of the drawing, lines at all, since every other line spends time alone; that is, apart from its task of outlining or representing, and it is in this time alone (to be itself, we might say) that it makes clear that it is above all a line with a life of its own and not just a worker with a task to execute.

Within abstract painting the distinction between the task and the freedom that more accurately reflects the turn of artistic will vanishes. In Jackson Pollock's large drawing of 1950 (Figs. 15 and 16) the passage of an almost pure sensitivity across the page is clear. In the detail shown in Figure 15 we have, in the third episode of the drawing the single clear act in front of us. Each trace on the paper is the exact and complete record of an impulse occurring within, roughly one second of time. Since the paint has been poured, the thickness and thinness record slower or more rapid motion of the hand. The impulse recorded in Figure 15 starts at the thin upper left point and ends with the thick, backward curve that balances and completes the dance-like gesture.

The two other parts of the drawing show the more complex accumulation of individual thoughts or impulses, while leaving each of them distinct enough to make it possible to trace them as movements. A full painting, *Number 13* of 1949 (Plate 8) shows the

Fig. 15. Jackson Pol-
lock, drawing, circa
1950, detail. Enamel
on paper. Drawing
Collection, Staatsga-
lerie, Stuttgart. Copy-
right 1991 Pollock-
Krasner Foundation/
ARS, New York.

elaboration of thousands of such individual episodes into a full-
scale painting in which the feeling of calligraphy, of writing with-
out words, and, finally, even of a kind of abstract story telling,
remain clear.

The genius of Pollock's paintings lies in the overlapping narra-
tive style that permitted these simple facts of trace and thought to
take on epic length and detail. By working always with only a few
colors, each of which was used only at a certain point in the history
of the painting, remaining for that reason visible in the final result
as a layer that occurred at a certain phase of the process—clearly
before this, clearly after that—his narrative style created space in
the very act of creating a history. The lucidity of the final work is
always a result of forbearance. Each event can only take place by
covering over and effacing whatever colors and events are already
present on the canvas. Each event lives at the expense of earlier
events since the painting is literally on top of itself at every mo-
ment. At the same time each layer by taking up too much attention
for itself blocks the possibility of any later layer unless that later
layer simply covers this one over and eliminates its events. A de-
corum among the layers exists within these paintings that is part
of their very clear elegance. Each leaves space for the other layers

Fig. 16. Jackson Pollock, drawing, circa 1950. Enamel on pa-
per. Drawing Collection, Staatsgalerie, Stuttgart. Copyright 1991
Pollock-Krasner Foundation/ARS, New York.

while none the less coming into existence only by means of covering up the layers beneath.

In a classic painting of 1950, *Autumn Rhythm: Number 30, 1950* (Plate 9), Pollock lets each of the small number of actors within the painting occur within the decorum of a common space. The background color is echoed in the darker, almost squared-off wide lines near the surface, both are near wheat or bronze in color. The primary work is done by black which varies from the splattered dots, to the thin pencil-like lines, to the thickened and even smudged black that dominates the upper right. The white that occurs more sparingly softens and spreads almost into patches or shapes. These four elements mark out a set of depths from the background canvas color forward, but only locally is the space defined. Each episode within the overall, epic painting suggests a depth and strategy for moving from ground to surface, and with each strategy we find a different scale, often the scale of the sky or the ocean in the implications of the distances between layers, at other times a more domestic, less galactic space.

However far this painting seems to stand from the simple and isolated gestures of the drawing of Figures 15 and 16 above, it nonetheless stands within the same invention of a no longer secret history of thought and motion, a history of traces that the final work presents simultaneously as a space and as an open narrative history, a story told about itself.

## Artisanal Realism

Now to return to the hard-working cook in Calais. One final feature of his masterpiece requires attention. The proof of the highest artisanal skill and therefore of the most elaborate training, lies in what we would call representational realism, the simulation in an alien material of the feeling of reality. The cook is required to carve a lion in jellied cream and produce a simulated bunch of grapes made of jelly. The best evidence of the magical or wondrous side of craftsmanship is this laborious and roundabout reproduction of what already exists, not the invention of some entirely new thing. The real is embodied or copied in materials so alien that the very gap between our idea of a lion and our idea of jellied cream lets each of them, once brought together, leap over its own nature at the touch of the craftsman's hand.

In Homer's *Iliad* the highest moment of wonder is produced by the work of the divine craftsman Hephastos whose workshop is

filled with the evidence of his cleverness and ingenuity. But when
he makes the shield for Achilles it is a triumph not different in
kind from the lion made in jellied cream. Homer's description makes
this simulation, or what Roland Barthes called "L'effet du réal,"
the key to artistic pleasure.[10] "And he made on it a field of soft
fallow, rich ploughed, broad and triple-tilled. There were many
ploughmen on it, wheeling their teams and driving them this way
and that. Wherever they had turned and reached the headland of
the field, a man would come forward and put a cup of honey-sweet
wine in their hands; then they would turn back down the furrows,
pressing on through the deep fallow to reach the headland again.
The field darkened behind them, and looked like the earth that is
ploughed, though it was made in gold. *This was the marvel of his
craftsmanship.*"[11] The wonder is felt at a brilliant moment of tech-
nique in which we feel, in looking at the shield, the difference be-
tween lighter, unturned earth and the dark earth that has already
been turned by the plow even though both light earth and darker
earth are really gold. The material distance between the most pre-
cious and unusual material—gold—and the material that is for all
of us the most common earth beneath our feet is, like the lion
made of jellied cream, part of the pleasure of artisanal magic. The
miracle lies, however, not simply in the craftsman's ability to have
us read certain irregularities in the gold as a man, a plow, a cup,
wine, earth, but in the capacity to let the gold remain gold while
simultaneously existing as dark brown, newly turned earth behind
the plow, and lighter unplowed earth in front.

As both the Calais cook and Homer demonstrate, there is an
intimate relationship within a craft tradition between Realism, the
mastery over a material—whether gold, cream, stone, words, or
paint—a mastery pushed to the point that the material can give
way experientially to our feeling that some other commonplace
thing—a lion, a bunch of grapes, a plowed field—is there, present
for the experience of the senses and the imagination rather than
the material itself—between Realism and the notion that since art
is an array of skills, then it is the use of those skills and the labor
of execution that are the most essential time-bearing features of
the finished object.

The ancient admiration for the painting in which the grapes
were so convincingly represented that birds came down to peck at
them contains, at a deep level, this link between Realism, artistic
value, the experience of wonder, and the highest demonstration of
self-effacing skill and care. Whatever minimal, conventional signs
might satisfy the human viewer willing to see certain marks or

daubs "as" grapes, the birds are more demanding judges. Within every representational strategy we reach a point where audience and artist are trained to the point that a kind of shorthand can take over in which fewer and fewer signs are needed to evoke the familiar subject. In 20th-century sculpture this has been a subtle and ingenious enterprise to reduce, as Brancusi did, the signs of a fish or bird or human head to a minimal disturbance of a smooth form. David Smith worked out, for the standing human figure something of the same minimal vocabulary of signs.

Seeing just this or that we prefer to read it as a face, eyes, nose, or a standing man with his arms at his side. It is part of the alchemy of both Klee and Wittgenstein that in the same years they approached almost experimentally this question of the few minimal signs that make us see some set of marks "as" this or that. Later, the magic of recognition from such minimal clues became one of the most over-used experiences in modern art. It stands as the alternative experience of wonder for a culture that has become bored with Realism. In Realism the magic of effects is overstated, the challenge is to find even the slightest flaw in the representational details that would give away that it is not a lion, but only jellied cream; not a newly plowed field, but only gold. This becomes an allegory of the fact that, since experts or knowing critics who are practiced in a given language are more likely to read in the reality that they claim to see in an object, an untrained viewer—a bird in the case of the painted grapes—is finally the better judge.

The rather easy claim that so-called Realism is just another set of conventions allies itself to the expectation that each artist will not only invent paintings or works of art, but entirely new genres of art, assemblies of conventions equal in value and complexity to those assembled within the convention of realism. The time and repetition stored in conventions that have worked and endured are what make them conventions, not the fact that they are assemblies of rules and arbitrary practices.

Finally, the description of the requirements for the cook's work reminds us that this is a culture in which work is commissioned, described in advance, and bound by a legally binding contract of the type that today only an architect works within. What the apprentice executes for his admission to mastery is typical of the work-to-order that his professional life will require.

I have used this rather whimsical example of the Calais Masterpiece to elicit a set of features of work that is typical of the range of objects of wonder and importance for which the term "masterpiece" was originally designed. Every element of the account of the

Calais cook could have been elicited from the Homeric account of the making of that greatest recorded masterpiece, the shield and armour of Achilles. As Walter Cahn has shown in his book tracing the history and mutation of this idea within European culture from the Middle Ages to the 19th century, the purification, or as we might say, the specialization of this term and its collapse under the cultural weight finally assigned to it are symptomatic features of our cultural history and equally of the history and meaning of work per se. The competition that I have traced between work and thought, between the temporal requirements of a finished product that gives evidence of the duration of labor and skill as opposed to one that testifies to the presence of instantaneous flashes of insight, means that the history of modern art is implicitly a history of modern labor, especially of the combination of assumptions stored within such terms as "skill," "apprenticeship," "craft procedures," "realism." The hectic, almost workaholic stance of Picasso is not evidence of the value of work, but of a certain defiance of it, a conversion of the site of effort into the occasion of a form of play, of thought so energetic that it sometimes looks like work. The temporal and time-bearing features of work are absent.

chapter **8**

# Hand-made Space

What we usually think of as the option of realistic representation for painting or sculpture is an option in name only. The actual choice that a canvas has in relation to space is only the choice of whether to mention space or be haunted by it. In the same way, the shaped material objects of sculpture can either bring up directly the features of the human figure and the everyday world of things or put up with them hovering in the background as something alluded to but still kept firmly present. The objects that we call art objects must, in the same way, either mention or be haunted by the everyday object world around them.

There is no way for even so simple and apparently negative an earth-work sculpture as a hole in the ground not to be felt as grave-like or basement-like, and in this hyphenation with the word "like" we capture the minimal background feeling of allusion, the hovering of possibility around all that is actual, and the simple fact that something that we spend more than a few seconds contemplating cannot avoid reminding us of something else. Pure presence is the single most improbable goal for any material shaped by human hands to achieve. The choice of mentioning or being haunted by reality is the only choice there is. This fact forces a choice of either an antagonistic relation of the kind that the last two chapters have described or a model-building and commerce between the space mentioned in art and the Working Space, as Frank Stella named it in his recent book, of social life as a whole.[1]

The space that representational paintings have mentioned, discoursed about, and triumphantly displayed since the 14th century

in Europe has been the space of a room seen through a window. This excavated, box-like room that we see into behind the surface of the picture plane is the spatial topic of the representation that goes on at the site of the picture plane itself. To look at the picture we look through it to the scene that it presents. In doing this we attend to the clues of scale and perspective that define the volume of space that it describes directly; that is, mentions. Where that space is a landscape we only have to extend, but in a daring way, this box-like room onto an improved and socialized outer world that as a result of human husbandry and interest has become something of a large outdoor room lacking only the feature of walls, a lack that the right and left sides of the picture overcome.

Ordinarily a window occurs on a wall in much the same location and proportion as a painting would; for that reason a work of art takes effect as an alternative to a window. Either painting or window interrupts the wall, breaking it open to offer relief from the depressing insistence on the here and now that is the imprisoning aspect of the four walls of every room. A mirror is, in spatial terms, a counter-object to either window or painting since from its position on the wall it can only reinforce the room itself by pedantically duplicating part of it, making it occur twice as a form of pseudo-relief from itself. By contrast to this re-imposition of the room, either a window or a painting takes effect as an escape from it. A window or a painting subsidizes a realm of freedom from the here and now of the room, a realm of spatial freedom parallel to our option within time to step free of ongoing experience by dwelling for a moment within our own inner scene of memory or imagination.

The point at which a spatial paradigm appears prominently inside the picture as content while summarizing the procedures of the painting itself is a decisive moment of self-reflection and transparency. In Piero della Francesca's *The Flagellation*, the precise spatial box, hollowed out behind the window-like surface, appears literally as a measurable room that supports the narrative architecture of the event, while decisively recording the spatial geometry of the illusionistic painting space that is now available for any event whatsoever. A decisive replacement of this illusionistic, room-like space occurred when Monet began to paint again and again the surface of a pond, a flat, busy gel of colors, reflections, objects, and spots of light. Although tipped at an angle to the painting's own surface so that we seem to stand on the bank and are clearly not hovering over the surface, the pond surface puns on the surface of

dried liquid that is the literal painting, a measurably deep surface within which shallow effects occur. Further, the pond water is nothing but a thickened atmosphere, able to register in a half inch of water effects of depth equivalent to the 150 feet of air between Monet and the haystack or cathedral front that had been among Monet's most famous subjects before he turned to the pond. Since the air itself was always Monet's topic he was able, by collapsing the air into the dense, near flatness of water, to make the effects occur in a summarized, self-conscious mimicry by means of the dry pond of paint on the canvas.

Monet's was not the only or even the most important displacement of the box-like room. Our commonplace description of modernism in painting describes a loss of interest in this excavated room that had become too familiar. Normally, it is the interest in the surface itself with its qualities of flatness, edge, composition, and the alternative of either dramatic composition or an overall sameness that we fix on as the residue of what remains intriguing for an art that has surrendered the fictional room. But to speak only of the literal and minimal surface is to imagine that such paintings no longer mention space at all, other than the almost Euclidean two-dimensional space of a plane without depth.

There is a clear alternative to this hermetic account. Seen from the perspective of the industrial world or from the point of view of the processes by means of which ordinary objects of all kinds were now made by the late 19th century, what took place within painting was rather different. From the social perspective it would be more accurate to say that painting traded in its preoccupation with a room-like space that had to be seen *through* the surface, for a table-top space seen *at* or *on* the surface. The pun on a window gave way to an equally potent spatial pun; the flat surface of the painting again and again after 1880—that is, from Cézanne and Degas on through Cubism—mentioned and then, once the metaphor was solidly in mind and endless reiteration was no longer necessary, implied, the artisanal working space of hand and eye, the table-top.

Along with the table-top, Degas, for one, explicitly projected his scene of action against a bare floor or stage. In his ballet or bath pictures, for example, this floor defined itself as a slightly larger table-top and an expansion of the flat plane of the canvas and table into the larger scale of the room, but now a room understood primarily as a ground of action. To arrange the action upon either table or floor allows it to be seen both as three-dimensional and as

a flat silhouette of itself, and it permits it to be seen as in front of or on top of an absolute barrier to sight, a table-top or floor that marks an end to the space of the picture.

Unlike a window, neither floor nor table-top is ever, in ordinary experience, seen at eye-level, on a wall, in the spatial position where we find paintings. From the time of the work of Cézanne and Degas in the 1880s and continuing on for the next hundred years, the primary spatial problem occurred around the question of how this horizontal plane of floor or table-top might be lifted up into the vertical location where it could be encountered and responded to as a painting. How could a spatial experience that we commonly have only by looking down be naturalized as something directly across from us, the location of face to face experiences? The raising of the table onto the wall divorces the cooperative moment of hand and eye by means of which the work was produced from the purely optical later stage in which it is consumed.

From Picasso's constructed still-lives to the work of Jasper Johns, the painter has attached objects to the canvas. At a certain point Frank Stella replaced the canvas with a wire mesh, giving up the possibility of painting on it in favor of an easier system for attaching pieces to it that otherwise would fall off. He made this substitution as a way of making clear the fact that the main use of the surface was not as a white, page-like place where drawing or painting might occur, but as a frame or support to hold the attached pieces in place. This problem occurs because a table-top or floor on which these objects would commonly be found would need only the force of gravity to keep them in place, but once the table-top has been lifted up and hung on the wall a system of attachment turns out to be needed because that same gravity that was once the table's ally is now its enemy.

After Cézanne and Degas a significant number of paintings, those of Cubism and those of Mondrian, Pollock, Stella, Rauschenberg, and Johns are no longer windows but rotated table-tops hoisted up into an unnatural location to face us on a wall. Already within Cézanne's still-life paintings, the artist gives the table-top an unnatural tilt so as to display better the objects even at the cost of our gravitational feeling that they must be sliding towards us (Fig. 17). Cézanne raises the table and presents it at this odd angle so that the represented angle can mediate between the horizontal real table and the vertical wall on which even a canvas that mentions and is dominated by the laws of table-top space must finally appear. In Degas an alternative, but equally ingenious, solution to that of Cézanne's tilted table, occurs. By choosing an unnaturally

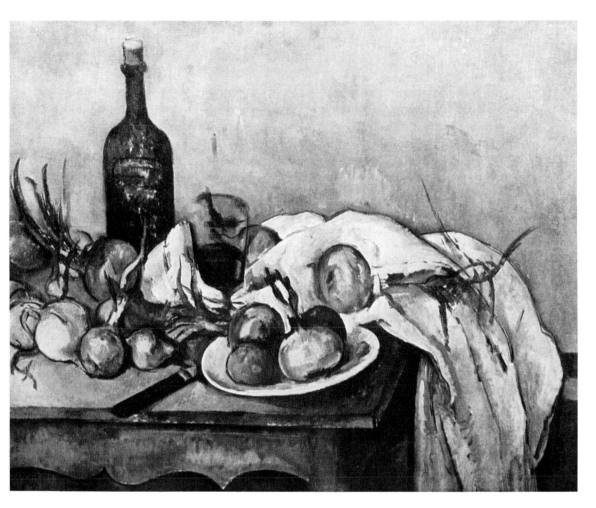

Fig. 17. Paul Cézanne, *Still Life with Peppermint Bottle*, 1890–
94. National Gallery of Art, Washington, D.C., Chester Dale
Collection.

high point of view, up above the scene of action, Degas composes
it against the floor and table, while allowing the peculiarity of his
point of view to signal to the viewer that his own angle of vision
to the painting itself is just as peculiar as the artist's had been to
the scene (see *The Tub*, p. 211).

In both Cézanne and Degas the table-top space is overt; it is
repeatedly announced by means of the actual representation, within
the picture, of an area of table or floor upon which the events are
ordered. At the same time the disturbing necessity of turning this
space 90° so that we can face it rather than hover over it is explic-

itly carried out within the work by means of these ingenious com-
promises of tilting or the choice of point of view. Degas and Cé-
zanne impose a spatial practice on an audience that by means of
their works could memorize a new relation to space that might
thereafter be drawn upon by Picasso and others in the century that
followed. In the explicit spatial transformation, and almost pedantic
practice that they required, Degas and Cézanne were, taken to-
gether, the Piero della Francesca of modern painting, since in the
heavily explicit geometry of his perspective Piero had trained and
rationalized the spatial model of the room seen through a window
and made it available as a familiar space within which later artists
and viewers could move freely and comfortably around.

The ballet dancers within the work of Degas are most often
seen within the labors of practice rather than the triumph of per-
formance. In attending to their training, which is itself a mastery
of a restricted space by the body, Degas has made mutually explan-
atory the three parallel activities of first, his own labor, second, the
exercises of his dancers, and third the practice of his audience. To
see his works the viewer, too, had to enter training; each work was
a practice session for the mastery of a new space. The dancer's floor
and the viewer's canvas are the platforms for this muscular exer-
cise. But both refer back to the site of work that would dominate
art from then on, the small, controllable space of a table-top where
the hands and eyes cooperate to dominate a space of industry and
assembly.

## Implicit Tables

Once established, fundamental images become invisible. The work
of Mondrian, for example, is implicitly table-like without illustrat-
ing its own procedures or carrying out any further training of its
audience because by 1920 the table-top can be assumed. Michael
Seuphor in his book on Mondrian has described a visit to Mondri-
an's studio where he saw two easels, one ''long out of service'' and
the other used only to show finished canvases. ''The actual work
was done on the table. It stood in front of the large window . . .
and was covered with a canvas waxed white and nailed to the un-
derside of the boards. I often surprised Mondrian there, armed with
a ruler and ribbons of transparent paper, which he used for mea-
suring.''[2] The canvas is, then, a detachable table-top. The painter
is able to work looking and reaching down as he hovers over it.
Mondrian's working method was later expanded by Jackson Pol-

lock, who tacked the canvas to the floor, enlarging the table to American dimensions. Leaning over the canvas, he released the paint to let it fall, drip, splatter, and run onto the surface. The later, more elegant development of this by-now invisible table came in the work of Helen Frankenthaler and Morris Louis, where a canvas was stretched on a floor and then stained with paint. The paint was permitted to run and soak; the painter sponged and scrubbed it back *into* the canvas itself, creating a final development in which events down in space, below the hand and eye of the painter, could once more appear *in* that surface, a witty reversal of Monet's gel-like liquid. But like Monet's pond-like canvases, these works had, as a second stage, to be hoisted up and rotated so that effects of gravity are converted into floating, counter-intuitive spectacles.

As photos taken in his studio show, Frank Stella's normal working process in recent years involves a return to Mondrian's table, but now only to build the maquettes for the works that would be enlarged, executed in metal and other materials and, finally, painted. Using the division of labor familiar in architecture between design and execution, Stella has accepted the split between model-building and painting, between the table on which the first small-scale version is assembled and the studio where the final work, in an enlarged form, is produced. What this work process entails is not only the architectural relation between design space and construction site, scale model and finished building, plan and execution. Even more important, it entails a version of the modern industrial relation between model and production run in which the first, nearly hand-made prototype is followed by unlimited replication and variation. The spatial site of this industrial relation is the work bench and drafting table, which Mondrian and Stella have explicitly carried over into the realm of art.

The years from the work of Degas and Cézanne in the 1880s, to the generation of Cubist works done around 1910, to the third generation of Mondrian and then such artists as Pollock, Johns, and Stella in the postwar period, has been the century in which the model of industrial production has appeared within painting by means of the pun between the work surface of a table and the surface of the work of art, but also by means of a radical extension of the genre of the still-life, and by means of the creation of a new space that both industrially and artistically should be called hand-made space.

### Industrial Still-life

The still-life is the product of a relationship to space that is not purely optical. A portrait or landscape would be our best instance of an act of stopping to look closely at a person or at an object that we see out there in space, across from, and at a distance from, the observer. We stop to gaze at or study a face or to gaze at the details of a scene without implying that we act on the face or the scene in any way. The combination of a certain distance and a form of interest free from the desire to act on the object yields a purely optical relation.

The still-life, on the other hand, is the product of a space defined by an act prior to the act of painting, an act of arrangement which is necessarily an action based on the cooperation of the eye and the hand. Each object has been picked up, brought to the scene and set in place by an act of choice. The arm's reach, its height from the floor, its extension down or outward, defines the tactile space of production; that is, a hand-made space. Within this space we pick up, move, and assemble. Within this shallow bowl of space a few feet in front of the middle of the body, the hands and the eye are able to seize, to control, and to create order. This is the space of work and of direct human action.

Tables, which are in fact just a part of the floor raised up so as to be in touch with our hands rather than our feet, are created to localize the dimensions of this space, their width being determined by just how far an average person can reach, their height being fixed by the reach of the hand downward when we are in a standing position bending over its surface. Assembly lines, work-benches, counters for the preparation of food, sales counters for the display of commodities that can be picked up: the world of production and consumption locates itself here. We make food and we eat food bent over a table. In so far as human beings make and dominate the world, this space provides the metaphor for that domination and world construction. Mastery and order, smallness of scale, convenience and accommodation are the characteristics of the hand's space. Within this space the eye guides but is overshadowed by the hand.

The space of the hand is the fundamental image space for modern art. Within that space the essential role is played by things, not persons or events, and things in so far as they are made, assembled, and transformed, that is, submitted to the conditions of production and industrialization that are present in the modern world as a whole. The ground of this space is the table-top, but the table-

top must be taken as a metaphor for the total control of any space whatsoever, just as we can speak, by extension, of factory farms or factory-like use of the sea and in so doing extend the space of the factory out over land and sea. The central genre of hand-made space is the still-life, and it will be the claim of the following pages that the explicit or implicit presence of the assumptions of the still-life carry into the realm of representation the ethos of the producing and transforming hand.

The still-life concerns a world of objects that, as Meyer Schapiro has described them, ". . . do not communicate with each other: their represented positions are . . . arbitrary, subject only to physical laws or accidents of manipulation. . . . Like the commodities in the windows of a shop they are a world of things, nature transposed or transformed for man."[3] That these objects occur on top of the flat plane of the table repeats the logic of an art in which events now occur on top of the canvas in the form of a constructed array of strokes, patches, or objects and no longer behind it as a composition of representations in illusionistic space. Schapiro has described the correspondence between the object represented or made by strokes of paint (the outer object) and the arranged object (the inner object) that is its subject:

> Early in our own century still life was a preferred theme of an art of painting that aimed at a salient concreteness of the medium through a more tangible brush-stroke and surface, even attaching real objects to the canvas beside the traditional pigment—a culmination of the tendency to view the painting itself as a material thing and to erase by various means the boundary between reality and representation. The work of art then is itself an ostensible object of handling like certain of the simulated and real objects that compose it. Without a fixed place in nature and submitted to arbitrary and often accidental manipulation, the still life on the table is an objective example of the formed but constantly rearranged, the freely disposable in reality and therefore connate with the idea of artistic liberty.[4]

Schapiro's word "liberty" masks the notion of the will but at least provides the reference point for all order: the decisions of the artist, not the inner logic of the objects which confess their arbitrary presence and arrangement. On the other hand, the God-like powers of transposition (the power to "interrupt" nature) and transformation (the power to remake nature) that Schapiro calls artistic liberty are nothing but variants of the general social form of the industrialized human domination of the world.

The first phase of the history of the presence of the table within

modernist art culminates in the work of Picasso, Braque, Gris, and others in the years following 1909; a second, equally important climax occurs in the work of Stella and Johns fifty years later. At both moments the table was tipped up to coincide with the surface of the work; frequently the two are co-extensive. The attachment of newspapers, cut patterns, and bits of fabric, wood, or metal, defines an object halfway between painting and sculpture, as in fact all paintings with thick tactile surfaces had been since Monet. The moment of absolute coincidence between model and fact is after all a sterile, self-commenting gesture. Only in the work of Braque, especially the important series of Studio paintings, does the direct, overt rendering of a table world continue throughout his career.

Once established, fundamental images become invisible. The conventionalizing of the once dramatic novelty of the canvas as table-top can be seen in the work of Rauschenberg and Jasper Johns where, as Leo Steinberg has remarked, the experience of a surface that "happened" down in space and was then hoisted into place is conspicuous.[5] With Johns and Rauschenberg the possibilities of the table surface have become vernacular. Coat hangers, alarm clocks, bits of wire or metal might, in an almost homespun and corny way, find themselves stuck to the thickly worked impasto pigment.

The route to this vernacular, witty conclusion leads from the unobtrusive invasion of pictorial space by the table-top with its still-life in Manet, through the almost violent struggle between table and room in Degas, to the identification of the space with the still life in the masterpieces of table space in Cézanne, and then to the increasingly cerebral or automatic use of that space in Picasso, Cubism, and American postwar painting. In certain paintings of Manet an inconspicuous still-life is inserted down in space. In the 1868 *Portrait of Théodore Duret* (Fig. 18), Manet creates his flattened non-space by blending floor and wall into a uniform brown. This effacing of the difference between floor and wall occurs almost as an act of prophecy for the century of work that would follow.

The face of Duret, placed high on the canvas, attracts the standard full-length social-psychological attention of the viewer. In the lower left-hand corner of the canvas appears a small table with glass, lemon, and water, and beneath the table, on the floor, lies a poisonous-green book. The viewer's eye can only take in figure and still-life as two discrete events. It is literally impossible to look in such a way as to take in both. The eye restlessly goes from one to the other, back and forth, changing scale and mode of attention with each step: there is no "whole" because the still-life has been inserted as an irritant, an alien presence. The space of a portrait

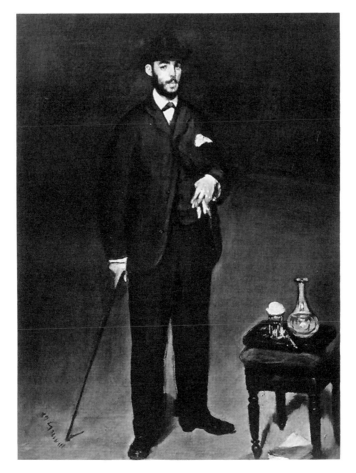

Fig. 18. Edouard Manet, *Portrait of Théodore Duret*, 1868. Petit Palais, Paris.

has been invaded by an alternative reality; a world organized to display full authoritative human presence is forced to compete with a world organized by means of the laws of side-by-side objects.

The identical division occurs in Picasso's *Demoiselles d'Avignon* (Fig. 19) in which a knife-like jutting corner of a table, sharpened by distortion, cuts in the bottom edge of the canvas with its display of fruit. The table of fruit lures the eye from the four figures represented, like Manet's *Théodore Duret*, against a background that has collapsed forward to annihilate the sense of a room. In Picasso the violent presence of the table, replacing the vanishing excavated space, is acknowledged by the angularity and intrusive commenting power of the table to declare the whole picture "still-life."

In Degas what remains of the room is often captured from above

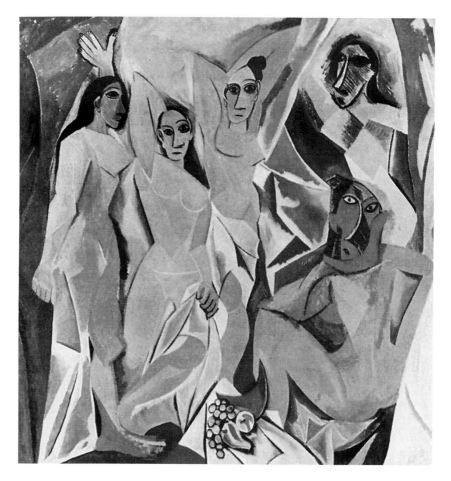

Fig. 19. Pablo Picasso, *Les Demoiselles d'Avignon*, 1907. Oil on canvas. The Museum of Modern Art, New York, acquired through the Lillie P. Bliss Bequest. Copyright 1991 ARS, New York/SPADEM.

at an angle as though we were looking down sideways at a table, and the space is interrupted by a table or set of flat planes that permits the total space to reorganize itself twice, first as space, then as still-life. The striking *Portrait of M. Diego Martelli* (Fig. 20) and the familiar *L'Absinthe* (Fig. 21) are blockaded by tables that both define and cancel the room. In the section that follows an extended analysis of the pastel work *The Tub* of 1886 will be given to show the ethos of the table space as it mediated between room and surface.

In Cézanne the space before us has to be described not as the invasion of a room-like space by a still-life, as in Manet, or the

Fig. 20. Edgar Degas, *Portrait of M. Diego Martelli*, 1879. Oil on canvas. National Gallery of Scotland, Edinburgh.

struggle between room and still-life, as in Degas, but as a domination of the visible world that is projected outward from the table-top, even where, as is often the case in Cézanne, the table itself rules from a discrete edge of the canvas. Meyer Schapiro has captured the essence of the social relation of still-life in a paragraph that needs to be quoted in its entirety:

> Still life . . . consists of objects that, whether artificial or natural, are subordinate to man as elements of use, manipulation, and enjoyment: these objects are smaller than ourselves, within arm's reach, and owe their presence and place to a human action, a purpose.

Fig. 21. Edgar Degas, *L'Absinthe*, 1877. The Louvre, Paris.

> They convey man's sense of his power over things in making or utilizing them; they are instruments as well as products of his skills, his thoughts, and appetites. While favored by an art that celebrates the visual as such, they appeal to all the senses and especially to touch and taste. They are the themes *par excellence* of an empirical standpoint wherein our knowledge of proximate objects, and especially of the instrumental is the model or ground of all knowledge.[6]

The remarkable combination of use and sensuality in which the full presence of the human will results in a completely human, sensory relation to experience is the most remarkable feature of Schapiro's description. The greatest of Cézanne's still-life paintings celebrate a ripeness and plenitude that bring forward not nature but the products of nature in close relation to the moment of consumption and human pleasure. The rich tones along with the grandeur of the arrangements make of certain of these works an almost regal display of what is in the end the ordinary and the everyday. Schapiro points to the proximity of pleasure and human manipulation, of the power to organize and arrange, and, on the other side, the full activity of sight, touch, and taste. That these objects are small and have been gathered here on this table-top does not at all evoke our protest against some tyranny of the human will or of the technological spirit. Purpose and arrangement are features of a rationality of the senses and not at all of some degraded *Zweckrationalität* (instrumental reason, in Schapiro's translation) as it has often been called. That "manipulation" can occur here as a value-free term suggests the extent to which Schapiro has correctly seen that a celebration of an industrializing relation to matter is essential to the pleasure of Cézanne's paintings and of the painting that follows.

## The Ethos of Construction

The history for which Cézanne represents a classic moment begins with the construction of subjects in Manet; separable stylistic conventions are found simply "there" within the picture space. In the portrait of Théodore Duret no glance can bring together the full-length figure and the small still-life in the lower left. There are two glances, or an alternating back and forth pair of looks, that take in the assembled image conventions, but nothing more. In Meyer Schapiro's description of Cézanne's images the synthesis is described temporally: "He loosened the perspective system of traditional art and gave to the space of the image the aspect of a world

created free-hand and put together piecemeal from successive perceptions, rather than offered complete to the eye in one coordinating glance as in the ready-made geometrical perspective of Renaissance art."[7] In Manet that coordination applies not to the details of perception but to the large sectors of the image, which have been joined together with an irony of alienated side-by-sidedness. The often remarked relation of persons in Manet's paintings, that they are together in space but share no common drama, is the primary carrier of juxtaposed non-relation. Deliberately, narrative connections are stripped away, and the figures are literally, in Cézanne's later metaphor, sitting at the same table but each contemplating his own secret array of cards. These cards become, as content, the external image for a compulsively fascinating, deliberately withheld, private world. The game that unites the figures around a table describes the laws of composition for the unrelated.

The far more important initial victory of construction was won on the small scale of the individual brush-strokes on the surface of the canvas. Whether Monet's dabs, van Gogh's violent hacking and ploughing of the liquid surface, or the patient assembly of the surface in Cézanne as a play on the assembly of objects, or even the obsessive assembly of dots and therefore dot-made objects in Seurat, the break between what is on the surface and what is within, between surface and image, between small-scale mastery and large-scale passivity, permits a divided loyalty to the real and to the made. The best image of large-scale passivity is Cézanne's mountain, which appears again and again relatively unchanged as though out of an almost peasant dumbness that conceals or shelters the subversive rebuilding of the mountain from within that occupies the small-scale, stroke-by-stroke interest of the paintings. The realm of the arbitrary, anti-narrational, juxtaposed reinvention of the world coexists with a naïve, large-scale loyalty to it as something that "just is."

In the work of Degas, particularly the famous set of pastel nudes done between 1885 and 1890, the ethos of construction appears in its most radical form while still remaining loyal to everyday realistic scenes and coherent narrative space. Degas wrestles from objects a new being. What occurs is that highly charged, easily recognized objects (the female nude is the best example) are forced to surrender their familiarity by means of unexpected poses and croppings. By means of its pose the object dissects itself. The painter can achieve the same effect, but in a superficial way, by cutting the object with another overlapping object or, most arbitrarily of all, with the picture edge. In the greatest of these works, *The Tub* of

Fig. 22. Edgar Degas, *The Tub*, 1886. Pastel on cardboard. Musée d'Orsay, Paris.

1886 (Fig. 22), a woman is seen juxtaposed to a table and she is seen from above in the conventions of table-top space. Her body, folded against itself, is no longer, at this angle, connected to our ordinary sense of a body. The parts, freed by the startling pose, take on a separate life that lets them seem to have new functions and to be joined to the body in new places, cooperating with surprising partners. The two arms are no longer a pair; one works like a leg and is set in a row of three with the other two legs. Function per se plays only a minor role in redesign. Parts join one another in novel arrays, creating lines that have no connection to ordinary anatomy and functional life.

The table, amputated by the image cropping, juts into the space without support and locates itself as a floating object, its rectangu-

larity contrasted to the round tub. The table becomes, for the eye, a kind of flat screen on which the experimental spaceless perception of the woman's body can take place. That is, the table becomes an alternative, flat, spatial paradigm to the room that Degas has represented as the space in which the scene occurs. The table becomes a surface on which the nearby body occurs, *as flatness*, even while remaining factually loose in the alternate world of three-dimensional space. Only the end of the brush, phallically extended past the edge of the table, and the rounded handle of the pitcher staple the two kinds of space together, but do so at the expense of sexual anxiety and rude intrusion.

The pose of the body disassembles the body. The leg has disappeared, and the foot appears reassembled to the buttocks. The thigh is now a horizontal part folded parallel to the upper half of the body. An extraordinary new central mass comes into being, and the base of this mass is a newly invented stand made up of one hand and one foot, joined around the lovely triangular basin piece that we see between the arm, the thigh, and the foot. The face has been cancelled, the sexual interest in the nude is folded away by the reverse position. The one breast shape cannot be perceived as a breast because it has been amalgamated to a negative space outlined by the linear "M," created by tracing the continuous shadow line up the inside of the arm, down the upper side of the breast, up the lower side for the "v" at the top of the "M," and back down following the side to the disappearance at the thigh. The actual body has a nearly grotesque lump-like form, hovering over three feet (one, of course, is the transformed hand), aimed parallel, sideways in progressive left-to-right effacement.

Degas's tactic of deconstruction, reassembly, and projective recomposition represent a more radical industrialization of and violence toward the image world (dramatically done as an act of violent possession of the "sacred" nude) than are the more often discussed, overtly radical works that came later, like Picasso's *Head of a Bull.* The Bull's head is made by removing the handle bars and leather seat from a bicycle (deconstruction), then joining them flat to yield an image of the Bull's head (reassembly), which is exhibited on the flat white wall of a museum at eye level (projective composition on the table-top of the museum wall). In Degas, the everyday act of bathing is permitted its ongoing visibility, while the painterly act of seeing the new form that is present at a certain frozen moment and composing additively in an unexpected way so as to create a second set of "objects" of which the everyday is unconscious goes on at the same time. The second objects are lit-

erally a violation of the first and, for this reason, the best of De-gas's work of this kind includes the uncomfortable feeling of intru-sion and voyeurism, of a knowing, depraved superiority of spatial position that acknowledges feelings of which the woman, seen from behind and apparently unaware that she is being observed, is in-nocent. Further, these are feelings that in order to express them-selves demand a radical surgery on the body and space to create new objects in which the woman could never recognize herself.

As one fact among many, the pose in the 1886 pastel is one that no combination of mirrors (familiar props in erotic paintings of the nude since Titian) could ever capture for the woman's own eyes. This is a pose purely for the *other*. All of the typical varia-tions of the Venus pose, including Manet's *Olympia*, can be cap-tured by the woman herself with a mirror. For that reason such poses feature a component of latent narcissism, a self-absorbed and self-pleasing feature that complicates their more prominent sexual, aesthetic beauty aimed outward at the gazing "other." In such nudes we can see in the eyes of the woman her pleasure and awareness in the fact that she is being looked at. Never is this true in Degas where the capture that has taken place is radical, reconstructive, and positionally self-annihilating.

What the instantaneity of the image captures (the position in *The Tub* couldn't be held for long) is far more fundamental than the photographic slice of life or "frozen moment." What is repre-sented is that there are no objects, only parts, and that the config-uration of parts at any moment of time is an interval of objecthood that is permutable, reassociable, and yet sensible as just-this-thing, in harmony and functional interrelation with itself throughout. The bicycle is a sensible thing (assembled by the user from the kit of parts he buys), but so is the later reassembly as a work of art that gives us the image of a bull's head.

The instantaneity of time within a transient pose creates the feeling of the arbitrariness of the present state while at the same time it reverses the order of worth: parts, in the long run, are the carriers of "being," not wholes, which are no more than provi-sional arrays of parts. The two conclusions so prominent in Picas-so's bicycle-bull are demonstrated in Degas's spatial composition. The alienated randomness of what is "here and now," the still-life promiscuity of nextness and closeness, the accidental angles and distances between things and, above all, the painter's angle of sight and his decision to end or "crop" objects into just so much and no more presence within the work—these spatial decisions create a ty-rannical world in which the will of the composer hovers over the

debris of what were once things. In Degas's *The Tub*, the cut-off white jug now has a straight-line edge and a full, rounded female edge and, as this new "object," it contains the two grossly contrasting linear features of the work that were present in the contrast of round tub and square-edged table-top. This new jug comments on the relation of body and table, the straight white edge of the table and the voluptuous long curve of the woman's arm, back, and buttocks. Table and rounded basin become a couple: a rounded, dark basin, and a white, brutally rectangular table. The mysterious shadows of the basin play against the flat banality of the table, but they do so only in this picture, and only in this cropping. The manipulated totality, arbitrary and yet aesthetically "locked," is the ironic, inorganic, unfused characteristic of wholes within modernism. For this, the table with its scattered, accidental composition of separate objects is the key image. Degas's white table holds a scattering of objects, a messy still-life that notifies us that the painting as a whole has been colonized by the accidental order we see on the table at the left. Unlike Manet's *Portrait of Théodore Duret*, Degas's painting has denied the body a distinct power to organize the space around a human personality. Instead, the body itself has surrendered to the still-life assortment and become, like the white pitcher, another element within the arrangement.

Of course, the table surface is only one highly explicit version of the organizing power of the rectangular canvas itself. Throughout Degas's work the features of the canvas are quoted inside the work. Since the edges crop (to use the photographic term) a far larger visual space, Degas makes use of door frames, walls, and other edges within the work to cut off the figures and to let him quote the edge-effect within the representation itself. In his pastel of 1883, *Woman in Her Bath Sponging Her Leg* (Fig. 23), the surface of the water in the tub becomes a cropping device that conceals all but the top of the body above the shoulders and, in addition, one arm that reaches out to sponge the one leg that is seen raised out of the water. These three pieces of her body, now a new, but complete, thing, we can accept because of the comforting surface of the water that reassures us that the rest of the body, although unseen, is still there. The water permits us to contemplate a new, reconstructed body, unified and manufactured at this moment by the act of raising the one leg out of the water and reaching forward with one arm to touch it, an act and a moment frozen by the artist. The arm joins the leg to the shoulders and back. The water surface that permits this cancellation of the ordinary body is a narrative pun on the picture surface itself.

Fig. 23. Edgar Degas, *Woman in Her Bath Sponging Her Leg,* 1883. Musée d'Orsay, Paris.

Since the invention of photography, and especially since the displacement of the theater by film and television, the most familiar representation of the body within art has been in a dramatically cropped form. Degas creates within painting the everyday accidents that now, in the aftermath of photography, become noticeable as evidence of facts that had always been the case. For the eyes the body exists as an endlessly reorganized form. In the pastel of 1886, *After the Bath, or Woman Drying Her Feet* (Fig. 24), the body is folded over itself so that three parts are interlocked like a fist seen from the side. This new form is composed of a side view of the back which in her bent-over position is seen horizontally and folded against the upper arm from shoulder to elbow, the arm resting along the thigh. This form looks almost grotesquely like the inside of the body suddenly made visible on its surface. The three parts that fold like a fist have no other posture in which they would assort and fit against one another to make this construction.

Degas most often achieves this industrialization of the body by choosing an angle at which key information vanishes. Seen from behind or above, the face and front are invisible. In the extraordinary picture in the Hillstead Museum in Farmington, Connecticut, *The Tub* (Fig. 25), also done in 1886, an assembly of the naked body is created by the angle of our attention to it that removes every traditional feature of a nude. Here again the body is pro-

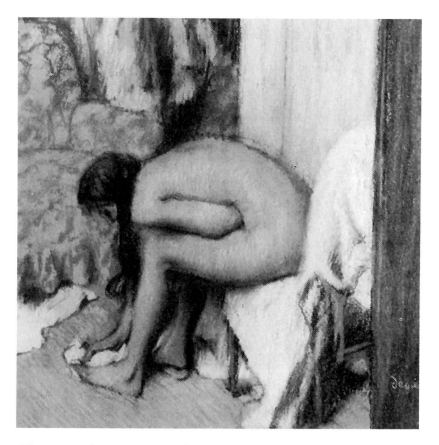

Fig. 24. Edgar Degas, *After the Bath, or Woman Drying Her feet*, 1886. Musée d'Orsay, Paris.

posed for contemplation against a flat shallow tub which becomes a space of projection for the form, a substitute table. Reaching down to clean the tub with a sponge, the woman's hand is once again serialized in a neat row with her two feet. A waving, lyrical line defines the entire left side of the figure, fusing the line of the arm with the edge of the back as far as the left hip. In the pastel this continuous curving line is flooded with light. The other side of the body disappears in darkness, but an elbow emerges from that darkness to reach almost to the edge of the work. In this, as in many other works, it is a startling and transient pose that forces a temporary reassembly of the body, a reassembly that denies its reality as a structure and an organic whole in order to restate it as an array of parts only temporarily present as this or that complete form. In *The Tub* it is the floor, ultimately, that is the table-top against

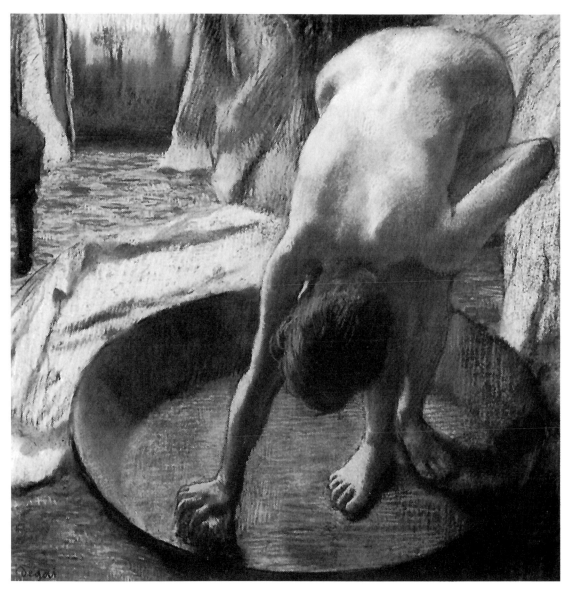

Fig. 25. Edgar Degas, *The Tub*, 1886. Pastel, Hillstead Museum, Farmington, Connecticut.

which this scene is arranged. At the far right of the picture a chair is severely cropped, intruding only one leg into the picture space. This fourth leg completes the hand and two feet of the woman at the other side of the space, and makes the chair and woman counter figures to one another. The cancellation of features within the chair takes place by means of the simple expedient of the picture edge that cuts it in two, one part visible, the other vanished. This deletion is equated by Degas with the pose and angle that in the case of the woman bring about a similar redesign, cancellation, and assembly of a new form out of familiar materials. The artist's patience and capacity to snap a picture of even the most transient pose is what Degas has substituted for the hand that prearranges the small objects of the ordinary still-life. In this he gives to everyday experience the conditions of still-life, the conditions of a handmade space. The plane of the floor and the plane of the picture state themselves as the screen on which this projection and assembly take place.

## The Table As Island or World

Meyer Schapiro has written of Cézanne's table as though it were an island, but it must be added that it is an island without an ecology of its own, an island onto which a certain set of unconnected objects and fragments have been, over time, shipwrecked. The artist working with the limited island-like world becomes a Robinson Crusoe figure, making his world out of the seeds and parts of a prior world from which only fragments have been recovered. Crusoe's must always be remembered as a second world. Ever since Max Weber equated Defoe's hero with the modern industrial relation to the world, we have taken Crusoe's island where his will is free to order, build, and impose his plans in terms of his own purposes and needs as a fundamental image for the modern relation to nature.[8] Crusoe's island is for a technological society what the Garden of Eden was for a religious relation to nature as God's creation and gift. The island miniaturizes the social and technological relation to the earth in terms of a single individual's relation to the amount of space that can be dominated by his own will. The artist by means of the table-top describes this same miniature model of the will. Schapiro describes Cézanne as follows:

> Cézanne's prolonged dwelling with still life may be viewed also as the game of an introverted personality who has found for his

art of representation an objective sphere in which he feels self-
sufficient, masterful, free from disturbing impulses and anxieties
aroused by other human beings, yet open to new sensation. Stable
but of endlessly shifting, intense color, while offering on the small
rounded forms an infinite nuancing of tones, *his still life is a model
world that he has carefully set up on the isolating supporting table,*
like the table of the strategist who mediates imaginary battles be-
tween the toy forces he has arranged on his variable terrain [em-
phasis added].[9]

What needs correction here is Schapiro's sense of retreat and intro-
verted sanctuary. However true this may be for Cézanne, in our
general history just the opposite is the case. For an industrial so-
ciety it is the world itself that is captured by means of the hand
held over the table, and for this Schapiro's military metaphor is
perfect.

The island-like table records a side-by-sidedness of objects that
has been magically overcome by the painter's own working process,
the assembly of side-by-side strokes on the surface. Art and world
diverge, but art has at this point taken the industrial attitude towards
the world, seeing it as raw material for purposes beyond itself, sub-
ject to meltings and fusings, transportation and recombination into
an arbitrary technological space. The still-life preserves the tem-
poral split between raw materials whose source and natural occur-
rence is elsewhere and a final composition of those materials into a
coherence that is an effective product within a quite different world.
In the case of painting, the table-top (or canvas) is the quite differ-
ent world where objects arrive and find themselves arranged and
locked into place as parts of a new product.

The painting has become a contrastive repetition of the tech-
nological will and its domination of the now shrunken table-top
world by means of the hands. After Cézanne the open industriali-
zation of the picture surface takes the form of the grafting onto
that surface of such actual world-bits as newspapers, patterns, pieces
of wood or metal along with such actual things as, in the case of
Jasper Johns, coat hangers, cups, or a broom. Ever since Picasso's
1914 construction *Still Life with Fringe* (Fig. 26), painting has known
how to quote the world rather than represent it. The table-top is
no longer at an angle to the surface but fused with it.

Other than in literal collage works, normally within Cubism
the objects occur indirectly; they are alluded to rather than quoted.
They occur as signs of things made by magical acts of difference.
In Picasso's *Glass, Bottle, and Guitar* of 1912 (Fig. 27), the glass is
"made" of separate materials, or rather, a set of signs that make

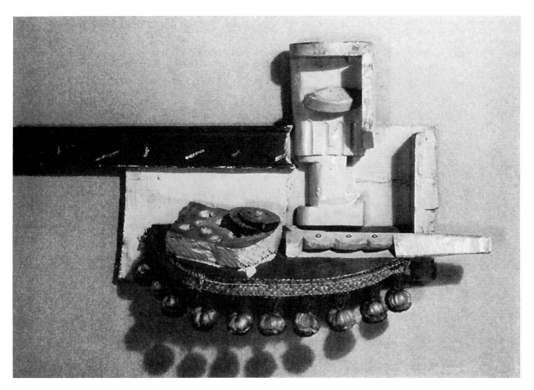

Fig. 26. Pablo Picasso, *Still Life with Fringe*, 1914. Painted wood and fringe. Tate Gallery, London. Copyright 1991 ARS, New York/SPADEM.

us experience the presence of a glass even in its absence is offered. Its left edge is a simple drawn line, but its right edge is outlined by the negative shape that occurs where the dark patch ends. Similarly, the guitar, on its upper edge, is defined by the shadow that has been illusionistically shaded in against it, while on the bottom its rounded shape is created by the way the newspaper has been trimmed. The round hole at the mid-point of the work has been drawn and shaded for shadows across two materials. Picasso designs the work to make us aware of two levels of reality, raw materials and finished products, each of which we might subject to an inventory. Among the raw materials are lines, pieces of newspaper, shadings, dark shapes, and lighter cut shapes on which a pattern occurs. The finished products are those listed in the title: glass, bottle, and guitar. Any one product, the glass for example, is not made out of one of the raw materials, as in the ordinary world glass would be made out of sand, or as, in the Klee drawing of the Witch that was discussed in the preceding chapter, the Witch was

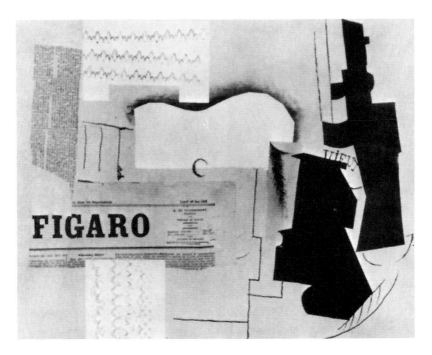

Fig. 27. Pablo Picasso, *Glass, Bottle, and Guitar*, 1912. Collage. Tate Gallery, London. Copyright 1991 ARS, New York/SPA-DEM.

"made" out of the raw material of drawn lines with their changes of direction. Instead, in Picasso's case, the objects live opportunistically off the incidental features of the materials. They are not made out of the materials since the materials never vanish from view. A co-existence is arranged by the artist that draws our attention to the process itself in which the world of objects is improvised locally by means of whatever materials are at hand.

In fact, Picasso's practice here stands closer to the workings of memory than to the industrial relation. What he describes is how we normally are *reminded of* something, not how we make it or find it available for use. The painting is nostalgic for the things that it wishes to think about even while working with something else. But even here Picasso has built in an aspect of the industrial relation. What he tries to keep in mind while working and assembling is just that realm of pleasure that guitars, music, bottles, glasses, and the reading of newspapers evokes; the world of leisure and rest that hovers in the background for everyone during working hours. While at work he "misses" these things, as we say. His painting

defines the recollection of a counter-world, or rather the intersection of two worlds, work and leisure, and defines that intersection by means of the missing things (guitar, glass, and bottle) which are the topic of the painting.

The "whole" guitar hovers *out of the picture space* as something transiently, episodically recollected, a metaphoric condition of alien materials. In the same way the missing bull is recollected, in Picasso's construction, by certain pieces of a bicycle. This is a world in which everything has been lost, but can be at any moment called back to mind by the world-debris that we can playfully assemble as a changing gallery of souvenirs of what has vanished.

It is this nostalgia and homesickness that separate the Cubist assembly from the radiant and daring acts of Cézanne and Degas— only half-completed acts of vision that played off the composed surface against a still intact world that remains visible in the narrative images within the canvas. The intellectual melancholy of Cubism, its hints of nearly vanished things, is (now that more than fifty years have passed) more and more clearly its fundamental mood. Such Cubist memories of objects are equally remote, as a transitional moment, from the candid, even vulgar celebration of the industrialization of surface and assembly that follows and is most effectively visible in American postwar art. In Pollock, de Kooning, Johns, Rauschenberg and Stella, the anatomy of will and destruction—making and debris, transformation and objectivity—reached a lyrical authority that is marred by nostalgia for what was once taken to be "the real world" only in the case of the sentimentalist Rauschenberg. The grand scale of these works, measured in feet to the Cubist centimeters, notates the advance from a miniaturist model-making that was preparatory to an assault on the world as a whole, an example of which would be the Picasso *Still-life with Fringe,* to the robust conquest that works like Stella's *Diavolozoppo* and *The Spirit-Spout* represent. These Stella works read as the reports of an already successful exploration.

## The Technological Will

In this hundred years of table-top space what is recorded is the aesthetic component of a technological relation to experience. The essence of this technological enterprise is best described in the later work of Heidegger, although to use his account we have to remove not only the reactionary politics of those descriptions but also the apocalyptic tone and the assault on modernity and scientific civili-

zation that, for Heidegger himself, lay at the heart of his project.[10] At the center of technology is the human act of taking power over the world, ending the existence of nature or, rather, bracketing nature as one component of the productive total system. The world is submitted to an inventory that analyzes it into an array of stocks and resources that can be moved from place to place, broken down through fire and force, and assembled through human decisions into a new object-world, the result of *work*. The stages of this rational reconstruction are exhaustively set out in Lewis Mumford's *Technics and Civilization* or in Siegfried Giedion's classic work, *Mechanization Takes Command*.[11]

In the first stage nature is deconstructed by means of a human inventory that fractures it into a list of resources that the earth has or possesses in the same way that governments have stockpiles of uranium, copper, or wheat. This intellectual analysis is followed by the actual seizing and refining of the separable stocks through force. Lewis Mumford described with great poetic skill how the actions and images of the mining industry underlie the first technological era, for it is in mining that the world first appears as broken lumps of pure matter. In the mining process we separate and heap together coal, gold, silver, or oil. Mining breaks a certain substance free of the natural world, refines it, and transports it to a stockpile. The entire natural world has already, in the imagination, been purified in this way into quantities of this or that substance. Mining, along with the subsequent processes of refining, transporting and quantifying provides, in Mumford's description, an intellectual model for the technological process of converting nature into an array of raw materials.

## Stages of Object Life

Within modern production four stages of object-life can be distinguished: First, the stage of materials or stocks; second the stage of parts in which shape has been given to materials to create repeating, identical part elements; third, the stage of assembly in which a working object is made out of a variety of parts drawn from different stocks; fourth, the stage of debris or junk in which we face a mixed set of former objects. Within a modern economy each of the four stages of the life history of objects takes place at widely separated locations. Each stage is equally a site of work, but a kind of work distinct from the Aristotelean or craft notion of giving form to matter.

Works of art in the modern period embody, call up, and isolate for attention one or another of these four stages; they have the choice of mentioning or being haunted by them. Minimalist works of art have commonly had as their topic the first stage in which the presence of a certain quantity of a single material is strongly experienced and experienced simply *as* material, that is, as sand, felt, wood, glass, wire, steel beams or plates in this or that quantity. The location of such works of art is commonly the floor, and a museum filled with a certain number of these works takes on inevitably the look of a warehouse. In the 20th century one of the inevitable missions of art has been to experiment with the sensory diversity now possible due to the great number of new materials introduced into everyday life during the last hundred years. The presence within ordinary experience of an explosion of material alternatives—the look of aluminum or lucite, the glow of a television screen, the feel of polyester, the colors made possible by the new chemical dyes—forced a time of habituation in aesthetics. In turn, the sensory practice that these new materials required reached back and applied the same attention to such traditional materials as wood which could again be seen in their naked materiality. Mass and material are the two characteristics of this first stage of object life open to the artist whose work in making a minimalist work of art consists in choosing a material and transporting it. The art act calls attention to the displacement by which a pile of felt or a set of steel plates, normally found here or there within social life, has been relocated so as to occur for some reason *here* on the floor of a gallery or museum. The estrangement that we feel in the face of such a relocation records and practices the slight sensory discomfort that we feel everyday in such an experience as looking at a display of tropical fruit in a grocery store in Boston in the middle of a January snowstorm. The art experience observes and makes conspicuous this changed meaning of the word *here* under modern conditions of portability. The fact that anything now occurs just *here* no longer has anything to do with its making up a natural part of this environment, because the total environment itself is the direct product of a world-wide portability that has no historical precedent. The environment in which we live has been itself assembled, brought to this place and integrated or composed so as to reflect a technological version of human needs and interests.

In spite of this, we experience, within this first stage, a feeling of closeness to the natural world from which the material has been only slightly separated, while at the same time seeing in any mere pile of sand, felt, or wood, an atmosphere of anticipation as though

the material was waiting to be used. If it has been brought to this place what will it be used for? What form will it be given? Inevitably, such piles of basic stocks of material bring to mind a construction site, so that, in the end, a museum with minimalist works staged on the various floors of its rooms and corridors evokes a cross between a warehouse and a construction site. Both places are locations of waiting; both are sites of anticipation and temporary presence. Any pile of mere material that stays somewhere very long takes on the feeling of having been abandoned there. We look at it as something brought *here* by someone for a definite purpose, but one that is no longer known. Abandoned material carries with it a feeling of defeat and failure that is exactly transcribed by saying that it is forgotten material, and in fact an embodiment of forgetting per se.

In the face of stocks of materials that do not find rapid use, this experiential despair over abandoned things takes over. For this reason the museum intention that things remain as they are for an indefinite period of time works to convert the optimistic anticipation that is at first present in stocks or piles of material into a forlorn despair. No other works of art have the power to make us feel, as minimalist works do, that they were *left* there rather than *brought* there.

Within the industrial process stocks of raw materials are formed into parts. This second stage of object life is the only stage that conforms to the Aristotelean notion that in all acts of making we impose form on matter. Industrial society makes parts in endlessly repeated sameness. No factory makes automobiles; they are assembled rather than made. Instead a factory makes tires, exactly alike, in production runs of millions, or batteries, windshields, radios, or the light bulbs for turning signals in production runs of millions. For the part stage of object life, the repetition of similar elements and the key feature of shape are central. Mechanical reproduction is the essential act of making within the phase where parts, at widely separated locations, are turned out.

In the third stage the variety of different parts and materials are assembled. Variety of parts, materials, and shapes, as well as the order among them move to the forefront of attention. At this stage the object works, as we say. It has composition and arrangement as prominent features. Among its parts we might speak of an almost narrative arrangement. At this point the object begins its useful life. This ordinary, working lifetime of an assembled object has been the stage of object life addressed conspicuously by Cubism as well as by the aesthetics of composition over the last hundred

years. Cubism kept before the observer the fact that the object had been made and assembled by the artist; that is, *made* rather than represented. By using tiny nearly identical facets, the artist defined making as the assembly of replicated parts into a variety of final products.

In the fourth and final stage of object life, the useful life is past and the object becomes debris. Once again the object exists mainly as parts, but now as used up or broken fragments that are mixed, as at a city dump or in a museum, with the parts and fragments of a chaos of objects. Such parts or fragments call up the humanized past of things. Each object that has been used, especially one that is now worn out, retains the capacity to bear traces that work on us almost as memories do. As parts of works of art such debris is self-consciously being reused and given a second life. The fourth stage of object life is the most directly humanistic. It is potentially tragic in its range of feeling, but more commonly it is elegiac or evocative of the pathetic state of ruins. Within the work of Jasper Johns the nobility of this debris stage reaches a power of solemnity and elegiac force that is nearly a modern form of the tragic.

Each of the four stages, because we commonly experience them as phases of a continuous object life, bears the temporal mood of its position within the sequence. Stocks of raw material are potential; they are future-oriented, just as parts are. The third stage in which we have a stable composition of diverse parts is present-oriented. It reads as a working object. The fourth stage is past-oriented, just as all debris and ruins are. The language and procedures of the third stage are those that have been the subject of this chapter which has claimed that the stage of assembly has played a fundamental part in the history of modern art from the time of Manet's compositions to the still-life paintings of Cézanne and Braque, to the Cubist and Constructivist assemblies of the first third of this century, and on to the American work after 1945. With the American phase, an unusually strong impact of the fourth or debris stage of objecthood became prominent.

## Art Object and Industrial Object: Parts, Works, Cover

The outcome of the modern system of production is not only a plenitude of new objects, but a new model for what an object is. As previous chapters have made clear, a certain pressure on every individual experience occurs as a result of the type of model object that hovers in the background defining our expectations. To com-

plete this chapter I want to spell out the features of industrial objects by means of an example like that of the table for the craft system; an example that differs from either the pins, the contentious work of art, or the masterpiece in that it registers the pleasure and accomplishment of what is new within our everyday relation to objects and not simply the claim that what modernity implies is a degraded relation to some previous object world. To do this I will briefly describe a bicycle as a model object, and in this I will try to make clear the connection back to the still-life, to the composition of objects as we see it practiced in Degas, and to the features of table-top space that have stood for the mediation between art and industrial world throughout this chapter.

The bicycle is an essentially new object of the type produced within mass production precisely because it is so visibly an array of parts. Each part is functional and made of the material best suited for that function, like the leather of the seat, the metal of the chain, or the rubber of the thin tires. Each part can be easily and specifically identified by someone who understands how the object works. The parts have only minimal points of contact with one another and they are for the most part visible. The variety of materials, the minimalization of points of juncture, the single function of each feature: all serve to define the whole as an array of parts or features which are prior in importance to the rather loosely organized whole. If we ask what has been "made," the answer would be that it is the stock of parts: the bolts and spokes, tires and seats. Frequently they have been made at widely separated factories, by working groups having no connection with one another. The making process that we understand as the traditional shaping of material more naturally yields parts in massive stocks of identical, non-functioning "features."

Each of the three points of contact with the body, for example, is specified by a part whose material and shape are unique. The seat is usually of leather and is shaped to the buttocks and designed to transmit the weight. The pedals, where the feet make contact are either of rubber or of saw-tooth edged metal so that the feet do not slip as they transmit the driving force to the machine. The handle-bars curve around to meet the two hands. The chrome bar ends with a material that can be gripped by the hands. Each of these contact points for hands, feet, and buttocks is separately addressed by materials that extend out from the central plane of the bike. Each is a feature of the bicycle that remains materially and visually distinct, as pedal, seat, and handle-bar tip. As a whole the object is assembled rather than *made* in the traditional sense. Usu-

ally, the factory assembly is incomplete, and the owner of the bike himself or herself does the final assembly at home.

In our traditional notion of making, for which we use Aristotelian categories, an object is made when form is given to matter. When stone is carved into a bust of George Washington, we speak of the bust as having been "made." In Aristotelean objects, matter is given form by the human hand guided by the foresight of the human imagination. Such objects are self-continuous throughout. The bicycle, on the other hand, is an assembled array of replaceable, standard features for which the act of assembly is a relatively insignificant stage of the process. Often the assembly process can be reversed; we can quickly break down a bicycle into a pile of parts. In our traditional idea of making this reversal is impossible. We can break a clay pot but we cannot disassemble it.

A primary distinction between the bicycle and an object such as an automobile, between a bridge and a skyscraper, is that automobile and skyscraper are just like the bridge or bicycle, arrays of standard parts and features, but now concealed within a smooth external skin that can, and frequently is, made of an entirely different material from the functioning parts within and has a unified aesthetic surface that blocks us from functional information. The curtain glass wall of a skyscraper is just such a mystifying, flat cover. The shell of an automobile, the outer surface of a radio, a refrigerator, or a computer, is intended to substitute a unified but irrelevant aesthetic experience for the sight of the ongoing processes within, the inner array of features and parts.

The change in object structure from the Aristotelian categories of matter and form, a description based in craft-production and adequate for it, gives way in the period of mass production to a work pattern of part assembly that creates a new emphasis, an almost biological emphasis, on the break between surface and interior, cover and machine. With sculpture, the loss of the monolith and the subsequent construction of unified wholes out of parts is the most significant experimental feature of the work of the century. In the works of David Smith and Anthony Caro the relatively thin spans by means of which space is occupied, showing (as a bridge does) an enormous amount of air through the frail, structural pieces of the sculpture, make of the sculpture almost a net around space, a tracing of the boundaries for a space most of which is, in fact, unoccupied. The object occupies space, penetrates space, but it is equally penetrated by space, as a bridge or a bicycle is. An array by Smith or Caro has the appearance of an "inside."

The disjunction between the surface and the interior creates the

conscious feeling, when we look at things, that they have an "inside" distinct from and discontinuous with their surface. This creates for art the question of exploring, on the one hand, the inside of uncovered space, and, on the other, the aesthetics of a bland cover. The skin or surface can become the subject, as it is in the New York skyscraper or in the paintings of the New York School of the 1960s with their bland or overall surface. In the packaged look of the art of the sixties, the early geometrical work of Stella, the less significant work of Warhol and Olitski, produced a kind of art that had a great deal in common with the commercial art of covers or wrappings. Wrappings are typically surfaces that allude to, by concealing and unifying an inside that is withheld. Thus the celebrated flatness of the art of the sixties takes on an entirely different meaning when read, not as the exploration of two-dimensional reality, but as an overall, brightly colored wrapping that conceals, as the outsides of objects do, a fragile or puzzling world within, the world of a gift or surprise. In the same way, the mirror wall of a skyscraper returns the glance of the observer to the environment, directing it away from the inner workings of the building itself.

At the other extreme from these works in which the cover has become the subject are the more significant works of the last generation in which the inside, the opened and visible array of parts, frequently in assemblies that are so casually unified that they seem parodic, has become the central concern. The work of Pollock, de Kooning, Rauschenberg, and Johns; the sculptures or assembled metal structures of David Smith, Frank Stella, and Caro; the architecture of Gehry and Venturi, offer the experience of diverse materials held in clusters. A direct and bold connection exists between a construction such as Frank Stella's *Fedallah* of 1988 (Fig. 28) and the house Frank Gehry built for himself in Los Angeles (Fig. 29), and between both works and the system of order and debris within the industrial environment of the American city as a whole. The refusal to disguise the relation of parts within an organic or packaged form, along with the refusal to stand free of the past that each part carries with it into the work, both are tactics of a fundamentally new domain of beauty and of the will within a modern conception of objects, one that is inevitably no longer based on craft but on industrial thinking.

Such works are (to return for a moment to our museum model) not singular objects at all but collections of images, styles, materials, and narratives. In their heterogeneity they are more like a compressed version of the museum itself. Viewed from this angle,

Fig. 28. Frank Stella, *Fedallah,* 1988. Mixed media on aluminum. Knoedler Gallery, New York. Copyright 1991 Frank Stella/ARS, New York.

Fig. 29. Frank Gehry, House in Los Angeles.

they are summarizing devices for the varied aesthetic parts col-
lected around them and within them, for the complex and unsorted
museum or city in which they are to be found.

However, now that we have reached this point it is possible to
say that the museum itself can only provisionally be described as
the key institution with dominion over the object world. The mu-
seum does particulate and subject to unanticipated resocialization
the object world of the past while creating a narrow channel of
access for objects now being made that aspire to become what the
future would be willing to include in such a past. At the same time
this museum itself within the wider social meaning of an industrial
society, has to be seen as an elaboration of the spirit of assembly,
of stocks, parts, composition, and debris that in their interconnec-
tions spell out the social space of modernity as a whole. The rise
of the highly intellectual form of the still life, the elevation of Cé-
zanne as the painter per se of the early modern period, both are
details of the mediation between industrial and social worlds that

the museum as an institution carries out on a larger scale. It is the museum that brought us to view the utensils and symbolic objects of the world as a unified and known stockpile. Each individual museum selects from and assembles a certain ordered composition from that cultural stock, a composition that in its own way is arbitrary and subject to later reassembly. The table-top, the still-life, the museum that houses that still-life and the industrial world that houses and funds the museum are Chinese boxes that replicate the same features on an ever larger scale. The aesthetics of this relation excludes the entire realm of domesticity, private ownership, and even individual relations of creation and use. The industrial relation is at heart a collective one. Within the frame, parts made by many hands occur. The object itself occurs surrounded and clustered with other objects to be seen by a viewer who must stand among others in a public space in order to have access to the experience. It is the humanism of this collective aesthetic experience both of production and reception that our cultural theory must now accept and defend.

chapter 9

# A Humanism of Objects

The aesthetics of modern objects has always been an aesthetics of recognition hidden within an aesthetics of estrangement. So familiar is this aesthetics that it makes up not only a central strand within all humanism, but might be said to be an aesthetics that begins from our own relation to ourselves.

Our intuitive and naïve sense, as expressed in our language, tells us that we have a body, not that we are a body. Delmore Schwartz, in a famous poem, quoted Whitehead to refer to the "withness of the body." It comes along. Schwartz called it, "the heavy bear that goes with me." A cumbersome companion, the body, in order to be recognized, first undergoes disguise. In Delmore Schwartz's image the body must first be seen as a bear to be, at a second stage, unmasked as the image of the self. In cultural history what recurs as a pattern is precisely the disguise and recognition of the body, as an image of the self, and a mediating term between self and world. Each disguise and recognition grounds one episode of humanism, and defines the nature of the self-separation that the human image rests upon.

The very terms "mask" and "unmasking," "disguise" and "recognition," misstate the cultural facts. Every cultural and productive act includes an elaboration of the self outside the boundaries of the body. Every instance of imagination or making installs the conditions of the body into material separable from the body and detachable from the self. Instead of thinking as we traditionally have of a narrow set of objects, mainly art, as the direct record of the making of the human image, we need to locate the terms with

which we can see every act of making as a making-human, and every act of making as a loss of self-material, a separation and a materialization that invite a second cultural act: the recovery of the self back from the materials in which it has been both expressed and buried. The human image depends in a unique way on the image of the body, and that image can be described as sheltered within its acts of imagination and production. In shelter it is installed, protected, and concealed, then it invites, as a climactic humane moment, an act of recognition that I am calling recovery.

However, the strategies of humanistic analysis have been most alert to those moments in the history of the human image when the sense of self achieves direct representation, where the pure image exists in works of art. Greek sculpture and the 17th-century portrait are the two most familiar examples. On the other side, the very success and comfort with moments of direct representation legitimatized a dismissive language, formerly centered on the word "barbaric" and in the modern period around the word "dehumanized" to define cultural moments when the human image is not given in a pure state but must be seized in an emergent or recovered state, wrested from near or confused images and established over against the not quite successfully discarded other world.

Cultural history defines three realms of the recovered human image: first, nature, seen as the range of animal species; second, the sacred or divine world; third, the constructed human world, the world of objects. The humanistic moments linked to these recoveries of the human image are: the Egyptian for the recovery from the animal realm; the medieval and early Renaissance for the recovery from the realm of the sacred; and the modern for the recovery from the world of things. It is paradoxical that among the alien realms from which the human image has been recovered it has not been the animal realm or the realm of the sacred that has presented the greatest resistance but the realm of the man-made, the human world at one remove, the object world.

In fact each of the three realms is man-made, and the three in combination exhaust the cultural possibilities. Once the human has been installed and then recovered from the animal realm, man has differentiated yet associated himself with a lower boundary. With the sacred he constructs an upper boundary and installs and then recovers his image. At last with the object world an equivalent and yet self-separated realm comes into being.

For each realm a similar process occurs historically. First, there is an exuberant elaboration of the realm as a tactical position with which the human can be identified and by means of which it can

be known. This first stage discovers endless resemblances, as, for example, Aesop's Fables do between human situations and the animal realm. Then once the realm is in place and coherent a distrust of the realm begins. The fact of the separation of the human from the source of its own self-understanding becomes dominant. The image is experienced as lost while the constructed realm seems inhuman and silent. After the exuberance of construction the anxiety about self-diminution brought about by the substantiality of the elaborated world holds the center of vision. From 1830 to 1900 and to some extent as a residual but now moderated stance, this middle phase of separation and anxiety has characterized our cultural relation to the technological, urban, man-made object world.

In a final stage, mediated through the work of art and humanistic culture, a series of recognitions and recoveries bonds the human to its realms. In the realm of the sacred, the distant and horrific divine figure has interposed between himself and the human a series of intermediate figures progressively articulating the distance. In medieval Christianity, Jesus, already intermediate between man and God, creates the second intervening position occupied by Mary, who created the third position occupied by the saints. That each position permits more and more abundant human representation in art determines its value in the recovery of the sacred. In each realm the failure to recover the human image issues in not permanent separation but engulfment. With the animal realm this engulfment takes the form of metamorphosis or sudden uncontrollable vacillation between the human and the animal as in the werewolf. For the realm of the sacred the capture takes the form of demonic possession. In the modern realm of objects the equivalent to metamorphosis and possession is what has been known since the mid-19th century as reification. Once captured the substance of the self can no longer imagine factoring out the differences between the self and the image realm. Metamorphosis, demonic possession, and reification, all imagine the self imprisoned within the terms of its own project of self-understanding. The recovery of the human is culturally blocked.

In cultural history the entanglement, estrangement, and recovery of the human image from the animal realm offers an essential precedent for our present humanism of the man-made. Totem cultures, including the Egyptian, the highest, most complex artistic and religious meditation on the loss and recovery of the human to the animal realm, imagine themselves in terms of a borderline between cultural stages. On the one side the human exists as one species along a continuum of species, but on the other the human

dominates the whole of nature and reassumes each individual species as one partial image of itself. The human steps out of nature and stands over against nature, seeing only in the sum of the remaining species a complete realm, any part of which—falcon, bull, lion, or scarab—can now be seen as partial images for elements of the human totality.

Hegel, in his decisive analysis of Egyptian art and religion in *The Phenomenology of Spirit* and *The Philosophy of History*, considers the many hybrid, man-animal figures of which the sphinx is the most important. The human is represented, but only as a part of a being that remains part animal. Hegel sees the spiritual or human as silent and enigmatic. It exists, "shut up within and dulled by the physical organization and sympathizes with the brute."[1] Brute life he describes as silent, unable to create representations of itself, culture. Therefore the animal is the natural image for the early cultural state of the human. Again and again the human can be factored out of the qualities of the animal world by a process never completed and always only partly accessible in any one species of animal. The human emerges as the human face on the body of the brute. But the moment of hybrids is only a special stage in the recovery of the body from the animal realm. First the realm of nature is created by the projection and attention of human concern. A lending out of the human occurs. Hunting, domestication of animals, classification of animals, analogizing of the human and animal worlds construct the realm of nature with the same techniques later used to construct the realms of the sacred or that of objects. That this occurs parallel to the fashioning of the political state means that the image of the human relation to subject nature will always mirror the ruler's relation to his people. The human image passes into, through, and is recovered back from the animal realm in a set of stages. In Egypt the animal is first represented alone. The very early Baboon of Namur (Fig. 30), the figure of a god, implies the human by means of a figure combining the animal just below man with the forces just above him. The tombstone of King Wadji (Fig. 31) shows the falcon Horus above a snake above three towers of the king's palace. The king himself hovers invisibly behind the three elements of his rule. In the hybrid stage king and animal appear together, as in the sphinx. Finally, the human is juxtaposed to the animal as in the famous statue of Chephren (Fig. 32). The seated ruler rests on a throne, the legs of which are lion paws. The armrests of the throne end in tiny lion heads. The sphinx has been broken into a man and a chair with residual lion elements miniaturized and frozen. Behind Chephren's head stands the falcon god

Fig. 30. Toth, Ba-
boon of Namur,
Egyptian, circa 3000
B.C. Alabaster. Staat-
liche Museum, Berlin.

Horus. From the front the falcon is invisible. At a different cultural
moment the falcon's head would have replaced the man's. But with
Chephren the factored and recovered human stands alongside the
elements it once was inextricable from. A latent figure of a lion
remains in the wig, face, and beard that stylize the ruler's actual
face in the direction of the now separated lion.

As the human is extricated, the animal can reappear as a thin
covering: a mask to be worn over the face, an animal skin worn as
a costume, or, even fainter, as a tattoo or stylization of hair and
beard. Likewise, the animal, once separated, can appear paired to
the man as pet or in scenes of the hunt where lions stand on two
feet in imitation (by reversal) of men, or, as in those curious stat-
ues where bearded heroes protect or wrap around themselves single
animals in a now gentle, curatorial relationship (Fig. 33). Eventu-
ally these images lead to the figure of Christ as the Good Shepherd
with a single lamb over his shoulders.

The Egyptian recovery permits the free-standing, fully human
image in the sculpture of the Greeks and, similarly, the medieval
and early Renaissance recovery from the sacred permits the unique
individualistic late Renaissance portraits. The Egyptian recovery

Fig. 31. Stele of King Wadji, Limestone from Abydos, Egyptian, circa 2900 B.C. The Louvre, Paris.

permits as well the gentler hybrids of centaur and siren and the reversion imagined in Ovid where the human passes back, in a negative reminder, into every possible animal form.

With both the Egyptian recovery from the animal realm and the late medieval recovery from the realm of the sacred it was the creation of objects, often art objects, that at first advanced the en-

Fig. 32. Statue of Chephren, Fourth Dynasty. Cairo Museum.

tanglement and sheltering of the human image and then assisted its recovery. In the third, the modern, objects themselves are the problematic realm with which the image is entangled and from which it must now be recovered. Paradoxically, only by the creation of further objects, potentially increasing the dispersal of the human image, can that image be recovered from the already existing objects. Many of the complexities of objecthood in modern art are, I believe, dependent on this paradox.

Fig. 33. Calf bearer, Greek circa 570 B.C., Marble from Mount Humettius. Acropolis Museum, Athens.

The timidity with which the object world was set in place needs to be remembered. At first there seems to have been a reluctance to dare to set in place any truly novel thing. Thus buckles appear in the form of snakes, pipes and jugs are formed to appear camouflaged within their resemblance to already existing things. Paint on the surface of the object, scenes, writing, designs: far from intensifying the presence of the object make us forget it even in looking directly at it. It competes with itself, its surface with its form for our recognition. Even in the 20th century the polished metal surfaces of objects decorate the form with the mirrored reflections of the environment and continue this hesitation to create any new objects whatsoever.

Nonetheless, the work of society for hundreds of years has as its major result the dramatic multiplication and systematic integration of the object realm. In that same period humanism has desperately worked to elaborate a counter-realm of imagery for the human based on solitude, consciousness, and nature, dematerialized and unembodied accounts of the self. The neglect of the body as a term within humanism stems from the intuitive certainty that the body, since it is mine rather than me, since it is property in Locke's sense of the world, is located in part within our mental geography as a sector of the world of things and ties its fate to the fate of objects. The body in other words is subject to changes of tone and possibility, feeling and intellectual location that occur in the general realm of commodities, machines, and objects. In so far as there is a terror of the object world or a casual contempt for objects easily replaceable and already too numerous, so too will the body engage our object terror or our casual contempt.

At the same time, as a hostage to the world of things, the body becomes a bridge across which the human image can be recovered and recognized within the object realm. That the technological world, the world of commodities and property, is not the alien realm that art tries to create counter-images to, but in fact the basic realm for any image making whatsoever—any representation whatsoever, any technique of construction whatsoever—seems to me to be the fundamental fact isolated by modern art.

Our major revision of the recent past will come when we can see that the apparent antagonism between society and its intellectual and artistic critics in the last century in fact masked a deep resemblance. The free-standing, self-reliant individual unable to imagine himself a part whether of society or of nature, and who, as an individual, stood over against nature, considering it a stock of materials for his production, whether that production was of

bridges and money or meanings and images and experiences: this industrial productive relation to the world underlies the most diverse positions. In every case the world is mastered; in every case it is transformed. Thoreau, who sees the field as something that can be made to say "beans," through his work, or the pond as matter that can generate parables and meanings through his meditative grip on the raw materials of experience, is a man colonizing matter from without no less than the chemists and industrialists of the century who made mountain ranges say "ore" and ore say "iron" and iron say "bridge."

In the realm of objects we have traditionally been able to acknowledge the presence of two unique individuals who stand across the object and exclude by their presence all others, or, rather, by their presence convert all others into an audience. As Chapter 6 showed in the case of the table, these two are the maker and the owner. Our humanistic stress on the unique style of the craftsman, his signature and personality, locates the worker as a ghostly presence implied by his traces. At its extreme these traces can be no more than imperfections, as when Ruskin praises in the Gothic the freedom of the worker even where that freedom is evidenced by his clumsiness that produces variations and flaws within the stone carving. The cult of the artist who signs his works and hovers behind them, outlined by his personal style, is one manifestation of the recognition of unique individual persons through objects that ornament the mythic figure of which they are the residue. That the craft object simultaneously outlines an owner, one for whom it is uniquely designed and who can therefore be found present in it, is equally important. Neither owner nor maker is part of the audience for the work: the social class of all those that the object is neither "by" nor "for," the onlookers at the conversation of making and using, making and having. In fact, the definition of audience in the period of craft objects can be given as all those who cannot in the presence of the object recognize themselves. For this reason all objects in museums have reversed, by means of an institutional frame, the priority of persons. In museums the things of the past are converted into objects set primarily in relation to onlookers, that is, to those who do not recognize themselves as spoken by or spoken to in the object.

The two major elements of mass production destroy the customary recognitions that supported the humanism of craft objects. First, replication destroys the recognition of the unique one "for" whom the object existed. Identical, mass-produced objects shadow a generic or generalized destination: anyone. Second, the division

of labor abolishes the signature of the unique maker and substitutes the partial presence of many, a fact often noted in the modern technique of collage where each bit of material has a separate origin, often in radically dissimilar acts of making. The collage principle as we see it, for example, in Cubism builds into even the most individualistic work the social fact of the division of labor.

The destruction of both recognitions substitutes collective presence for individual presence and summarizes one variety of what has been called "dehumanization" in the modern period. However, it is just this abolition of the two individual figures of maker and owner that multiplies the force of the collective third term, the audience. Where, in the case of the craft object, the audience defines itself precisely as those unable to achieve recognition in the object, under modern conditions, the collective and spectatorial condition of the audience enables, by matching the conditions of making and using, a decisive humanistic recognition, the recovery of the body from the realm of things.

Even before the appearance of works of art that dramatized the presence of the human image in the object world, the latent presence of the human made up one formal element of the design of things. Objects combine discrete positive and negative sets of body parts. A spoon is, at one end, a negative of the hand, designed to fit in the space left within a fist. At the other end of the spoon is a positive of the mouth. Food is carried from a bowl, in a spoon into the mouth, then to the stomach. Each of the four containers maps the others as a sequence of spaces. Behind the spoon the body part set of fist and mouth appears.

Most objects imply the human by existing like jigsaw pieces whose outer surfaces have meaning only when it is seen that they are designed to snap into position against the body. The design or form of these objects reveals itself in two installments. First is the self-contained harmony of actual parts, lines, and shapes. Then, for the second installment, the assumed human presence has to be included. The form of a coffee cup, its curves and hollows, relation of height to width, can be described internally. But then the form is made up of a set of interlocking elements that reach out to the body. The handle is of this size and configuration because of the thumb and fingers that will grasp and lift it. The rim is designed to fit against the mouth. The size and depth are the dimensions they are because of the size of the stomach, the appetite for coffee, the number of sips that are felt to make up a drink. The relation of width to height and the material of the cup control temperature to match the liquid to the body's temperature. The features of the

cup can only be understood by preserving a hovering human image nearby. The cup is adjacent to the body even when seen alone, and in its elements are recorded the details of the body.

It is not an accidental fact that the words for the parts of the body are shared out and given freely to the object world. Nor is this a metaphoric use of words. The cup is made up of a handle that meets the hand and conforms to it, a lip that meets the lips. That jars have mouths, bottles, necks, and chairs, arms and legs creates a community of human extension and insists on the recovery back out of the objects of the human presence.

The words for the parts of a cup—"lip," "handle"—record in language the essential fact that the edges of the body have never been absolute. We might imagine that a cultural taboo existed such that no word for a part of the body could also apply to things. Jealous and timid, the human race could fear a contamination from the flow of resemblances and linkages between man and things. That we in fact do the opposite makes possible both the flooding of the world of matter with human meanings and the subsequent recovery of the human image from that world.

A steam shovel combines a head and an arm. The cabin is a squared head and control center with a windshield eye. The arm of the shovel magnifies a hand, forearm, and arm. Inside the cabin a lever or control stick miniaturizes the arm and mediates between the actual arm of the operator and the giant arm outside. The three arms, human, miniature, and gigantic, are translating one another's motions and will. In a steam shovel the head and an arm are fused without the intervening body.

The object world, by materializing sections of the body, separates off parts and then fuses them as a new array. In doing this the object world materializes not fragmented or diminished wholes but acts. Eating is materialized in a spoon. Grasping and lifting are materialized in the steam shovel. Rodin materializes walking in the headless, armless *Walking Man* of the 1870s. The free variety of recombined body parts makes dominant the reality of acts and their weakening relation to agents. The object world is a participial world; moving, eating, lifting, covering, embedded in material form.

To recover the image is often to dispel the particular technological combination of separation and magnification. When I watch a car driving across a bridge I can see that the car magnifies the driver's motion which has its source in walking or running. The magnification occurs through separation from the surface. The car interposes itself as does the road, between feet and earth while magnifying the speed. Yet it is only because the facts of motion

and place existed in a natural state that they are available to magnification. The bridge can only have occurred to thought because of the natural act of leaping over a small stream. This natural act is preserved, materialized, and magnified in the iron bridge that through separation permits the human leap over a mile-wide river. Either bridge or car materializes a fundamental body act. The photographs of objects without persons have a force entirely different from landscape because of the retention of the germinal human acts in magnified material form. Even empty, the streets and bridges image the human.

There are five elements of the technological world that seem most resistant to the human image. First, the dramatic change of scale towards either the gigantic or the miniature. Second, the materialization of acts rather than agents. Third, the separation of the body parts for external elaboration. Fourth, the contrast of the body to the essential materials—glass, metal, and plastic—of the technical world. Fifth, the dramatic spatial separation of the body from its images that appear over against it at a distance.

The fifth of these, that the images are *there* in space rather than *here* where the body is, creates an expense of vision. The body can be seen only by being separated from the self. This is true only for cultures of art. In cultures of mask and costume the image of the self is here, superimposed on the body and not visible to the self. The price of unity is self-invisibility, but the price of self-visibility is separation, as the technology of the common household mirror makes obvious.

Of these five factors, the materialization of acts rather than agents and the presence of the body in parts are interdependent, as I have shown in the everyday examples of spoon, cup, and steam shovel. Even more important, both are elements of what has been called "fragmentation" and are closely tied to the ordinary meaning of the loss of the human in our entanglement with objects. Theories of culture and work in the last two hundred years and, finally, key works of modern art have centered on the reality and place of the part or fragment.

The term "fragmentation," which humanistic criticism uses to come to terms with element after element of modern experience, originates in an analysis of work. Specialization and division of labor do not divide the labor but the laborer. The workers at a mill become "hands" because the presence on the job of more of the self than the hands subtracts from the speed and accuracy of the hands.

In Schiller's *Letters on Aesthetic Education*, cultural fragmen-

tation occurs in several stages. First comes the stage of wholeness, identified with Greece, where no isolated skill can be brought to a stage of development beyond the general development of the self's integrated skills. In the second stage, division of skills permits the warrior to reach a higher degree of fighting skill by neglecting all other elements of the self. The writing of poetry, skill at running, business acumen, all are released and in division reach heights unthought of earlier but at the expense of integral wholeness. In Schiller's final stage of fragmentation, however, an even greater energy of a single fragmented skill is attained by setting the organism in a state of internal conflict by creating active repression of the unwanted skills to fuel by a negative energy the single needed aspect of the self. For Schiller, the realm of art, play, and the imagination conserves the images of the whole. Culture in the narrow sense is taken to be outside the laws of work. As Marx and, later, interpreters of Marx such as Lukács sharpened this analysis of work and division of the body, culture itself, including art, were no longer immune. As Lukács wrote, this fractioning leads to "the destruction of every image of the whole."[2] The disorder of the whole coexists with the rational perfection of the isolated and autonomous parts.

From Rodin on, the part of the body or the body conspicuously missing parts is a normal element of sculpture. However, as Rilke noticed more than seventy-five years ago in his Rodin essays, artistic completeness had now been separated from thing wholeness and the artist could see that "the body consists of so many stages for the display of life, of such life as in any and every part can be individual and great, and he has the power to bestow on any part of the vast, vibrating surface of the body the independence and completeness of a whole."[3]

In the famous *Walking Man* of 1877 (Fig. 34), a totality without head or arms, or in *Iris, Messenger of God* of 1890 where torso and single arm fold like limbs against one of the pair of legs that form the body center, Rodin has relocated the mass at the extremities and invented the body as an extension of its limbs. This device reappears in Giacometti, where the standing man is in shape a single leg over which, in miniature form, the complete figure has been superimposed. In Brancusi's work a further step is taken. The body part emerges from a whole object, a pun is created between part and whole, body and thing. The work *Sleeping Muse* (Fig. 35) recovers the face from an egg by only the most delicate changes in the surface. That such works do not read as mutilations or ampu-

Fig. 34. Auguste Rodin, *The Walking Man*, 1877. Bronze. National Gallery of Art, Washington, D.C., Gift of Mrs. John W. Simpson, 1942.

tations of the form demands a vocabulary altogether separate from the contrast of integral being and fragment.

In the world of things the process of production had created a pivotal position for the part. No longer—as in the craft object—did the art of making depend on the shaping of a raw material (clay, for example) into an object (a vase) thus giving form to matter. Instead matter was shaped into parts which were then capable of assembly into one or another finished object. The central set of parts is like the letters of the alphabet, open to assembly into infinite combinations—words. As Leo Steinberg has noted in the case of Rodin, the parts exist and recombine in work after work in a

Fig. 35. Constantin Brancusi, *Sleeping Muse*, 1909–11. Marble. The Hirschhorn Museum and Sculpture Garden, Smithsonian Institution, Washington, D.C. Copyright 1991 ARS, New York/ ADAGP.

variety of temporary manifestations.[4] Later with Picasso's constructed Cubist sculptures of the 1910s the world with its scraps is taken as the part inventory over which the artist's acts of assembly can freely play.

The moment when the act of making comes to mean the stage of assembly, and not the act of forming raw material, marks the ascendancy of industrial ideas of the object and the simultaneous shift of centrality from either material or final object to the key stage of part. Where this occurs an abolition of thing from below has taken place.

The object now becomes a transient aggregate given to assem-

bly, disassembly, and reassembly. In other words, the object is given freely to transformation. Picasso's sculpture of a bull's head made from the seat and handle-bars of a bicycle reassembles what had been up to that moment the assembly called bicycle into one called work of art, image of a bull. In the same act he admits that this assembly itself is one possibility and that the disassembly and future permutation of the parts exists as an element of the nature of the present work. The objects become restless and weak, imposing themselves on the stock of parts only feebly and at a felt distance from the matter. At first there is, in effect, a feeling of object loss, as though the world of actual things had ceased to exist but memories of things (like the bull in the case of Picasso) could be evoked out of combinations of scrap. But at the price of weakening the reality of any single precise object what we have done through the part system is to transfer the reality to the system as a whole and to the play of transformations and possibilities that it invites.

Behind these three terms—transformation, the weakening of temporary whole objects and the dominance of parts—stand the systematic and magical possibilities first created *between* objects through the exchange market and now created *inside* objects by the force of our production system. Marx's well-known description of commodities defined the mystical connections between things once use value had given way to exchange value. One loaf of bread has use value to me only if I find myself hungry in the brief period of time before the bread goes stale. But since an exchange market exists that any object can enter and find itself in relation to any other object, my loaf of bread is potentially transformable into a pair of socks, a magazine, a ride on a bus. Between objects, in other words, once there is a market, any object can be seen either as itself or as a ghostly sum of all the possible things for which it can be exchanged. Therefore, it is weaker as a self-subsistent thing, a "just-this"; as though its surface were a movie screen onto which we see constantly projected all other things. The mirror surface—whether chrome, reflecting glass, or polished metal that has become the standard finish for objects of all sizes from small appliances to sky-scrapers and appears first in art in the work of Brancusi—embodies this commodity screen over which the alternate object images can pass. The object is no longer a thing once the commodity market exists. It is a ticket permitting my entry to all other things. In the market system this magic, otherness, and weakening of self-identification is instituted as a relation between things. The appearance of money, the non-thing capable of realizing the implicit re-

lations between all actual things climaxes the progression of all three elements.

By means of part production and assembly, the identical magic, weakening of the object, and strengthening of both system and part at the expense of objecthood are radicalized and appear inside the things themselves. It is this that Picasso's bull celebrates and rehearses as a fundamental fact of modern perception. The things hover like ghosts offstage but can be recollected by suggestions. It was precisely through this hovering presence across assembled parts that the body was recovered within the key modernist images, and the ethos of this recovery based itself on the techniques of the major artistic form of object awareness: still-life.

At first glance nothing could seem more remote from the representation of the human image than the ethos of still-life, the form essential to the world of objects, and descriptive of our active domination of and freedom in the face of objects. To repeat Meyer Schapiro's characterization, the still-life concerns,

> Things that we manipulate and that owe their position to our handling, small artificial things that are subordinate to ourselves, that serve us and delight us: still life is an extension of our being as masters of nature, as artisans and tool users.[5]

The scale of mastery changes from age to age and, with the development of sufficient power, even mountains, rivers, and the weather can come to be seen as subject to our handling, movable from place to place, subject to arrangement, or in the artistic language, subject to "composition." That the whole of nature on whatever scale can be seen from the perspective of still-life—that is, subordinate to the human will, visible as a stock of movable resources, available to combinational principles that are those of human desire, not natural law: these fundamental facts are implicitly represented and celebrated in the prominence of still-life, collage, and montage techniques in modernism. The world is seen as a table-top ruled by the human hand and eye.

Surprisingly, the second great subject of Cubist fracturing techniques and still-life ethos is the portrait. The human figure is disassembled, made subject to composition and rearrangement, dissolved into a part inventory that can be moved into recombinations, and made expressive of the will and freedom of the artist. At this moment the human image has become subject to the laws of objects under industrial conditions. The life work of Picasso after Cubism explores the disassembly and reassembly of the human fig-

ure. Neither the term "distortion" nor the term "expression" accounts for this freedom toward the body.

In retrospect we can see that what appears openly and directly as the subject in Picasso's work existed indirectly and with realistic narrative explanations in the previous generation in the work of Degas. As the previous chapter showed, Degas works from an industrial relation to the body, but he does so within scenes of daily life, such as a bath, where the visual redesign of the parts of the body can appear natural, if momentary. The narrative explanations conceal, momentarily, the novel freedom of the artist towards the body, but conceal and explain that freedom only for a moment that permits the viewer to adjust to the violence without an experience of shock. Nonetheless, Degas's contemporaries saw these great pastels as a misogynist's uglification of the female nude.

In the work of Picasso the narrative explanation of cropping, angles of vision, cancellation, and posture disappear and the free assembly of the body's parts take place as a willful gesture. Working in two directions, Picasso pressed the questions of the human form into the most dramatic possible restatements of the freedom and power of the constructing will. On the one hand the set of body parts swims free of symmetries, spatial separations, and positions to combine freely within a flat space. Puns between parts replace symmetries and override structure. Within the set of parts, feet, hands, buttocks, breasts, eyes, noses, and mouths break scale and float into separable expressive units. From the opposite direction, Picasso began with his scrap constructions the repeatable demonstration that any matter, any scrap, any combination of materials could be joined to create a sign of the human figure. In the *Venus de Gaz* (Fig. 36) an ordinary double burner, taken from a stove and held vertically, creates the hovering secondary presence of a primitive goddess. In the scrap and wire figures of the late twenties and early thirties the bits of metal join to release the human facts behind them. After Picasso the heroic form of his struggle with industrial materials comes to a climax in the work of David Smith.

In this effort to free from inside man-made things the fact of their humanity and to create, across I-beams, machine parts, and debris, the implicit human world to which they always refer lies a necessary inversion of the theory of work that describes all objecthood as frozen human labor, human time, and human need. Through work the human is injected into matter, mixed with material, and set apart over against the worker. In advance it could not be certain

Fig. 36. Pablo Picasso,
*Venus de Gaz.*
Copyright 1991 ARS,
New York/SPADEM.

whether at that moment the human, lost into the thing world, would remain recoverable by a connection of recognition. Aristotle's term "recognition" implies that the self lost into the world in action can be recovered by the act of "owning" the acts in a moment of self-identification. In the sculpture of Picasso and David Smith, a similar recognition occurs across the world of things. By an act of transfer, our acknowledgment of a companionable human presence in the welded I-beams of Smith's *Sentinel III* (Fig. 37) involves us in a willingness to recognize the same presence in bridges, skyscrapers, and pylons. The act of recovery performed in art rehearses the imagination in the fundamental act of connection necessary to live through as well as in the man-made world at large. Each recovery in an individual work states that the object world in general exists as a rebus, spelling and re-spelling the human name.

Fig. 37. David Smith, *Sentinel III*, 1957. Painted steel. Collection of Mr. and Mrs. Stephen Paine, Boston. VAGA, New York, 1991.

# Notes

### Chapter 1. Art and the Future's Past

1. Martin Heidegger, *Being and Time* (New York, 1963) and in his *History of the Concept of Time* (Bloomington, 1986), see section 23.

2. Paul Kristeller, "The Modern System of the Arts," *Journal of the History of Ideas*, XII, (1951): 496–527, and XIII, (1952): 17–46, reprinted in Kristeller, *Renaissance Thought*: II, *Papers on Humanism and the Arts* (New York, 1965), 163–221.

3. For the general history and theory of the museum, the basic texts are: André Bazin, *The Museum Age*, tr. Jane Cahill (New York, 1967); Niels Van Holst, *Creators, Collectors, and Connoisseurs* (New York, 1967); Jean Claude Lebensztein, "L'Espace de l'art," *Critique*, 26 (1970) and André Malraux, *Voices of Silence*, trans. Gilbert Stuart (Garden City, N.Y., 1953). Many of the key ideas in Malraux's book along with its stance can be found in the important but very brief essay by Paul Valéry, "Le Problème des musées" which appeared in 1923. Valéry's essay was collected in his *Pièces sur l'art* and in the *Pléiade* edition, Vol. II, pp. 1290–93.

4. Van Holst, *Creators*, 208.

5. Michel Foucault, *The Order of Things: An Archaeology of the Human Sciences* (New York, 1973).

6. Johann Joachim Winckelmann, *Geschichte der Kunst des Alterums* (1764–68).

7. Van Holst, *Creators*, 210.

8. Ibid., 207.

9. Paul Valéry, "Le Problème des musées," II: 1291.

10. Heidegger, *Being and Time*.

11. Malraux, *Voices*, 604.

12. Ibid., 13–14.

13. Ibid., 615.

14. Max Weber, "*Die drei reinen Typen der legitimen Herrschaft*," in Max Weber, *Soziologie, Universal Geschichtliche Analysen, Politik*, ed. Johannes Winckelmann (Stuttgart, 1973).

15. Walter Benjamin, "The Work of Art in the Age of Mechanical Reproduction," in *Illuminations*, ed. Hannah Arendt (New York, 1969).

16. Clement Greenberg, "Counter Avant-Garde," *Art International*, 15 (1971): 148.

17. Malraux, *Voices*, 14.

18. Valéry, *Le Problème des musées*, II: 1290.

19. Ibid.

20. Michael Fried, *Three American Painters* (Cambridge, 1965).

21. Hans Georg Gadamer, *Truth and Method* (New York, 1982).

22. Hans Robert Jauss, *Towards an Aesthetic of Reception* (Minneapolis, 1982).

23. Constable to John Fisher, 6 Dec. 1822, cited in Bazin, *Museum Age*, 212.

24. Malraux, *Voices*, 44.

25. Svetlana Alpers in her book *The Art of Describing: Dutch Art in the Seventeenth Century* (Chicago, 1983) explored the consequences for the 17th century of such visual practices as those introduced by map making and the new microscope. Each period has its own cluster of acts that structure the fact of seeing in a way that is at least in part novel.

26. Jürgen Habermas, *Strukturwandel der Öffentlichkeit* (Berlin, 1971).

## Chapter 2. Object Time and Museum Space

1. W. J. Bate, *The Burden of the Past and the English Poet* (Cambridge, Mass., 1970).

2. Macaulay's essay on Milton is discussed by Bate in *The Burden of the Past*.

3. G. W. F. Hegel, "Introduction" to *The Philosophy of Fine Art*, trans. S. P. B. Osmaston (London, 1920), I: 44.

4. Heinrich Wölfflin, *Principles of Art History. The Problem of the Development of Style in Later Art*, tr. M. D. Hottingen (New York, 1932).

5. Alois Riegl, *Spätrömische Kunstindustrie* (Berlin, 2nd ed., 1927).

6. Arnold Hauser, *The Philosophy of Art History* (New York, 1959), 163.

7. George Kubler, *The Shape of Time: Remarks on the History of Things* (1962; rpt. New Haven, 1970), 48.

8. Clement Greenberg, *Art and Culture* (Boston, 1961), 4.

9. Friedrich Nietzsche, *The Use and Abuse of History*, trans. Adrian Collins (New York, 1949), 34.

10. Fried, *Three American Painters*, 8.

11. Greenberg, *Art and Culture*, 50.

12. Fried, *Painters*, 10.

13. Viktor Shklovski's idea of estranging or making "perceptible" is defined in the essays available in the collection *Russian Formalist Criticism, Four Essays*, ed. by Lee T. Lemon, Marion J. Reis (Nebraska, 1965).

14. Fried, *Painters*.

15. Greenberg, *Art and Culture*.

16. James J. Gibson, *The Senses Considered as Perceptual Systems* (Ithaca, 1966) and *The Perception of the Visual World* (Ithaca, 1950).

17. Edward T. Hall, *The Hidden Dimension* (New York, 1966) and Richard Neutra, *Survival Through Design* (New York, 1969).

18. Robert Venturi, Denise Scott Brown, Steven Izenour, *Learning from Las Vegas* (Cambridge, Mass., 1977).

## Chapter 4. Sequence, Drift, Copy, Invention

1. For the concept of Appropriation see the work of Robert Weimann, especially his *Structure and Society* (Baltimore, 1984).

2. E. D. Hirsch, "Meaning and Significance Reinterpreted," in *Critical Inquiry* (II, 1984).

3. Saul Kripke, *Naming and Necessity* (Cambridge, Mass., 1982).

4. Kubler, *Shape of Time.*

5. Pierre Bourdieu, *Outline of a Theory of Practice* (Cambridge, 1977).

6. Brooke Hindle, *Emulation and Invention* (New York, 1983).

7. Michael Baxandall, *Patterns of Intention* (New Haven, 1985).

8. Hindle, *Emulation and Invention.*

9. Hugh C. Aitkin, *Syntony and Spark: The Origins of Radio* (Princeton, 1985) and *The Continuous Wave: Technology & American Radio* (Princeton, 1985).

10. Gadamer, *Truth and Method,* see especially section xx.

11. The description is that of Clement Greenberg in his essay on Cézanne in *Art and Culture.*

12. Jauss, *Towards an Aesthetic of Reception.*

## Chapter 5. Frank Stella and the Strategy of the Series

1. The series is listed at the end of William Rubin, *Frank Stella 1970–1987* (New York: 1987), 164–76.

2. Leo Steinberg, "Picasso's Brothel," in *Art News,* vol. LXXXI, Sept. and Oct. 1972.

3. A selection of the photographs have been printed in Diane Waldman, *Wilhelm de Kooning* (New York, 1988), 88–89.

4. Jauss, *Aesthetic of Reception.*

5. H. P. L'Orange, *Art Forms & Civic Life in the Late Roman Empire* (Princeton, 1963).

6. Kripke, *Naming and Necessity.*

## Chapter 6. Pins, a Table, Works of Art

1. Paul Valéry, "La Conquête de l'ubiquité," in *Oeuvres,* vol. II, Edition Plèiade (Paris, 1960).

2. *Ibid.,* 1284.

3. Hannah Arendt, *The Human Condition* (Chicago, 1958), 108.

4. *Ibid.*, p. 111.

5. In *The Republic* Plato's model object is a bed.

6. Kevin Lynch, *The Image of the City* (Cambridge, Mass., 1960), 3.

7. A. S. Eddington, *The Nature of the Physical World* (Cambridge, Mass., 1928), xi–xix.

8. Jean-Jacques Rousseau, *Émile*, trans. Barbara Foxley (London, 1974), 163.

9. Leo Steinberg, *Michelangelo's Last Paintings* (New York, 1975), 8–15.

10. John Locke, *Two Treatises of Government*, ed. Peter Laslett (Cambridge, Eng., 1960), 27–28.

11. Arendt, *Human Condition*, 120.

12. *Ibid.*, 111.

13. Gadamer, *Truth and Method*, 125.

14. Adrian Stokes, *The Image in Form: Selected Writings of Adrian Stokes*, ed. Richard Wollheim (London, 1972), 118–22.

15. See Lewis Mumford, *Technics and Civilization* (New York, 1934), 14–17. See also Carlo Cipolla, *Clocks and Culture 1300–1700* (New York, 1977).

16. Cipolla, *Clocks*, 106.

17. Mumford, *Technics*, 127.

18. *Ibid.*, 125.

19. Immanuel Kant, *Critique of Judgment*, trans. J. H. Bernard (New York, 1951), 219.

20. Karl Marx, *Capital*, 3 vols. trans. Ben Fowkes (New York, 1977; Vintage Edition), I: 463.

21. Ibid., 461.

22. Alasdair Clayre, *Work and Play* (New York, 1974), 63.

23. Adam Smith, *An Inquiry into the Nature and Causes of the Wealth of Nations*, ed. Bruce Mazlish (New York, 1961), 4–5.

24. Heidegger, *Being and Time*, 105.

25. Clayre, *Work and Play*, 37.

26. Marx, *Capital*, I: 589.

27. Thorstein Veblen, *The Instinct of Workmanship, and the State of the Industrial Arts* (New York, 1914), 306–7.

28. Georg Lukács, *History and Class Consciousness*, trans. by Rodney Livingstone (Cambridge, Mass., 1971), 89.

29. See, for example, John Kenneth Galbraith, *The New Industrial State* (Boston, 1971).

30. Valéry's words were quoted by Walter Benjamin on the title page of his essay "The Work of Art in the Age of Mechanical Reproduction," in *Illuminations*.

31. Galbraith, *New Industrial State*.

32. Letter of 13 Nov. 1925 to Witold von Hulewicz. The letter deals with the themes of the Elegies. Reprinted in Rilke, *Duino Elegies* (New York, 1939), 129.

33. Siegfried Giedion, *Mechanization Takes Command* (New York, 1948).

34. The image is Nietzsche's in *The Use and Abuse of History* but it has also been used and elaborated by Jacques Derrida in his essay on metaphor "White Mythology," in *Disseminations,* trans. Barbara Johnson (Chicago, 1984).

35. Meyer, Schapiro, "Recent Abstract Painting," in *Modern Art: Selected Papers* (New York, 1978).

36. Ibid., 217.

37. Ibid., 218.

38. Ibid., 218.

39. Ibid., 219.

40. Ibid., 218.

41. Greenberg, *Art and Culture.*

## Chapter 7. Art Works and Art Thoughts

1. Walter Cahn, *Masterpieces: Chapters on the History of an Idea* (Princeton, 1979).

2. Ibid., 5–6.

3. Arendt, *The Human Condition.*

4. Tocqueville, Alexis de, *Democracy in America,* (New York, 1945), 452.

5. Rousseau, *Émile.*

6. Paul Valéry quoted in Walter Benjamin, "The Work of Art in the Age of Mechanical Reproduction," in *Illuminations.*

7. Ibid.

8. Ibid.

9. For the distinction between inside and cover see the following chapter.

10. Roland Barthes, "L'Effect du réal," in *Critical Essays,* (New York, 1971).

11. Homer, *The Iliad,* trans. Martin Hammond (London, 1987), 322.

## Chapter 8. Hand-made Space

1. Frank Stella, *Working Space* (Cambridge, Mass., 1986).

2. Michael Seuphor, *Piet Mondrian; Life and Works* (New York, 1956), 158.

3. Meyer Schapiro, "The Apples of Cézanne," in *Modern Art: 19th & 20th Centuries* (New York, 1978).

4. Ibid., p. 21.

5. Leo Steinberg, *Other Criteria* (New York, 1972), 17–54.

6. Schapiro, *Modern Art,* 19.

7. Meyer Schapiro, *Cézanne* (New York, 1952), 10.

8. Max Weber, *The Protestant Ethic and the Spirit of Capitalism,* trans. Parsons (New York, 1958).

9. Schapiro, *Modern Art,* 27.

10. In his book on Nietzsche and in his essay translated as "The Question of Technique."

11. Mumford, *Technics and Civilization* and Giedion, *Mechanization Takes Command.*

## Chapter 9. A Humanism of Objects

1. G. W. F. Hegel, *The Philosophy of History,* trans. by J. Sibree (New York, 1956), 212.

2. Lukács, *History and Class Consciousness,* 103.

3. Rilke, Rainer Maria, *Rodin,* in *Sämtliche Werke,* 5 (Frankfurt, 1965) 164–65.

4. Steinberg, *Other Criteria,* 322–403.

5. Schapiro, *Modern Art,* 10.

# Index